Hopkins Lives
An Exhibition and Catalogue

To the Rev. George Cochran, OP.

George,

A small presentation in return
for your most thoughtful hospitality
during my visit to deliver a lecture in
the President's Forum series, October 1989.
With all good wishes

Thomas MacKenzie

HOPKINS LIVES
An Exhibition and Catalogue

Compiled and Introduced by Carl Sutton
Edited by Dave Oliphant

Harry Ransom Humanities Research Center • The University of Texas at Austin

ISBN 0-87959-110-2

Illustrations photographed by Patrick Keeley.

Cover illustration: Detail from *Hopkins Lives* (1989) by Larry Johnson. Taken from the official exhibition poster incorporating the exhibition logo based on Gerard Manley Hopkins's drawing of a beech tree and the exhibition theme sonnet by Hopkins, "Thou art indeed just, Lord, if I contend." See item 538 in the accompanying catalogue.

Contents

Item 516: Joan Caryl's *Portrait of Hopkins* (n.d.). Oil on canvas. 48 x 36 ins.

Introduction

When Gerard Manley Hopkins died on 8 June 1889, not quite 45 years of age, none of his major, mature poems had been published. Not a single obituary (of which there are at least seven, the last-dated running to six printed pages and compiled months after the poet's death) mentions Hopkins's poetry. Now, in the centenary year of his death, Hopkins is recognized as one of the genuinely great poets of the English language and as one of the three or four greatest Victorian poets—if not the greatest, so far as influence is concerned.

Upon Hopkins's death Robert Bridges came into possession of all of his friend's mature poetry, but for whatever reasons besides his stated one that the reading public was not yet ready for the peculiarities of Hopkins's work, Bridges delayed publishing a collection of Hopkins's poems for almost thirty years. Although he did allow, frequently in fragmentary form, a trickling of Hopkins's poetry to reach the reading public through various anthologies between 1893 and 1917, only in 1918 did Bridges issue the first "complete" edition, the appearance of which is now recognized as one of the truly great and significant events in the history of English poetry. And thus began the miraculous and tragic irony of one who repeatedly in his last few years referred to himself as "Time's eunuch" who could "not breed one work that wakes."

The theme of this Centenary Exhibition is two-fold, both parts of which are related: 1) to trace the emergence of Hopkins from almost total obscurity as a poet during his lifetime and for a full generation afterwards to a position of absolute security in the Pantheon of English-language poets; and 2) to present substantial evidence that Hopkins might very well be, as evidenced by his influence in all communications and arts media throughout the world, the most often cited and most frequent source of inspiration to creative individuals in all fields and from all walks of life of any English-language poet—always with, of course, the exception of Shakespeare.

Although the most intense activity in assembling this show has obviously occurred since my official designation as curator in May 1985 by then-HRHRC director Decherd Turner, this exhibition—commemorating the hundredth anniversary of the death of the English poet Gerard Manley Hopkins (1844-1889)—results from a series of apparently unrelated events dating back over the past 30 years. In the spring of 1948 in a post-Masters course in twentieth-century English-language poetry, I, shamefully late for a literature student who had already accumulated 80 hours in English and

American literature, encountered Hopkins for the first time. The impact was immediate and irreversible. When I returned to my teaching duties in the fall of 1948, I began introducing into any course which allowed it a "Hopkins unit." During my 31 years of teaching following my discovery of Hopkins in 1948—I retired in 1979—I subjected at least 7,000 youngsters to the Hopkins experience. No other figure I taught in my entire 42 years of classroom work sparked such interesting and rewarding controversy. Students—especially art, music, and English majors, but also youngsters from other fields—almost immediately began bringing me allusions to Hopkins and works of their own resulting from their reactions to the poet. Without knowing it, I had begun "collecting" Hopkins.

In the 1960s my wife Elizabeth and I began commissioning artwork based on the poet's life and creative work to hang in our home. At the same time we began seriously collecting Hopkins books, relying initially and primarily on Blackwell's, Bertram Rota, and Charles Cox in England and on Howard Woolmer in the United States, and later, on other sources these four recommended. In 1970 we became charter members of the just-formed Hopkins Society in England and obtained permission from the parent organization to form an official chapter of the Society in Denton, Texas, where I taught at North Texas State University (now the University of North Texas). Until my retirement at Christmas 1979, our chapter met monthly in our home. In the spring of 1975, the HRHRC graciously loaned me all of its Hopkins holdings to set up an exhibition in Denton to celebrate the one-hundredth anniversary of the writing of *The Wreck of the Deutschland*. That summer Elizabeth and I mapped out a thirty-day "pilgrimage" following Hopkins from his birthplace site to his grave. At the beginning of this trek we attended a number of times the London exhibition celebrating *The Wreck* organized under the auspices of the Sunderland Arts Centre.

After the installation of the Hopkins memorial in Westminster Abbey in December 1975, the Hopkins Society was dissolved, and The International Hopkins Association was founded by Richard Giles, editor and publisher of *The Hopkins Quarterly*, which he had founded in 1974 with his colleague John R. Hopkins. Elizabeth and I became charter, lifetime members of the IHA and have continued our interest in the organization and its various activities.

In 1983, we began trying to decide what to do eventually with our personal Hopkins collection. My wife, whose two degrees are from The University of Texas at Austin and whose abiding affection for the institution had caused us to become charter members of the University's Chancellor's Council, opted for consulting the HRHRC about whether it was interested in the collection. We brashly asked, over the telephone, then-director Decherd Turner whether the HRHRC would be interested in having the collection. Shortly thereafter Mr. Turner spent a day in our home inspecting the collection and determined that it would be a useful addition to the Center's holdings.

In 1984, we attended the week-long conference held in Dublin to commemorate the one-hundredth anniversary of Hopkins's arrival to teach at University College, where he spent the last five years of his life and where he wrote the sonnets which have secured his rank as one of the genuinely great poets of the English language, despite the meager quantity of his mature work. Shortly after our return to the States from the conference—where there had been much breakfast-table talk about ceremonies for 1989—we spoke with Mr. Turner about a commemoration of some kind at the HRHRC, since the Center possesses the largest collection of Hopkins manuscripts this side of the Atlantic and since the public has never before had the privilege of viewing the greater part of these holdings. In May 1985, Mr. Turner, stressing his desire that the exhibition should emphasize Hopkins's representation in iconography, authorized me as curator to begin accumulating materials for a major, international Hopkins exhibition to open 1 June 1989, and to run through 30 September 1989.

Since, priceless as the HRHRC holdings indeed are, they do not compare with the volumes of manuscripts in Oxford, we decided that the theme of the Center's exhibition would be the presence of Hopkins in the world today—in every medium of human communication for which there was evidence of his influence. It was decided, therefore, that the exhibition should be entitled HOPKINS LIVES, that the fame—or lack of fame—of the individual contributor would carry no weight, and that the abiding purpose of the exhibition would be to show the universality of Hopkins's appeal.

With the cooperation of The International Hopkins Association—which is co-sponsoring this event—I sent out 400 form letters asking for assistance in assembling the exhibition. The response was overwhelming. In the past three-and-one-half years, I have written at least 1,000 personal letters and have received more than 700 responses. As a result, represented in the exhibition catalogue are more than 1,500 individual items (all of which cannot be shown in the exhibition because of space limitations). The items derive essentially from three sources: the HRHRC holdings, my wife's and my own private collection, and contributions and loans from more than 300 individuals from 6 different continents.

My personal hopes concerning the exhibition are 1) that it will interest the individual viewers, stimulating their desire to learn more about Hopkins, the man and his work; 2) that it will encourage scholarly investigation into the degree of influence the poet has had and is having on the arts and communications media; 3) that it will elicit responses from readers of the catalogue to suggest items that should have been included but were not; and 4) that it prove, indeed, that HOPKINS LIVES.

<div style="text-align: right">

Carl Sutton, Curator
1 February 1989

</div>

In the Valley of the Elwy
(Spring and counterpointed)

I remember a house where all were good
To me, God knows, deserving no such thing.
Comforting smell breathed at very entering,
Fetched fresh off, I suppose, from such sweet wood.

That cordial air made those kind people a hood
All round, as a bevy of eggs the mothering wing
Will or mild nights the new morsels of spring:
Why, it seemed of course; : seemed of right it should.

Lovely the woods, waters, meadows, combes, vales,
All the air things wear that make this house, this
Wales;
: only, the inmate does not correspond.

God, lover of souls, swaying considerate scales,
Complete thy creature dear, Oh, where it fails,
Being mighty a master, being a father and fond.

May 23 1877

Item 2: "In the Valley of the Elwy," holograph poem by Gerard Manley Hopkins, dated "May 23 1877."

The Gerard Manley Hopkins Archive
of the Harry Ransom Humanities Research Center

BY JOSEPH J. FEENEY, S.J.

Oxford excepted, The University of Texas at Austin holds the world's finest collection of Hopkins material. As if from an academic toyshop, rare delights spill out: There are manuscripts and drawings and books, some by Hopkins himself, some by his mother and father, some by his talented family. There are poems and letters from family members in England and Wales and Ireland and China. There are pencil sketches that Hopkins drew when he was ten, and photographs of the poet and his family—some taken by his uncle George, a judge, who took up this hobby in 1849.[1] There is an eloquent 1885 letter to his brother Everard in which Hopkins calls poetry "the darling child of speech" and argues that poetry "must be spoken" for *"till it is spoken it is not performed."* And in Hopkins's own handwriting there are manuscripts of the poems "Spring" (1) and "In the Valley of the Elwy" (2) with careful musical notations for spoken performance.[2]

Yet other delights pour forth. From Hopkins himself come letters to his family (one warns his father about the discomfort of "argosy" suspenders), letters to an Irish poet, letters to a school friend about poetry and religion, and pencil sketches from Oxford and Kent and the Isle of Wight. From his parents' families—the Hopkinses and the Smiths—come family letters, pencil sketches (including one of Hopkins's mother), a birthday-poem, a jolly (and funny) letter from his brother Lionel in China, individual photographs of Hopkins and of ten relatives, fourteen of his father's bookplates, even the program of an amateur family entertainment in which Hopkins, at age nineteen, played the lead. A final delight: five copies of the rare first edition of *Poems* (1918).

Poems, sketches, letters, photographs, books: the Texas collection weaves together image with word, and presents Hopkins as artist—young artist—as well as poet. Years later these two talents came to fusion in the virtuoso

[1]For the date, see Lance Sieveking, *The Eye of the Beholder* (London: Hulton, 1957), p. 227.

[2]Numerals in parentheses refer to items listed by catalogue number at the end of this introduction.

performances of his great, tensile poems. Verbally sparkling and visually sharp and intense, these poems recreate with brilliance the early sketches' sense of shape and line and form. Thus image and word, sketch and poem, illuminate each other even as the poems express great elation or deep suffering. Also rich in word and image is the family material in the Texas collection that manifests a familial heritage and establishes a context for Hopkins's work as poet and artist.

HOPKINS, POET AND ARTIST

In his years at London's Highgate School and at Oxford University, the young Hopkins faced an important choice: whether to be poet or artist or perhaps both. In early September of 1862, entering his last months at the Highgate School, he was "writing a good many poetical snatches lately" as well as "numbers of descriptions of sunrises, sunsets, sunlight in the trees, flowers, windy skies etc. etc."[3] Six months later he was still at it: "I have been writing a good deal, in poetry I mean, lately." He had even published a poem in the magazine *Once a Week*.[4] But the following summer, on a holiday trip to the Isle of Wight, he devoted himself to "sketching (in pencil chiefly) a good deal" from "a Ruskinese point of view."[5] Hopkins's dual talent, however, becomes even clearer in a long letter from the summer of 1864. Soaring with the brash confidence of the young, he describes some new poems, notes a friend's praise, and concludes,

> I hope . . . you will not think me too egotistical in speaking thus at length and thus freely about myself and my hopes. I now have a more rational hope than before of doing something—in poetry and painting. About the first I have said all there is to say in a letter; about the latter I have no more room to speak, but when I next see you I have great things to tell.[6]

"Doing something—in poetry and painting": Hopkins at twenty knew his talents, his interests, and his possibilities. He knew his unusual gifts as writer and artist, and the Center's collection emphasizes precisely those two talents.

Hopkins-the-poet shines in the sonnets "Spring" (1) and "In the Valley of the Elwy" (2), both of which date from 1877, that unusually happy and productive year of the Jesuit priest's ordination. "Spring," handwritten in Hopkins's clear, rounded script, is one of his famous celebrations of nature:

[3]Claude Colleer Abbott, ed., *Further Letters of Gerard Manley Hopkins: Including His Correspondence with Coventry Patmore* (London: Oxford University Press, 1956), pp. 8, 13.
[4]Ibid., p. 16.
[5]Ibid., p. 202.
[6]Ibid., p. 214.

Nothing is so beautiful as Spring;
When weeds, in wheels, shoot up long, lovely, and lush;
Thrush's eggs look little low heavens, and thrush
Through the echoing timber does so rinse and wring

The ear, it strikes like lightnings to hear him sing;
The glassy peartree leaves and blooms, they brush
The descending blue; that blue is all in a rush
Of richness; the racing lambs too have fair their fling.[7]

As a poem "Spring" is fresh and lively: fresh, because Hopkins discovers joy and beauty in something as unconventional and unromantic as weeds; lively, because the viewer's eye flashes from delight to delight—from weeds to thrush-eggs to thrush-song to peartree to sky to lambs—while the words and sounds rush out with near-breathless enthusiasm. The words show action and speed: "shoot up," "rinse," "wring," "strikes," "lightnings," "sing," "brush," "rush," "racing lambs," "fling." But the poem is also a sketch whose artist notices form ("weeds, in wheels," "long" stems, oval "eggs"), texture ("lush"), brightness and color ("lightnings," "glassy," "blue"), and motion ("racing lambs," "strikes like lightnings"). Another painterly touch is the word "brush": the peartree's leaves and blooms "brush" the sky's "descending blue." Hopkins-the-poet writes with the skills and the eye of Hopkins-the-artist.

Other manuscripts show Hopkins in the act of deciding on a poem's very words. A fragment from "The Loss of the Eurydice" (3) shows him working out rhythm and diction, as when "Fresh" replaces "And fresh," and "for souls sunk in seeming" replaces "lives ride yet sank in seeming." The title of "The Sacrifice" (4) is also an experiment, for the poem was later designated "Morning, Midday, and Evening Sacrifice."

Likewise the collection's letters illuminate Hopkins-the-poet. In 1862 the eighteen-year-old Hopkins, a bright, brash young man, addresses his friend E. H. Coleridge as "Dear Poet" (6), tells him what to read and why, sends his translation of a Greek soliloquy, comments on Tennyson, and includes a long Miltonic poem that he has recently written. Six months later (8) he casually urges Coleridge to read his poem "Winter with the Gulf Stream," recently published in *Once a Week*. In 1885 a wiser, more experienced man writes his brother Everard (17). Still retaining self-confidence, he comments on some books and says, "Let me recommend you a masterly one." But at forty-one he has grown able to admit mistakes (though reluctantly): "The run-over rhymes [in 'The Loss of the Eurydice'] were experimental, perhaps a mistake; I do not know that I shd. repeat them." This mature Hopkins can also be eloquent, impassioned, balanced, as he argues that poetry must be carefully studied and, above all, performed:

[7]HRHRC material by Hopkins is reproduced by permission of the Center and of the British Province of the Society of Jesus. I quote the Texas version of "Spring."

13

> Poetry was originally meant for either singing or reciting. . . .
> Sound-effects were intended, wonderful combinations even. . . .
> [Poetry] must be spoken; *till it is spoken it is not performed*, it does
> not perform, it is not itself. . . . As poetry is emphatically speech,
> speech purged of dross like gold in the furnace, so it must have
> emphatically the essential elements of speech. . . . I believe you now
> understand. Perform the *Eurydice*, then see.

His sincerity in this letter is disarming and touching: "I am sweetly soothed by
your saying that you cd. make anyone understand my poem by reciting it well.
That is what I always hoped, thought, and said; it is my precise aim."

As a middle-aged critic he has also developed forbearance. Writing an
overly persistent poet, Katharine Tynan, he comments on her work with more
kindness and care than her poems deserve:

> Thank you very much for yr. elegant new volume, which I hope more
> inwardly to value when I have read it all. The reading of the earlier
> pages gives me the impression of a freer and surer hand than before.
> You seem also to employ more sparingly the form characteristic of our
> time which consists in two short epithets like 'gold soft hair', 'warm
> wet cheek', and so on. . . . But when I meet you there is a metrical
> point I should like to remonstrate with you upon.(20)

Even as a critic, he was always a poet of technical integrity, with considered
care for sound, originality, diction, and rhythm.

Similarly, Hopkins shows himself the artist in both letter and sketch. In
1862, in his teens, he plans "to do the pictures in the Exhibition" (6). In 1871,
sending his father "a faithful picture of Stonyhurst," he remarks that "before it
was printed [it] seems to have been a pretty drawing," although "the hill above
is . . . not done justice to" (13). But Hopkins's art criticism best appears in two
letters to his brother Everard, a professional artist. Discussing in 1885 a
recent illustration of Everard's (17), Hopkins admits that, like the picture of
Stonyhurst, "the drawing, the draughtsmanship, has been injured in engrav-
ing." Yet, he continues to tell his brother the truth: "I am disappointed in it for
faults which are not the engraver's"—faults of perspective, unity, coherence,
treatment of crowds, and "want of liveliness." That list is embarrassingly full,
and in his next letter (18) Hopkins's conscience catches him. He regrets "the
faults I found with your picture" for "I did not want to discourage." And he also
encloses, with comment, some "Irish drawings (old ones)" he had clipped from
the newspapers.

In his original drawings (23-40) Hopkins favored pencil. Four early sketches
(23-26) show a lively rabbit, a mouse, a parrot, and a butterfly, all done when
he was ten. A mature drawing, "At the Baths of Rosenlaui–July 18" (31), nicely
catches the water's motion. Other sketches stress shape and form, as in the
monogram of his initials (32, 40) and the sweeping beech tree (34) which

14

Item 31: "At the Baths of Rosenlaui—July 18," pencil drawing by Gerard Manley Hopkins. 140 x 113 mm.

Item 44: Portrait, bust of Gerard Manley Hopkins, aged about 18. 154 x 114 mm. HRHRC Photography Collection, file P-4B.

serves as this exhibition's logo. All the drawings express his love of nature—of trees and water, of leaves and bushes, of animals and vines and clouds.

These poems and sketches exemplify Hopkins's basic desire as creator: to catch and express an object's uniqueness through "inscape" and "instress." For him, an object's "inscape" is its unique shape, form, essence, individuality, "design," "pattern."[8] Its "instress" is the object's unique inner energy which, when well expressed or communicated by the object, sets up a responsive energy in the beholder.[9] For Hopkins—poet, artist, lover of individuality—this creation of inscape and instress was the supreme goal.

HOPKINS: THE TEXAS PORTRAIT

The holdings of the Harry Ransom Humanities Research Center, in many ways randomly collected, provide a surprisingly full picture of Hopkins as a person. The portrait, of course, is inevitably incomplete: there is no mention of his great poems "The Wreck of the Deutschland" or "The Windhover," and mere hints of his 1866 conversion, his friendship with Robert Bridges, and his ability to discover God in creation. But if not a full-length view, the Texas material offers an accurate, nuanced, richly colored profile of the poet.

As visual biography, the photographs (41-46) situate the young Hopkins within an affectionate Victorian family. An 1856 portrait (41) shows him in profile at the age of 12;[10] a note on the back adds, "Gerard Manley Hopkins photographed by his Uncle George de Giberne (Judge) 1856 at Epsom Surrey. It was at Epsom that his Aunt Maria gave Gerard drawing lessons at this time. He did some charming sketches of trees." (This "Aunt Maria" Giberne, née Smith, was Hopkins's mother's sister, and wife to the Judge.) In another photograph (42), the young Hopkins stands arrayed in costume— plumed hat, lace collar, cloak, sash, ring on finger—perhaps for a family entertainment (as in 108). One photograph (43), also by his uncle, shows Hopkins, at age fourteen, leaning on a chair; on the back is a relative's comment, "I still have the chair!" His uncle photographed him again at about the age of eighteen (44), and a carte-de-visite (45), dated February 1863 and taken by a photographer of Oxford and Eton, may come from a preliminary visit to Oxford before he went up to Balliol College in April. The final photograph (46) shows him with mustache, beard, white bow tie, and hair

[8]Claude Colleer Abbott, ed., *The Letters of Gerard Manley Hopkins to Robert Bridges*, second edition (London: Oxford University Press, 1955), p. 66.

[9]For a fuller treatment, see Norman H. MacKenzie, *A Reader's Guide to Gerard Manley Hopkins* (Ithaca: Cornell University Press, 1981), pp. 232-35.

[10]In *All My Eyes See: The Visual World of Gerard Manley Hopkins* (Sunderland: Ceolfrith, 1975), the editor, R.K.R. Thornton, assigns this portrait to 1858 (p. 9). Henceforth *AMES*.

parted in the center.[11] These photographs, passed down through his family, indicate both their affection for Hopkins and (in later years) their pride in his reputation.

The inner Hopkins appears in the collection's poems, letters, and drawings, for besides his love of poetry and art, they also show his major interests—religion, family, friends, music—and his broad curiosity. His celebration of God and God's world appears at the exhibition's beginning in the poem "Spring" (1). The dedicatory cross atop the page makes the poem an offering to God, and the text itself proclaims that spring's beauty is a gift from God. The poem also shows how, as a theological student in Wales (1874-1877), Hopkins had integrated his life as poet, Jesuit, and priest-to-be. And a moral concern, indeed even a direct prayer, suffuses the sestets of both "Spring" and "In the Valley of the Elwy" (2). The latter (in the Texas version) reads,

> God, lover of souls, swaying considerate scales,
> Complete thy creature dear, Oh, where it fails,
> Being mighty a master, being a father and fond.

Two letters to Coleridge (9, 10), written earlier while Hopkins was still an Anglican, combine thought and emotion as he discusses religion, warns against an Enlightenment-Christianity, and praises Christ's Incarnation and his *"loveable"* Real Presence in the Eucharist. Seventeen years later, in a moving letter to his sister Grace (15), he offers religious consolation at the time of her fiancé's death. Oscillating between an academic discussion of Providence and such personal grief as "I have not written this without tears," Hopkins finally arrives at a firm, peaceful conviction: "I said mass for Henry Weber this morning and during the mass I felt strongly those motions from God (as I believe them to be) which I have often before now received touching the condition of the departed, by which was signified that it was well with him."

In various ways, Hopkins commonly expressed love and affection for his family. In one letter (6) he shares family news with a friend and in two others (13, 18) he sends Christmas greetings to his father and his brother. When visiting his mother's family, the Smiths, in then-rural Croydon, he would sketch the countryside around their house (29, 30, 35). In 1884 he greets his father on his birthday (14), and then rambles on familiarly about statistics, a vacation in Western Ireland, the Jesuits he will meet, his bad pen, the weather, his uncomfortable shoes, Irish phrases, a funny Irishman, and a warning against those "argosy braces" ("you will never draw an easy breath

[11]This photograph's date, "Hopkins aged 30," is questioned by Bevis Hillier in "Portraits of Hopkins," *AMES*, p. 6. An 1866 photograph with two Oxford friends (*AMES*, p. 6) shows him with mustache, and his experiment with a beard may similarly date from his Oxford days rather than from 1874 when, already six years a Jesuit, he was about to begin his theological studies for the priesthood.

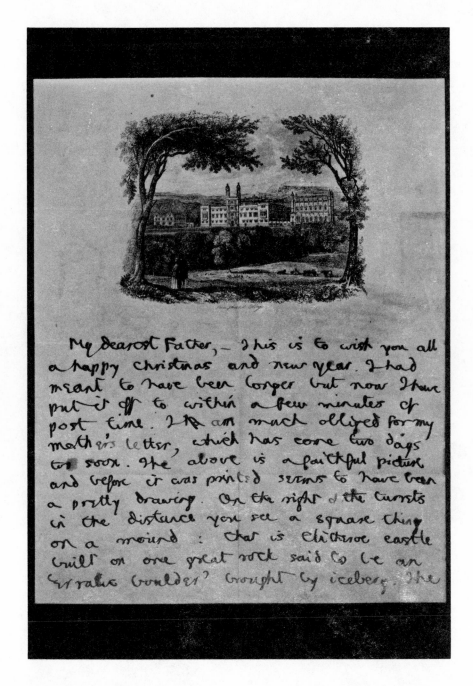

My dearest Father, — This is to wish you all a happy Christmas and new year. I had meant to have been longer but now I have put it off to within a few minutes of post time. I am much obliged for my mother's letter, which has come two days too soon. The above is a faithful picture and before it was printed seems to have been a pretty drawing. On the right of the turrets in the distance you see a square thing on a mound: that is Clitheroe castle built on one great rock said to be an 'erratic boulder' brought by iceberg. The

Item 13: Autograph letter from Gerard Manley Hopkins to Manley Hopkins (GMH's father), dated "Stonyhurst . . . Whalley.—Dec. 23, 1871."

from the day you put them on"). He gently consoles his sister in her bereavement (15), yet five months later quibbles with her about who owes whom a letter (16). He criticizes his brother Everard's sketch (17) and apologizes seven weeks later (18). And he writes touchingly about his family's move from his boyhood home: "It seemed like death almost at first for us to leave Hampstead, but on the other hand Haslemere is a delightful thought" (17). He is clearly at ease with his family and shows himself a devoted son and brother.

Hopkins was also a faithful friend, often sending and asking news of mutual friends (8, 10, 12). He writes greetings to individuals "and to everybody" (11), offers generous congratulations (6, 10), and frequently signs himself "your affectionate friend" (7, 8, 10, 11, 12). His gratitude is strong and warm; as a Jesuit he praises Welsh hospitality—"I remember a house where all were good / To me" (2)—and has Irish "friends at Donnybrook, so hearty and so kind that nothing can be more so" (18). He recommends the poems of his friend Robert Bridges while keeping a pushy poet at bay (19-22), and invites his old friend E.H. Coleridge to visit him at Oxford (8) and Edgbaston (11, 12). The Edgbaston visit even brings out Hopkins's humor. Coleridge had wanted to hear Newman preach, but Hopkins replies that "It is no good: I cannot find when Dr. Newman will preach, for the reason that he does not know himself." But, he adds, "If you like to come some Sunday and agree to let me convince you that F. Ambrose St. John is Dr. Newman and overlook the fact that he is fat, rosy, short, and very audible instead of all the opposite it will be very jolly" (12).

The young Hopkins early recognizes music's "pleasures" and "subtle charms" (5), and decades later he writes his sister about concerts in Dublin (16). In the same letter he comments on Dublin musicians, Greek music, English composers, and the graduation-piece written by a Miss Taylor, one of University College's nine "lady bachelors." A year later, amid comments on the symphony and on Gregorian chant, he writes his brother Everard that poetry "was originally meant for either singing or reciting," and requires a lively, musical performance (17). In the manuscripts of "Spring" (1) and "In the Valley of the Elwy" (2) he spells out the rhythm, stress, and tempo for such a performance. Prepared for his sister Grace, a musician,[12] the text of "Spring" (1) has eighteen musical symbols: nine slurs (⌒), four "turns" (∿), and five stress-marks (⦂). (He uses musical symbols analogously.) The cancellation of a slur in line 13 underscores Hopkins's care for rhythmic precision. Other notations indicate that lines 1-9 are to be performed "*staccato*," and that there should be a "*rall.*"—a *rallentando* or slowing—in lines 10 and 14. At the top of the manuscript Hopkins prescribes an "unfolding rhythm, with sprung

<hr>

[12]W.H. Gardner and N.H. MacKenzie, eds., *The Poems of Gerard Manley Hopkins*, fourth edition (London: Oxford University Press, 1967), p. xliv.

leadings: no counterpoint."[13] The exhibition's other holograph poem, "In the Valley of the Elwy" (2), has twenty-one musical symbols, in addition to indications of tempo ("*rall.*" twice), stress ("*sf.*"—*sforzando* or with emphasis), and rhythm—"Sprung and counterpointed." Just as Hopkins was devoted to music, he was musically punctilious in his poems.

In these poems and in his letters and sketches Hopkins also shows his diverse enthusiasms and interests. He loves nature's beauty—"Lovely the woods, waters, meadows, combes, vales" (2)—and as a late-Romantic he sketches a ruined castle (33), churches (34, 39), and farm buildings (35). As for beauty in human form, he praises the "innocent-minded Mayday in girl and boy" (1), certain Irish expressions ("The effect is very pretty and pointed") (14), even the human voice on a phonograph record:

> Perhaps the inflections and intonations of the speaking voice may give effects more beautiful than any attainable by the fixed pitches of music. I look on this as an infinite field and very little worked. It has this great difficulty, that the art depends entirely on living tradition. The phonograph may give us one, but hitherto there could be no record of fine spoken utterance.
>
> Incalculable effect could be produced by the delivery of Wordsworth's *Margaret*. . . . With the aid of a phonograph each phrase could be fixed and learnt by heart like a song. (17)

Hopkins's curiosity is encompassing: Goethe's *Faust* (5), the triviality of life (10), statistics (14), public speaking and health (16), the effect of volcanic dust on weather (16), Greek music (16), natural religion (17), language ("give o'ër, as they say in Lancashire") (17), plainchant (17), and Elizabethan poets (17). Culture and politics engage him, as he worries about England's growing atheism, declining public morality, foreign policy under Gladstone, and relations with Ireland (18). And he is passionately patriotic; while teaching in Ireland he reads the Pope's letter to the English bishops and finds "such heartfelt affection for England that I kiss the words when I read them" (18).

During these years of teaching in Dublin—1884 to 1889—Hopkins often suffered from a deep depression and, though the Texas holdings do not stress this depression, they imply his dejection there. As early as June 1883, while still at England's Stonyhurst College, he wrote his sister Grace that "I have . . . warnings sometimes of an approaching death: I had such a one lately, but it was slight and I paid little attention to it" (15). In November 1884, after nine months in Dublin, he was about to "begin lectures (no more than lessons)," and "was not sorry" to begin the lectures, since "they say (indeed

[13]In the enormously complicated matter of Hopkins's rhythms, see (for a beginning) MacKenzie, *Reader's Guide*, pp. 238-40, his comments in *Poems*, fourth edition (1967), pp. 264-65, and Catherine Phillips, *Gerard Manley Hopkins*, The Oxford Authors Series (Oxford: Oxford University Press, 1986), pp. xli and 307.

prove) that public speaking, acting, preaching, and so on prolongs [*sic*] life" (16). Death was on his mind.

The following years brought further anguish: eyestrain, headaches, depression, anxiety, loneliness, political irritation, uncompleted projects, the pressure of examinations, even a seeming desertion by God. His "Terrible Sonnets" or "Sonnets of Desolation" brilliantly express his pain, but the Texas collection offers few indications of this pain or of the subsequent hope and peace expressed in the poems "That Nature is a Heraclitean Fire and of the comfort of the Resurrection," "Thou art indeed just, Lord," or even "To R.B." Some few hints of his Dublin suffering, however, do appear in two letters to the Irish poet Katharine Tynan. In 1887 Hopkins called June "my busiest time of year or at least the most anxious, when I prepare my examination papers" (20), and on June 8, only six days later, he again groaned,

> In replying to your kind bidding I have to say what you must bear in mind about everything, that this is with me the busiest time of the year and that the work of examination leaves leisure and strength (of mind at all events) for no other thing. During it all is haste and pressure, before it all anxiety and worry. (21)

Two years later to the day—8 June 1889—he was dead, a victim of typhoid fever. He had passed through his great depression and in his last months had found peace—a Godly peace—even when his inspiration was dry. But at his death Hopkins was not yet forty-five, and few of his poems were known.

Shortly after Hopkins's death, an Irish Jesuit expressed his sense of loss and incompleteness in a letter to Robert Bridges. "From the bent of [Fr Hopkins's] mind and work," he wrote, "I should think he would have been glad to leave something permanent in literature or art."[14] Three of these words—"literature or art"—should strike the visitor to this exhibition, for Hopkins's dual talent was remembered in precisely that pairing which intrigued him as a youth and which epitomizes the Hopkins collection at the HRHRC.

THE POET'S FAMILY: THE HOPKINSES AND THE SMITHS

The family items in the Texas collection, though not literary documents, are biographically valuable since they reflect the milieu of Hopkins's growth, offer insight into his family, and indicate early influences on his literature and art.

The poet's father, Manley Hopkins (95), was by occupation a marine-insurance adjuster and by avocation a writer of poetry and prose. His curiosity

[14]Humphry House, ed., *The Journals and Papers of Gerard Manley Hopkins* (London: Oxford University Press, 1959), xi.

spread as widely as his son's and, besides an unpublished novel, he published eight books (one coauthored with his brother) on such subjects as Hawaii, mathematics, marine insurance, and piety.[15] In 1862 came *Hawaii: The Past, Present, and Future of Its Island-Kingdom* (111) and in 1892 the undistinguished *Spicilegium Poeticum: A Gathering of Verses* (113). More original was *The Cardinal Numbers* (1887) (112), to which his son Gerard contributed passages on visualizing numbers and on how Welsh people count. With surprising freshness this study of the words "one" to "ten" wanders through mathematics, architecture, the Hebrew alphabet, milk deliveries, an alehouse, metaphysics, Aboriginal customs, cricket, dancing, the Hebrew psalms, St. Paul, Spanish literature, and Greek words—all these in the first fifteen pages.

Like his son, Manley Hopkins enjoys puns, and in *The Cardinal Numbers* he also demonstrates an endearing whimsy:

> It would seem as if some animals had a certain appreciation of numbers. A pig used to be exhibited which picked out numbers on playing-cards. He was hence named "the learned pig." A dog of the writer's springs on his legs as the clock strikes *ten* at night. The well-known pigeons of the Piazza at Venice do, or did, assemble themselves by their hundreds for their food, at the stroke of *one*.[16]

In the next sentence he shrugs, "None of these creatures, probably, count, or can account for, the strokes of the clock, which, nevertheless, act on their nervous constitution in some obscure manner." Then recalling the Venetian pigeons who once assembled at the stroke of one, he adds in a footnote, "This remarkable instinct is interfered with, now, by visitors giving the birds food at all hours."

Manley Hopkins's humor, both puns and whimsy, reappears in his son's writings, but more interesting, perhaps, is a similarity in their thought-processes. Both father and son commonly gather countless details—details often recondite, bizarre, and seemingly unrelated—and then coherently link them together in some new and original way. The thought-patterns of *The Cardinal Numbers*—milk deliveries, alehouse, metaphysics, Aboriginal customs, cricket—reappear, for example, in the catalogues of "Spring" or "The Starlight Night" or "Pied Beauty."

Other relatives enjoy their own literary skills. In 1854, when Hopkins was ten, someone wrote two moralistic children's stories, "A Story of a Doll" and "The Dove" (106, 107), in a small green-leather notebook. The handwriting seems that of Kate Smith Hopkins, the poet's mother (96), and she may well have composed them and read them to her children. The family may also have

[15]Ibid., p. 331.

[16]Manley Hopkins, *The Cardinal Numbers* (London: Sampson Low, Marston, Searle, and Rivington, 1887), p. 12.

written (or adapted) their amateur theatrical entertainments—"YE MIS-
TLETOE BOUGHE!" (108), for example, or the play which featured the
young Gerard Hopkins in plumed hat (42).

Everard Hopkins (97) shows conventional skills in his patriotic poem
"Mafeking 1900" (56), as does his sister Kate in rhymed birthday-verses for a
cousin (70). In an 1875 letter from China (68), their brother Lionel shows
himself a lively storyteller as, after typical family puns, he tells about "a new
young clergyman" recently come out to China and temporarily staying with a
friend:

> This young prelate is exceedingly short sighted. . . . When
> someone went to return his call there the other day, he came hastily
> into the room, tried to walk through a sofa, bowed ceremoniously to
> an umbrella which he took for his visitor, turned with a winning smile
> to a silver candlestick and asked it to introduce him; then, discovering
> his mistake, he backed hastily into a chair and seated himself heavily
> on the lap of a lady who was already there: rising as suddenly with a
> burst of blushes and apologies, he retired in confusion through what
> he intended to be a room door, but in fact only passed into a store-
> cupboard and hastily shut the door behind him. This cupboard being
> very small, in his anxiety to find where he had landed himself, he
> upset a large jar of honey on the shelf, which, as a crowning misery,
> dripped for 2 hours and 23 minutes down the back of his neck, at
> which time he was much too ashamed to come out into the room. At
> the end of it, he was rescued—a sticky, cold, and nearly broken
> hearted creature.[17]

Both families had heritages in art. The Smiths, Hopkins's mother's family,
were related to the painter Thomas Gainsborough, and did engraving,
lithography, painting, and sketching; three of them exhibited at the Royal
Academy and two at the Society of Female Artists.[18] An uncle, Edward Smith,
was a professional artist.[19] His sister, Maria Smith Giberne (102, 103), was the
aunt who in the 1850s taught Hopkins to draw during his visits to her house at
Epsom. According to family memory, "she and her nephew often sat side by
side sketching in the woods and lanes round Epsom and Croydon, both of
which in those days were small country towns."[20] In the Texas collection she
certainly did the 1838 sketch of Hopkins's mother (72), probably drew the
1863 views of Hampstead (73-76), and possibly also sketched the Epsom

[17]Quoted by permission of Mr. Leo Handley.
[18]R. K. R. Thornton, "The People Hopkins Knew," in *AMES*, pp. 33, 35-36.
[18]*Journals*, p. 380.
[20]Sieveking, p. 276.

24

landscapes (86-91).[21] Her husband, Judge George Giberne (or de Giberne)[22] (104), also "drew beautifully"[23] and as a pioneering photographer developed and refined his visual sense (41, 42, 43, 44). Another aunt, Matilda Smith Birkett, did pencil sketches (77) and her sister, Laura Smith Hodges, decorated her letters with drawings of leaves and flowers (78-85).

On the paternal side, Ann Eleanor Hopkins, the poet's "Aunt Annie," "had some talent for drawing and painting" and "fostered" his early drawing.[24] In 1859 she did two watercolors of Hopkins—one now in Oxford's Bodleian Library and the more famous one in London's National Portrait Gallery.[25] Frances Anne Hopkins, an aunt by marriage, "had little formal training but became a good draughtsman and painter in watercolour and oils"; she exhibited at the Royal Academy, and North Americans valued her paintings of Canadian river scenes and canoe men—the "voyageurs."[26]

In Hopkins's own generation two brothers, Arthur and Everard, became professional illustrators and painters. Arthur, three years younger than Gerard, may have been his sketching companion on the Isle of Wight, and drew black-and-white illustrations for *Punch*, the *Illustrated London News*, and the *Graphic*. He later worked in oils and watercolors and exhibited at the Royal Academy.[27] According to a letter of Gerard's, Arthur "takes criticism very peaceably always" (18). Arthur himself, with an artist's eye, uses a thank-you note (71) to comment on an illustrator's "appreciation and rendering of very gentle bits of sky and cloud, and his way of treating trees."

Everard Hopkins, sixteen years younger than Gerard and the youngest in the family, enjoyed an easy and familiar relationship with his oldest brother. An artist and illustrator, Everard published in the *Illustrated London News* and the *Graphic*, and in tribute to his brother named his only child Gerard. It was Everard's *Graphic* drawing which in 1885 stimulated the poet's long critique (17), in which he told Everard his subject—an angry crowd—was "uncongenial" since "naturally you would like repose and long flowing lines, low colours, and the conditions of grace and ease."

[21]Jerome Bump tentatively attributed the Epsom landscapes to Maria Smith Giberne ("Catalogue of the Hopkins Collection in the Humanities Research Centre [*sic*] of the University of Texas," *The Hopkins Quarterly* 5 [1979]: 147); an art student at The University of Texas attributes them to Everard Hopkins (interview with Kathleen Gee [HRHRC Iconography Department], Austin, 7 June 1988).

[22]For the versions of his name, see *Journals*, pp. 298-99; *Further Letters*, p. 102; and Sieveking, p. 275.

[23]*Journals*, p. 298.

[24]Ibid., p. 332.

[25]Hillier, in *AMES*, p. 3. See also cover and p.v.

[26]Thornton, in *AMES*, pp. 33, 35-36; see also *Journals*, pp. 336-37.

[27]Thornton, in *AMES*, p. 36; for a discussion and examples of his work, see pp. 36-43, and *Journals*, pp. 302-03. *AMES* has an example of Everard's work on p. 44.

An epistolary family, the Hopkinses are often lively in their correspondence. Some letters are serious—assuring care for bereaved relatives (62)—but many are light, ranging through Easter greetings (67), quirks of language (69), and minor family news (57, 58) to pure wordplay (68). Beginning to write in childhood (even the poet's mother has a letter addressed to "dear Mamma" [63]), as adults the Hopkins family writes diversely of a loud organist at church (59), a trip to Worcester (64), the weather, a grandson, a foreign-office appointment (66), Chopin, and dressmaking (67). Though Manley Hopkins admits that "I am not given to much letter writing" (61), he and his wife still send notes even in an "abundant dearth of events" (57) when "there is absolutely nothing to say" (65). Parents write children, children write each other and their cousins, and some family traits grow clear: warmth and affection, verbal ease, interest in literature and art, lightness of touch, broad curiosity, and such a firm familial confidence that they keep letters and photographs for future generations.

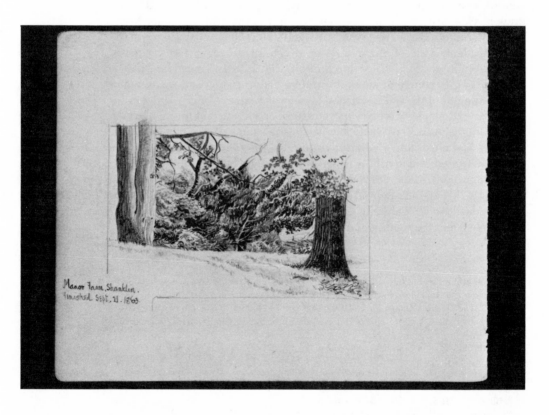

Item 38: "Manor Farm, Shanklin. Finished Sept. 21. 1863," pencil drawing by Gerard Manley Hopkins. 145 x 113 mm.

Skill in wordcraft, skill in drawing: an emphasis on this dual talent of Hopkins and of his family characterizes the rich collection of the Humanities Research Center. But why and how were these holdings, so diverse in source and content, ever brought together in Austin?

Early in this century, The University of Texas began to develop a research strength in English and American literature when, in 1918 and 1925, it acquired the Wrenn and Stark collections with manuscripts by Byron and the Brontës as well as by other figures from the Romantic and Victorian periods. By the middle of this century The University of Texas, deciding to expand its research collection significantly, chose to build on its strengths and to collect English, American, and French literature of the late nineteenth and twentieth centuries. Then in 1957, Dr. Harry Ransom began to develop the holdings into a major research collection of twentieth-century and contemporary writers.[28] The Hopkins material thus constitutes a part—a very significant part—of a larger institutional plan and, though most Hopkins manuscripts were already in Oxford at the University's Bodleian Library and the Jesuits' Campion Hall, The University of Texas gradually gathered together the world's third most important Hopkins archive.

The Hopkins material came together in various ways. The poet's letters to E.H. Coleridge arrived in the E.H. Coleridge collection; other items— Hopkins's letters to his brother Everard and some first editions of *Poems*, for example—were separate purchases or parts of larger acquisitions. But the major part of the Hopkins collection was purchased on 13 July 1966 when Sotheby and Co., of London, auctioned, as their Catalogue put it, "The Property of Lady Pooley (Niece of Gerard Manley Hopkins)."[29] This material, discovered by Lady Pooley in 1964 in a table-desk that had belonged to Hopkins's sister Grace, included such important items as the holographs of "Spring" and "In the Valley of the Elwy," the early version of "The Sacrifice," Hopkins's two letters to his sister Grace, all the Hopkins sketches, the first edition of *Poems* inscribed by Hopkins's mother, most of the family letters, and most of the family drawings.

Many of the photographs, according to notes on their backs, came from Hopkins's cousin, Lancelot de Giberne Sieveking (who also used the name Lance Sieveking). These photographs, together with Hopkins's two letters to his father, some family drawings, and various other items, were offered for

[28]Interview with John Kirkpatrick, Austin, 9 June 1988;"The Harry Ransom Humanities Research Center, The University of Texas at Austin," Brochure, n.d., pp. 3 and 4.

[29]Catalogue for the sale of 12-13 July 1966, p. 122. On Lady Cristabel Pooley and the source of the material, see Norman H. MacKenzie, "Foreword . . . ," in *The Poems of Gerard Manley Hopkins*, fourth edition (1967), p. xliv.

sale by the antiquarian bookseller J. Stevens Cox, on the isle of Guernsey. Acquired through the House of El Dieff in New York, they arrived in Austin in 1967.[30] These two purchases of 1966-67 brought the Hopkins collection at Texas to international significance.

Other items in the Texas collection, variously gathered together, demonstrate the regard of fellow writers. Edith Sitwell's Hopkins collection at the HRHRC, with underlinings and marginal marks in ink, shows her interest in his poems, journals, letters, and criticism (115-22). Also in the HRHRC's collection, the American poet Anne Sexton's library contains marginal inkmarks, calling attention to such Hopkins poems as "Spring and Fall," "(Carrion Comfort)," "No worst," and "I wake and feel the fell of dark." The poem "My own heart let me more have pity on" seems her favorite, for it has not only her normal marks of esteem but also triple exclamation points— "!!!"—at its top (114).

Evelyn Waugh, finally, expressed his regard for Hopkins in typical fashion. In his library at the HRHRC there are at least three books about Hopkins, each with Waugh's autograph and bookplate. One book, *Immortal Diamond*, had come as a gift from its editor, Norman Weyand, S.J., and after reading it Waugh sent it to a friend, enclosing a note now pasted inside the cover. In his characteristic way Waugh used this note to tweak or insult everyone in sight— the book's editor, the editor's countrymen, even Waugh's own friend. Yet in the act of slashing his victims, Waugh offered enthusiastic, though offhanded, praise to Hopkins. The handwritten note (125) reads,

> Delighted to hear you are interested in Hopkins. You might be interested in parts of this book—by Americans. Americans, poor things, can never strike a mean between sensationalism and priggishness. Most of this book is too stiff for you. But you might find a few pages to interest you.[31]

Terse, jaundiced, acidly typical of its author, this note somehow provides a capstone, or perhaps better an extra grace note, to strengthen the exhibition's argument that Hopkins indeed lives. For Hopkins still lives and thrives among the gentle and the acrid, among unbelievers and believers, among English compatriots and worldwide admirers. He lives on and flourishes in word and image, in poem and drawing, in letter and photograph, and stands brilliant and foil-like even now in 1989, one hundred years after his death.

[30]J. Stevens Cox, *The Literary Repository*, No. 1/1966, on file in the HRHRC.
[31]Quoted by permission of the Waugh Estate.

This essay was aided by a Travel to Collections Grant from the National Endowment for the Humanities, for which I express gratitude.

1 "Spring." Holograph poem, dated "May 1877."

2 "In the Valley of the Elwy." Holograph poem, dated "May 23 1877." On verso of item no. 1.

3 ["The Loss of the Eurydice," stanzas 29 and 30]. Holograph fragment, initialed and dated "G.M.H. April 1878 Mount St. Mary's, Spink Hill, Derbyshire."

4 "The Sacrifice" (later, "Morning, Midday, and Evening Sacrifice"). Holograph poem, dated "Oxford, summer 1879."

5 Holograph letter signed to a Doctor Münke (correctly "Müncke," German master at the Highgate School), dated "Elgin House. May 8th."

6 Holograph letter signed to E.H. Coleridge (GMH's friend from the Highgate School and later at Oxford), dated "Sept. 3rd. 1862. Oak Hill, Hampstead."

7 Holograph letter signed to E.H. Coleridge, dated "Oak Hill. March 2nd."

8 Holograph letter signed to E.H. Coleridge, dated "March 22nd."

9 Autograph letter signed to E.H. Coleridge, dated "June 1, 1864." Letterhead embossed; opening page[s] missing.

10 Holograph letter signed to E.H. Coleridge, dated "Jan. 22, 1866."

11 Holograph letter signed to E.H. Coleridge, dated "The Oratory, Edgbaston, Birmingham. Oct. 26, 1867."

12 Holograph letter signed to E.H. Coleridge, dated "Nov. 14." (Item nos. 6-12 are in the E.H. Coleridge Collection of the HRHRC.)

13 Autograph letter signed to Manley Hopkins (GMH's father), dated "Stonyhurst . . . Whalley.—Dec. 23, 1871."

14 Holograph letter signed to Manley Hopkins, dated "July 5 1844 Castlebar, County Mayo." ("1844" is a mistake for "1884.")

15 Holograph letter signed to Grace Hopkins (GMH's sister), dated "Stonyhurst. June 9 1883." A later page is dated June 10.

16 Holograph letter unsigned to Grace Hopkins, dated "University College, Stephen's Green, Dublin. Nov. 2 1884." Closing page[s] missing.

17 Autograph letter signed to Everard Hopkins (GMH's brother), dated "Clongowes Wood College, Naas. Nov. 5 1885."

18 Autograph letter signed to Everard Hopkins, dated "University College, St Stephen's Green, Dublin. Dec. 23 '85."

19 Autograph letter signed to Katharine Tynan (Irish poet), dated "University College, St Stephen's Green, Dublin. Nov. 14 1886."

20 Autograph letter signed to Katharine Tynan, dated "University College, St Stephen's Green, Dublin. June 2 1887."

21 Autograph letter signed to Katharine Tynan, dated "University College, St Stephen's Green, Dublin. July 8 1887."

22 Autograph letter signed to Katharine Tynan, dated "University College, St Stephen's Green, Dublin. Sept. 15 1888."

DRAWINGS BY HOPKINS

23-26 Four sketches of a rabbit, mouse, parrot, and butterfly. Pencil. Irregularly shaped, on verso of envelope, 202 x 176 mm. overall. At top, apparently in the writing of Hopkins's mother: "G M.H impromptus 25th Nov. 1854 ['i.e. about 10 years old' added in blue pencil]."

27 "April 8. Day of the Boat race. On the Cherwell." Pencil. 145 x 113 mm. Riverscape, with sculls in distance.

28 "May 12. Nr. Oxford." Pencil. 145 x 113 mm. Leaves.

29 "Plane. Blunt House, Croydon. July 3." Pencil. 145 x 113 mm. Tree.

30 "July 5. Purley." Pencil. On same sheet (recto) as item no. 29. Shapes (bushes?).

31 "At the Baths of Rosenlaui—July 18." Pencil. 140 x 113 mm. Water flowing over and among boulders.

32 "In Lord Yarborough's Place, S. Lawrence, Undercliff. July 22." Pencil. 135 x 113 m. Trees, with GMH monogram at bottom.

30

33 "From the Keep, Carisbrooke Castle. July 25." Pencil. 136 x 113 mm. Ruined castle walls, with vines.

34 "Beech, Godshill Church behind. Fr. Appledurcombe. July 25." Pencil. 145 x 113 mm. Tree, with church and other trees.

35 "Aug. 27. Croydon." Pencil. On verso of items 29 and 30. Farm buildings and landscape.

36 "Shanklin. Sept. 10." Pencil. 130 x 113 mm. Landscape, clouds.

37 "Shanklin. Sept. 12." Pencil. 125 x 113 mm. Trees.

38 "Manor Farm, Shanklin. Finished Sept. 21. 1863." Pencil. 145 x 113 mm. Trees and bushes between tree trunks.

39 "Benenden, Kent, fr. Hemsted Park. Oct. 11. 1863." Pencil. 145 x 113 mm. Church amid trees, hill behind.

40 Trees and branches. Pencil. 140 x 113 mm. GMH monogram at bottom. (Items 27-40 seem cut out of the same sketchbook. For information on Hopkins's sketchbooks, see Norman White, "The Context of Hopkins' Drawings," in *AMES*, pp. 53, 55-57.)

PHOTOGRAPHS OF HOPKINS

41 Portrait, ¾ left profile. 142 x 121 mm. On back: "Gerard Manley Hopkins photographed by his Uncle George de Giberne (Judge) 1856 at Epsom Surrey. It was at Epsom that his Aunt Maria [Giberne] gave Gerard drawing lessons at this time. He did some charming sketches of trees." HRHRC Photography Collection, file P-1.

42 Three-quarter length, in costume (with plumed hat, ring on finger, flowers in hand). 150 x 124 mm. On back: "Gerard Manley Hopkins in fancy dress 1856 taken by his uncle Judge George de Giberne at Epsom, Surrey." HRHRC Photography Collection, file P-2.

43 Carte-de-visite, full length. 85 x 55 mm. On back: "Gerard Manley Hopkins at the age of fourteen taken at Epsom by his Uncle Judge George de Giberne." Hopkins is leaning on a chair. HRHRC Photography Collection, file P-3.

44 Portrait, bust. 154 x 114 mm. On back: "Taken by his uncle George

Giberne Gerard Manley Hopkins aged about 18." HRHRC Photography Collection, file P-4B.

45 Carte-de-visite, portrait, ½ left profile. 92 x 56 mm. On back: "Febry 1863. Gerard Manley Hopkins." Taken by Hills and Saunders, photographers, Oxford and Eton. Same clothing as in item 44. HRHRC Photography Collection, file P-4A.

46 Portrait, ¾ right profile. 88 x 58 mm. On back: "Gerard Manley Hopkins aged 30." His hair is parted in the center, and he wears mustache, beard, and white bow tie. HRHRC Photography Collection, file P-4C.

BOOKS BY HOPKINS

47 Page proofs for first edition of the *Poems of Gerard Manley Hopkins*, ed. Robert Bridges (London: Humphrey Milford, 1918). Prelims and pages 1-92, omitting all the editorial material by Bridges. A few minor errors are corrected by an unidentified hand, e.g., the title "Spring and Fal" on p. 51.

48 First edition, *Poems of Gerard Manley Hopkins*, ed. Robert Bridges (London: Humphrey Milford, 1918). With "Manley Hopkins" bookplate (as in item 109) inside front cover. Inscribed: "Isabel Giberne Sieveking—from Aunt Kate—11 March 1919." (Isabel Giberne Sieveking was GMH's first cousin; the book was given to her by Hopkins's mother who, born on 3 March 1821, was then 98 years old.)

49 First edition, *Poems of Gerard Manley Hopkins*, ed. Robert Bridges (London: Humphrey Milford, 1918). Inscribed: "Alice Corbin Henderson" (Chicago poet, critic, and the first associate editor of *Poetry* magazine).

50 First edition, *Poems of Gerard Manley Hopkins*, ed. Robert Bridges (London: Humphrey Milford, 1918). Inscribed: "R.G. Howarth."

51 First edition, *Poems of Gerard Manley Hopkins*, ed. Robert Bridges (London: Humphrey Milford, 1918). Inscribed: "J.B.W. from R.R.W."

52 First edition, *Poems of Gerard Manley Hopkins*, ed. Robert Bridges (London: Humphrey Milford, 1918). In mint condition, with dust jacket.

53 First edition, *A Vision of the Mermaids* (London: Humphrey Milford at the Oxford University Press, 1929). Facsimile of holograph text, illustrated by GMH. Inscribed: "Lancelot de Giberne Sieveking / 15 Tite Street. / Chelsea. /

With love from Cousins / Grace and Lionel / The Garth / Haslemere." Limited edition, no. 5 of 250. (Lancelot de Giberne Sieveking—elsewhere Lance Sieveking—was GMH's cousin, son of Isabel Giberne Sieveking and grandson of [Judge] George and Maria Smith Giberne.)

54 First edition, *A Vision of the Mermaids* (London: Humphrey Milford at the Oxford University Press, 1929). No. 142 of 250.

55 First edition, *A Vision of the Mermaids* (London: Humphrey Milford at the Oxford University Press, 1929). No. 153 of 250.

MANUSCRIPTS BY THE HOPKINS FAMILY

56 Everard Hopkins, "Mafeking 1900." Poem, in hand of Kate Smith Hopkins (GMH's mother).

57 Autograph letter initialed, Manley Hopkins to Grace Hopkins, dated "The Garth, Haslemere. Sunday 28th May 1893."

58 Autograph letter initialed, Manley Hopkins to Grace Hopkins, dated "The Garth, Haslemere. Saturday 10th June 1893."

59 Autograph letter initialed, Manley Hopkins to Grace Hopkins, dated "The Garth, Haslemere. Sunday evening 18th Aug. 1895." With envelope postmarked "10 AM Au 19 95," addressed to "Miss Grace Hopkins, c/o Mrs. Lewis, Westgate, Winchester."

60 Autograph letter initialed, Manley Hopkins to Grace Hopkins, dated "The Garth, Haslemere. 20th April 1896." With envelope postmarked "8.15 PM Ap 20 96," addressed to "Miss Grace Hopkins, Sea view House, Bath road, Bournemouth."

61 Autograph letter initialed, Manley Hopkins to Grace Hopkins, dated "The Garth, Haslemere. 5th August 1896." With envelope postmarked "8.15 PM Au 6 96," addressed to "Miss Grace Hopkins, E. Sieveking Esq, 4 Lyon Road, Harrow."

62 Holograph letter initialed, Manley Hopkins to Maria [Smith] Giberne (GMH's aunt), dated "Oak Hill. Friday night. 15th July 1881."

63 Holograph letter signed, Kate Smith [Hopkins] to "Mamma" [Maria Hodges Smith], n.d., but from childhood.

64 Holograph letter signed, Kate Smith Hopkins to Grace Hopkins, dated "The Star. Worcester Oct 14th."

65 Autograph letter signed, Kate Smith Hopkins to Grace Hopkins, dated "Oct 19th The Garth, Haslemere." With envelope whose postmark, "SP 16," does not correspond.

66 Autograph letter signed, Kate Smith Hopkins to Grace Hopkins, dated "Nov 14th The Garth, Haslemere."

67 Autograph letter signed, Grace Hopkins to Isabel Giberne Sieveking (GMH's first cousin), from "The Garth, Haslemere," n.d. but ca. Easter.

68 Holograph letter initialed, Lionel Hopkins (GMH's brother) to Grace Hopkins, from China, dated "Dec. 8 1875" and continued on Dec. 15. Closing page[s] missing.

69 Autograph letter signed, Lionel Hopkins to Lance Sieveking, dated "The Garth, Haslemere, Surrey. 7 May 1945." With envelope postmarked "715 PM 7 May 1945," addressed to "Lance Sieveking, Esq. Broadcasting House, London. W.1."

70 Autograph letter signed, in verse, Kate Hopkins (GMH's sister) to Lance Sieveking, dated "March 1910, 7, Pembroke Road, Kensington." Nine-stanza (63-line) verse-letter for Sieveking's birthday. With envelope postmarked "Earls Court, S.W. 11:15 A.M. Mr 19 10," addressed to "Lancelot Sieveking, 1. Exmouth Place, Hastings."

71 Holograph letter signed, Arthur Hopkins (GMH's brother) to Evelyn Giberne (GMH's cousin), dated "42 Arkwright Road, Hampstead, N.W.3, 12 Nov. 1929."

DRAWINGS BY THE HOPKINS OR SMITH FAMILIES

72 Maria Smith [Giberne], bust of Kate Smith [Hopkins] (GMH's mother). Pencil. 109 x 91 mm. On back: "Kate Smith—Drawn by Maria, Given to me July 12th 1838."

73 [Maria Giberne?], "View from my window, Hampstead June 4th." Pencil. 163 x 128 mm. Landscape.

74 [Maria Giberne?], "In the garden. Hampstead. June 6th." Pencil. 163 x 128 mm. Trees.

75 [Maria Giberne?], ". . . ley . . . 8th." Pencil. 163 x 128 mm. Tree. (Items 73-75 seem cut from the same sketchbook; size [all 128 mm. wide] and dating suggest attribution to Maria Giberne. See item 76.)

76 [Maria Giberne?], "Garden. Hampstead, June 8th." Pencil. 176 x 128 mm. Tree. (For attribution, see *AMES*, pp. 72, 87 n.6.)

77 Matilda Smith [Birkett] (GMH's aunt), old houses in a village. Pencil, highlighted in white. 150 x 112 mm. Inscribed: "Tilly's drawing—Given to me Febry 22nd 1839—Kate [Smith (Hopkins)]."

78-84 Laura Smith [Hodges] (GMH's aunt), seven drawings done as headings of letters to Kate Smith Hopkins. Ink, three with gold and colors added. From 113 x 93 mm. to 126 x 122 mm. Clipped from the letters. Flowers and foliage.

85 Laura Smith [Hodges], drawing done as heading of letter to Manley Hopkins. Watercolor. 114 x 100 mm. Flowers and foliage.

86 [Hopkins or Smith family], landscape at Epsom. Pencil. 36.5 x 25 cm. Tree and house.

87 [Hopkins or Smith family], landscape at Epsom. Pencil. On same sheet (recto) as item 86. Tree and path.

88 [Hopkins or Smith family], landscape at Epsom. Pencil. 36.5 x 25 cm. Tree.

89 [Hopkins or Smith family], landscape at Epsom. Pencil. On same sheet (recto) as item 88. Trees.

90 [Hopkins or Smith family], landscape at Epsom. Pencil. 36.5 x 25 cm. Tree, other trees behind.

91 [Hopkins or Smith family], landscape at Epsom. Pencil. 36.5 x 25 cm. Tree, other trees behind. (Items 86-91 seem to be from the same large sketchbook. The four sheets are in the Iconography Department of the HRHRC.)

92 [Hopkins or Smith family], "Mamma. Dec. 21." Pencil. 137 x 111 mm. Woman seated in chair reading book, from behind at angle.

93 [Hopkins or Smith family], old house in rural setting. Ink. 156 x 97 mm.

94 [Hopkins or Smith family], partial plan (map) of Cambridge University. Ink. 230 x 181 mm.

HOPKINS OR SMITH FAMILY PHOTOGRAPHS

95 Manley Hopkins. Cabinet card, ¾ length. 139 x 106 mm. HRHRC Photography Collection, file P-5.

96 Kate Smith Hopkins. Portrait, ¾ right profile. 139 x 121 mm. HRHRC Photography Collection, file P-6.

97 Everard Hopkins. Portrait, ½ length. 155 x 100 mm. HRHRC Photography Collection, file P-7.

98 Cyril Hopkins (GMH's brother), as a youth. Portrait, ½ length. 85 x 55 mm. HRHRC Photography Collection, file P-8.

99 Grace Hopkins. Carte-de-visite, full length. 85 x 56 mm. HRHRC Photography Collection, file P-9.

100 Milicent Hopkins (GMH's sister), as a girl. Carte-de-visite, full length. 90 x 64 mm. HRHRC Photography Collection, file P-10.

101 Frances Smith (GMH's aunt). Carte-de-visite, full length. 89 x 60 mm. On back: "Gerard's Aunt Fanny of Blunt House." HRHRC Photography Collection, file P-11.

102 Maria Giberne. Portrait, ½ length. 86 x 55 mm. On back: "Maria Giberne Gerard's aunt who taught him drawing at Epsom in the 1850's." HRHRC Photography Collection, file P-12.

103 Maria Giberne. Portrait, ¾ length. 125 x 99 mm. On back: "Maria Giberne (née Smith) Gerard [sic] Aunt who taught him to draw." HRHRC Photography Collection, file P-13.

104 Judge George de Giberne (George Giberne). Oval, ½ length. 74 x 55 mm. On back: "Judge George de Giberne Gerard's uncle who photographed him." HRHRC Photography Collection, file P-14.

105 Edgar Giberne (GMH's cousin). Portrait, ½ left profile, dated "July. 1871." 94 x 62 mm. HRHRC Photography Collection, file P-15.

106-107 [Hopkins Family], "A Story of a Doll" and "The Dove." Two stories, both in one bound notebook, ink with a few pencil revisions, dated "Oct. 1854." Apparently in the handwriting of Kate Smith Hopkins. At beginning, ink drawing by T[homas] Hood (artist, friend of Hopkins family) of a boy looking at a doll in a toy-store window.

108 [Hopkins or Smith family], "YE MISTLETOE BOUGHE! or The Rod, the Robbers!! and the Revival!!!" Program for an amateur Christmas entertainment, ink, dated "Thursday Jan 22. 1863." GMH plays the major role, "Prince Carmoisin (with joyful eyes)"; other roles are taken by such family members as G. Giberne, Edgar Giberne, Cyril Hopkins, E. Smith, Mrs. Manley Hopkins, Miss Giberne, Mrs. Giberne, A. Hopkins, etc.

109 Fourteen bookplates, printed. Coat of arms (flaming tower), motto "ESSE QUAM VIDERI" ("[It is better] to be than to seem"), and at bottom, "Manley Hopkins."

110 Two flowers, in pulled-thread embroidery. Wrapper is inscribed: "One of the sprays worked for the Queen's Wedding dress–not used—Honiton. 1839. Given to A.E.H. [Ann Eleanor Hopkins] by M. Manley. Manley [Devon], 1842." With envelope marked "Queen's Honiton Spray."

BOOKS BY MANLEY HOPKINS

111 *Hawaii: The Past, Present, and Future of Its Island-Kingdom.* London: Longman, Green, Longman, and Roberts, 1862. On spine: *The Sandwich Islands.* Autograph inscription on p. i: "George and Maria Giberne, / with M.H's affectionate / regards. Aug. 1862." Below, autograph signature: "L de G. Sieveking 1911."

112 *The Cardinal Numbers.* London: Sampson Low, Marston, Searle, and Rivington, 1887.

113 *Spicilegium Poeticum: A Gathering of Verses.* London: Leadenhall, [1892]. Autograph inscription on endpaper: "Isabel Sieveking. / from M.H. with / kind love. / August 1892."

From the Library of Anne Sexton:

114 *Poems and Prose of Gerard Manley Hopkins.* Selected With an Introduction and Notes by W.H. Gardner. Baltimore: Penguin, 1953. The Penguin Poets Series. Notations in ink.

From the Library of Edith Sitwell:

115 *Poems of Gerard Manley Hopkins.* Ed. Robert Bridges. With additional poems and introduction by Charles Williams. London: Oxford University Press, 1930. Second edition. Several titles underlined, and notations in ink.

116 *Selected Poems.* London: Nonesuch, 1954. Autograph inscription on endpaper: "To Edith, on the day of her reception into the Church at Farm St. With much affection and admiration, Philip Caraman, SJ. 4th August 1955."

117 *Poems and Prose of Gerard Manley Hopkins.* Selected With an Introduction and Notes by W.H. Gardner. Baltimore: Penguin, 1953. The Penguin Poets Series. Notations in ink.

118 *Further Letters of Gerard Manley Hopkins.* Ed. Claude Colleer Abbott. London: Oxford University Press, 1938. With dust jacket. Notations in ink.

119 *The Journals and Papers of Gerard Manley Hopkins.* Ed. Humphry House. London: Oxford University Press, 1959. With dust jacket. Autograph on endpaper: "Edith Sitwell." Notations in ink.

120 W.H. Gardner. *Gerard Manley Hopkins (1844-1889): a Study of Poetic Idiosyncrasy in Relation to Poetic Tradition.* London: Martin Secker and Warburg, 1944. With dust jacket. Autograph inside front cover: "Edith Sitwell." Notations in ink and some dog-eared pages.

121 W.A.M. Peters, S.J. *Gerard Manley Hopkins: A Critical Essay Towards the Understanding of His Poetry.* London: Oxford University Press, 1948. With dust jacket. Notations in ink.

122 F.R. Leavis. *New Bearings in English Poetry: A Study of the Contemporary Situation.* London: Chatto and Windus, 1950. In dust jacket. Notations in ink, but not in the Hopkins section.

From the Library of Evelyn Waugh:

123 John Pick. *Gerard Manley Hopkins: Priest and Poet.* London: Oxford University Press, 1942. EW bookplate inside front cover, and autograph on endpaper: "Evelyn Waugh Stinchcombe Nov. 42."

124 W.H. Gardner. *Gerard Manley Hopkins (1844-1889): a Study of Poetic Idiosyncrasy in Relation to Poetic Tradition.* London: Martin Secker and Warburg, 1944. EW bookplate inside front cover, and autograph on endpaper: "Evelyn Waugh Ragusa 8 Jan 45."

125 Norman Weyand, S.J., ed. *Immortal Diamond: Studies in Gerard Manley Hopkins.* New York: Sheed and Ward, 1949. Holograph letter by Waugh pasted inside front cover (see text above); editor's inscription on endpaper: "*To* Evelyn and Laura Waugh— / with pleasant memories of their Loyola, Chicago visit, 1949. / In Domino, / Norman Weyand, S.J." EW bookplate on next page.

MUSICAL SCORE, TO HOPKINS TEXT

126 J. Willard Roosevelt. "The Leaden Echo and The Golden Echo." Photographed musical score "set for reciting voice and piano," with words by GMH. 13 pp., on music paper, n.d.

127 Early studies for item 126. Pencil, without title or name.

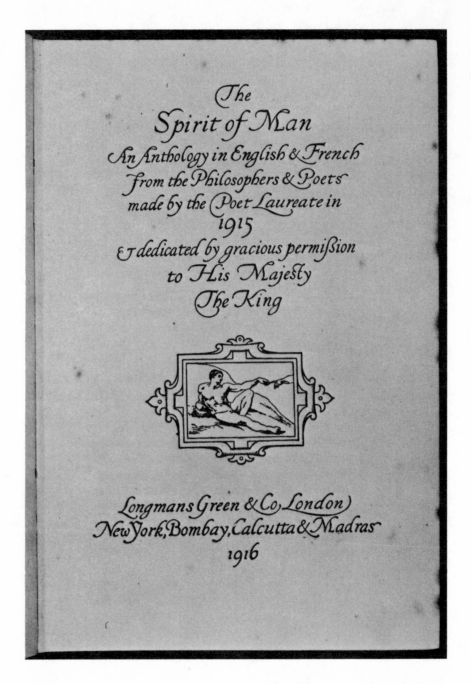

The
Spirit of Man
An Anthology in English & French
from the Philosophers & Poets
made by the Poet Laureate in
1915
& dedicated by gracious permission
to His Majesty
The King

Longmans Green & Co London
New York, Bombay, Calcutta & Madras
1916

Item 138: Robert Bridges, ed. *The Spirit of Man: An Anthology in English & French from the Philosophers & Poets.* London: Longmans Green & Co., 1915.

The Emergence of Gerard Manley Hopkins From Obscurity to Recognition (1889-1918)

By Todd K. Bender

John Crowe Ransom, the editor of the *Kenyon Review* and one of the most influential leaders of the "New Criticism" in the decades following World War II, customarily began his undergraduate lectures on Modern Poetry at Kenyon College with the confident and astute assertion that modern poetry begins with Gerard Manley Hopkins. When the poet-priest died in 1889, it could hardly have been expected that he would come to be considered the forerunner of the great Modernist revolution in art accomplished after World War I by T.S. Eliot and Ezra Pound. A few scattered short poems and fragments by Hopkins were published during his lifetime, and a few more began to appear posthumously, but it was thirty years after his death before the first edition of the collected *Poems of Gerard Manley Hopkins* appeared in 1918, edited by Robert Bridges. How is it, contemporary readers may well wonder, that Hopkins's work as a poet was so little known in his lifetime, so slow to emerge in the thirty years after his death, and so miraculously retrieved from obscurity to spark the Modernist revolution between the great Wars?

The countermovement in the career of his closest literary associate, Robert Bridges, is equally perplexing. As editor of Hopkins's *Poems*, Bridges proudly displays on the title page his credentials as Poet Laureate of England; but today, fifty years later, he is reduced from his position of literary influence and power to a mere footnote, remembered mainly as the editor of his once obscure friend. The neglect of Hopkins's poems before 1919 and the neglect of Robert Bridges's works today provide an ironic symmetry.

The few records directly concerning Hopkins or written by him and printed before 1918 are well documented in Tom Dunne's *Gerard Manley Hopkins: A Comprehensive Bibliography* (1976), and only a few additions or corrections to Dunne's careful work have been noted. Bibliographical items are identified here by Dunne's code and the poems by Hopkins by the number given them in the Fourth Edition of the collected *Poems* (1967).

During Hopkins's lifetime the few published examples of his work were always severely limited in circulation, as can be seen from Dunne's list of nine items (A1-A9) that appeared for the most part in periodicals. The first published poem by Hopkins, entitled "Winter with the Gulf Stream" (A1), was printed in 1863 in *Once a Week* when the poet was still a schoolboy. Other examples of his work included translations into Latin of poems by Dryden and Shakespeare (A4 and A7-8), an occasional piece written to celebrate the silver jubilee of the Bishop of Shrewsbury in 1876 (A3), and "Morning, Midday, and Evening Sacrifice" (A9), which was included in *The Bible Birthday Book* compiled in 1887 by Canon Richard Watson Dixon. The other early examples of Hopkins's poetry published during his lifetime are: "Barnfloor and Winepress" (A2) in *Union Review* (1865); "Angelus ad Virginem" (A5) in *Month* (1882); and "The Child is Father to the Man," "Cockle's Antibilious Pills," and "No News in the *Times* To-Day" (A6) in *Stonyhurst Magazine* (1883). With Hopkins's death on 8 June 1889 at the age of 44, not a single one of his major poems was in print.

Between the time of the poet's death and the publication in 1918 of the First Edition of his *Poems*, the following anthologies or compilations included examples of Hopkins's poetry:

In May 1890, "Ad Mariam" appeared in volume 26 of *The Blandyke Papers* (A10), a private Jesuit publication with a very limited circulation.

In August 1893, Alfred H. Miles, in *The Poets and the Poetry of the Century* (A11), a ten-volume set, devoted approximately ten pages to Hopkins's work with an introductory note by Bridges. This is the first substantial exposure of Hopkins's poetry to the general reading public. The eleven poems printed are some of the poet's most powerful work, including sonnets of elation and celebration of nature, such as "The Starlight Night" and "Spring"; poems suggesting spiritual desolation and struggle in "Thou art indeed just, Lord" and "To seem the stranger"; the lush, youthful "A Vision of the Mermaids"; and "The Habit of Perfection," a religious meditation showing for the first time Hopkins's use of structures such as "composition of place" and "application of the senses" to shape his verse. Although not all the poems are quoted in their entirety, this is a noteworthy sampling of Hopkins's best work. Nevertheless, the anonymous reviewer of the Miles volume in the *Manchester Guardian* (A12), for 29 August 1893, severely questions the merit of Hopkins's poems, and in *Athenaeum* (A13), for 23 September 1893, the anonymous reviewer merely mentions Hopkins in passing without criticism.

In February 1894, "Ad Mariam" was reprinted in *Stonyhurst Magazine* (A14), vol. 5, no. 72, along with a covering letter signed simply O.S.J. The poem is indicative of the fact that Hopkins's adult life was shaped by the Roman Catholic faith and the order of the Society of Jesus. All his poetry is to some degree religious, but certain poems seem more particularly framed for a

A BOOK OF
CHRISTMAS VERSE

SELECTED BY H. C. BEECHING: WITH

TEN DESIGNS BY WALTER CRANE

LONDON: METHUEN AND COMPANY

36 ESSEX ST. STRAND: MDCCCXCV

Item 130: Title page of *A Book of Christmas Verse* (1895).

Roman Catholic setting, while others appeal in a general way to the sensibility of all readers. In Hopkins's life a strong split between his Roman Catholic faith and the outer world created painful tensions, separating him, for example, from his family and from his friend, Robert Bridges. After Hopkins's death, this struggle continues as Roman Catholic readers stress his more doctrinaire texts, while other readers, like Bridges, try to place the poet in a more general, humanist tradition.

In 1895 H.C. Beeching's *Lyra Sacra / A Book of Religious Verse* (A15) introduces the reader to Hopkins's religious verse as it speaks to men and women of all faiths and creeds, with the first publication of "God's Grandeur," "Heaven-Haven," and "Thee, God, I come from." This anthology also reprints "Barnfloor and Winepress" (A2) and "Morning, Midday, and Evening Sacrifice" (A9). The Beeching volume was reviewed anonymously in *Speaker* (A16), for 20 April 1895, and again Hopkins is mentioned in a slighting manner.

A Book of Christmas Verse (A17), also selected by H.C. Beeching in 1895, presents "The Blessed Virgin compared to the Air we Breathe" under its original title, "Mary Mother of Divine Grace Compared to the Air we Breathe." This poem was subsequently reprinted in 1902, along with "Rosa Mystica," in *Carmina Mariana* (A22), edited by Orby Shipley, and was partially reprinted in 1906 in *The Madonna of the Poets* (A26), compiled by Anita Bartle.

Seven years later, in 1902, *A Little Book of Life and Death* (A23), compiled by Elizabeth Waterhouse, reprints "Heaven-Haven." In a review of this collection, entitled "The Preferential Anthology," which appeared in *Academy and Literature* (A24), for 19 July 1902, the poet Francis Thompson quotes the text of "Heaven-Haven," the only evidence we have that Thompson knew the work of Hopkins. "Heaven-Haven" was subsequently reprinted in 1906 in *A Book of Memory: the Birthday Book of the Blessed Dead* (A27), compiled by Katherine Tynan.

Carl Sutton has made an important discovery, not noted in Dunne's *Bibliography*, concerning Thomas Bird Mosher's *Amphora* (1912). Mosher, sometimes called "the passionate pirate," printed without permission in his book *Amphora* the untitled text of "Heaven-Haven." This is apparently the first book printed in the United States containing a poem by Hopkins. In a letter to Sutton, Dunne (who had not known about Mosher's book when his bibliography was published) suggests that Mosher's book is probably the literary piracy Bridges complains about in an unspecified letter to Hopkins's mother.

"The Starlight Night," one of Hopkins's finest nature sonnets, which had previously appeared in Alfred H. Miles's *The Poets and the Poetry of the Century* (A11), was reprinted in 1912 in *The Oxford Book of Victorian Verse* (A28), edited by Arthur Quiller-Couch.

In 1916 Bridges edited *The Spirit of Man* (A30), an anthology that included wholly, or in part, six poems by Hopkins: "Spring and Fall," "The Candle Indoors," "The Habit of Perfection" (which had previously appeared in Miles [A11]), "The Wreck of the Deutschland" (stanza I appears for the first time in mutilated form), and "In the Valley of the Elwy" and "The Handsome Heart" (both appearing in full for the first time). This volume elicited five reviews which noted Hopkins's contributions (A31, A32, A33, A34, A35).

The Oxford Book of English Mystical Verse (A36), edited in 1917 by D.H.S. Nicholson and A.H.E. Lee, included "The Habit of Perfection," "God's Grandeur," and "Mary Mother of Divine Grace Compared to the Air we Breathe." In the same year Joyce Kilmer's *Dreams and Images: An Anthology of Catholic Poets* (A37), published in New York, included "The Starlight Night," "The Habit of Perfection," and "Spring."

Only the following poems by Hopkins had been printed completely or in part before 1918:

"A Vision of the Mermaids" (2)
"Winter with the Gulf Stream" (3)
"Barnfloor and Winepress" (6)
"Heaven-Haven" (9)
"The Habit of Perfection" (22)
"Nondum" (23)
"Ad Mariam" (26)
"Rosa Mystica" (27)
"The Wreck of the Deutschland" (28)
"The Silver Jubilee" (29)
"God's Grandeur" (31)
"The Starlight Night" (32)
"Spring" (33)
"In the Valley of the Elwy" (34)
"The Candle Indoors" (46)
"The Handsome Heart" (47)
"Morning, Midday, and Evening Sacrifice" (49)
"Spring and Fall" (55)
"Inversnaid" (56)
"The Blessed Virgin compared to the Air we Breathe" (60)
"To seem the stranger lies my lot, my life" (66)
"Thou art indeed just, Lord, if I contend" (74)
"To R.B." (76)
"The Elopement" (135)
"The Child is Father to the Man" (147)
"Thee, God, I come from, to thee go" (155)
"Latin Version of Dryden's Epigram on Milton" (181)

PRAYERS FROM THE POETS

A Calendar of Devotion

COMPILED AND EDITED BY

LAURIE MAGNUS MA

AUTHOR OF 'A PRIMER OF
WORDSWORTH' ETC

AND

CECIL HEADLAM BA

AUTHOR OF 'PRAYERS OF
THE SAINTS'. 'THE STORY
OF NUREMBERG. ETC

WILLIAM BLACKWOOD AND SONS
EDINBURGH · AND · LONDON
MDCCCXCIX

Item 131: Title page of *Prayers from the Poets: A Calendar of Devotion* (1899).

"Songs from Shakespeare, in Latin and Greek" (182)
"Angelus ad Virginem" (Appendix D)

Even with the publication of the first collected edition of Hopkins's poems, the poet was still not well known outside the immediate circle of his correspondents and associates. The revelation of his poetry to the reading public was mainly, though not entirely, brought about through the agency of his friend, Robert Seymour Bridges (1844-1930), whose poetic fame had grown enormously over the thirty years since Hopkins's death. A comparison of the two poets' literary careers reveals, perhaps, the reasons for the later emergence of Hopkins as a major English poet and the decline of Bridges as an influential figure in the history of English poetry.

Hopkins as an undergraduate at Oxford was, by all accounts, a remarkably brilliant student of classical languages. Bridges, on the other hand, was considered rather average, yet Bridges rose to very high eminence in the literary world, while his friend's poems were hardly noticed in the 1880s and 1890s. George L. McKay's *A Bibliography of Bridges* (1933) shows the growing stream of lyric and dramatic poetry by Bridges culminating in his *Poetical Works* in six volumes published by Oxford University Press (1898-1905): *Poems* (1873; second series, 1879; third series, 1880; shorter poems in four books, 1890; book five, 1893); *The Growth of Love* (1876); *Prometheus the Firegiver, a masque* (1884); and *Eros and Psyche, a narrative poem* (1885). Following the six-volume collected works, Bridges continued to publish: *Demeter, a masque* (1905); *Poems* (1913); and his final, massive work, *The Testament of Beauty* (1927-1929). In the last years of Hopkins's life, he wrote to Bridges as an unknown poet addressing a rising star, and yet this relationship reverses the roles of the two men when they were close friends in undergraduate studies. Then it was Hopkins who was the "Star of Balliol," Bridges the earnest worker showing little extraordinary promise.

While Hopkins lived, Bridges was his keenest literary critic. Also, Hopkins's theories of meter and "sprung rhythm" were developed partly in response to Bridges. For this reason, Bridges's *Milton's Prosody* (1893) is an important foil for Hopkins's very unMiltonic measures.

After Bridges, the poet Coventry Patmore (1823-1896) was Hopkins's second most important literary companion. Although not widely read today, Patmore was one of the most popular and successful writers of Hopkins's time. As with Bridges, Hopkins corresponded with Patmore as an unknown addressing a major figure. Patmore's "Essay on English Metrical Law" must be read as a companion to Bridges's *Milton's Prosody* as background to Hopkins's theories of meter and poetic form. The third poet, joining Bridges and Patmore in the privileged triad of correspondents with Hopkins, is Canon Richard Watson Dixon (1833-1900), who tried vainly in a number of ways to promote interest in Hopkins's poetry while he was still alive.

As we have seen, no more than 9 of Hopkins's poems appeared in print during his lifetime. Out of the 184 poems assigned to him by Catherine Phillips in her 1986 *Gerard Manley Hopkins* in the Oxford Authors Series, no more than 30 were published before 1918, many only in fragments and some even in mutilated form. If readers knew Hopkins's work today *only* by these 39 poems, how different would be our evaluation of his genius, how diminished our grasp of his gifts.

Carmina Mariana

SECOND SERIES

AN ENGLISH ANTHOLOGY IN VERSE

IN HONOUR OF AND IN RELATION TO

The Blessed Virgin Mary

COLLECTED AND ARRANGED BY

ORBY SHIPLEY, M.A.

Editor of ' Annus Sanctus : Hymns of the Church for the Ecclesiastical Year '

Manresa Press

PRIVATELY PRINTED FOR THE EDITOR BY
JOHN GRIFFIN, ROEHAMPTON, S.W.
1902

Item 132: Title page of *Carmina Mariana* (1902).

128 Alfred H. Miles, ed. *The Poets and the Poetry of the Century: Robert Bridges and Contemporary Poets*. London: Hutchinson & Co., [1893].

129 H.C. Beeching, ed. *Lyra Sacra / A Book of Religious Verse*. London: Methuen & Co., 1895.

130 H.C. Beeching, ed. *A Book of Christmas Verse*. London: Methuen & Co., 1895.

131 Laurie Magnus and Cecil Headlam, comps. *Prayers from the Poets: A Calendar of Devotion*. Edinburgh and London: William Blackwood and Sons, 1899.

132 Orby Shipley, ed. *Carmina Mariana*. London: Burns and Oates, 1902.

133 Elizabeth Waterhouse, ed. *A Little Book of Life and Death*. London: Methuen & Co., 1902.

134 Anita Bartle, comp. *The Madonna of the Poets*. London: Burns and Oates, 1906.

135 Katharine Tynan, comp. *A Book of Memory: The Birthday Book of the Blessed Dead*. London: Hodder & Stoughton, 1906.

136 Thomas Bird Mosher, ed. *A Collection of Prose and Verse Chosen by the Editor of the Bibelot*. Portland: Thomas Bird Mosher, 1912.

137 Arthur Quiller-Couch, ed. *The Oxford Book of Victorian Verse*. Oxford: Clarendon Press, 1912.

138 [Robert Bridges, ed.]. *The Spirit of Man: An Anthology in English & French from the Philosophers & Poets*. London: Longmans Green & Co., 1915.

139 D.H.S. Nicholson and A.H.E. Lee, eds. *The Oxford Book of English Mystical Verse*. Oxford: Clarendon Press, 1917.

140 Joyce Kilmer, ed. *Dreams and Images: An Anthology of Catholic Poets*. New York: Boni and Liveright, 1917.

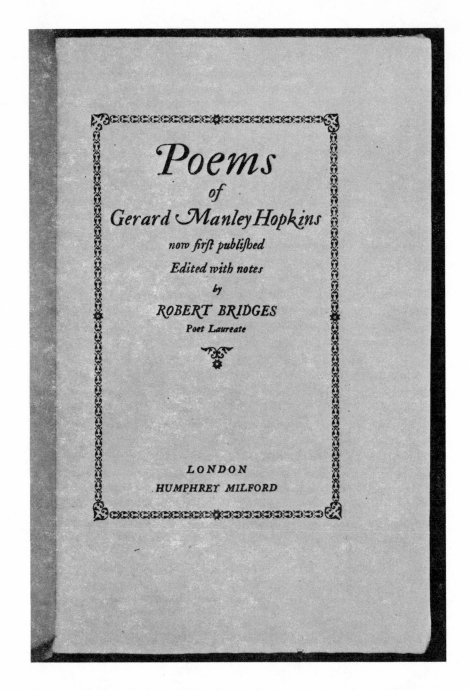

Poems
of
Gerard Manley Hopkins
now first published
Edited with notes
by
ROBERT BRIDGES
Poet Laureate

LONDON
HUMPHREY MILFORD

Item 141: Title page of the First Edition of *Poems of Gerard Manley Hopkins*, edited in 1918 by Robert Bridges.

From Manuscript to Printed Text:
The Hazardous Transmission of the Hopkins Canon

By Norman H. MacKenzie

John Ruskin, who through *Modern Painters* expended many years of his life in the defense and promotion of J.M.W. Turner's startling innovations, found "utterly inexplicable" the casual neglect with which the artist himself treated the finished canvases in his own studio.[1] Gerard Manley Hopkins, whose technical innovations in spoken rather than written poetry might be regarded as an analogue of Turner's in color and space, showed a more complex pattern of attitudes to his own productions. Though moved from one post to another at short notice, Hopkins contrived to take with him his old journals and even the essays written as an undergraduate for his tutors. His poetry, however, threatened to compete with the meticulous carrying out of his duty, either as a student, teacher, or priest, and once the overmastering urge to create a poem had been relieved, he took no special pains to preserve the manuscript, and in fact he often abandoned a piece not quite finished or let his thoughts wander as he copied it out. His solution, unfortunately only a partial one, was in effect to appoint Robert Bridges a sort of literary custodian even before he entered the Jesuit Novitiate.[2]

The contributions made by Bridges towards the formation of the Hopkins canon are often undervalued. He preserved and updated all the major poetic autographs, and his interest in his friend's new theories, accompanied by healthy challenges to his more radical experiments, provoked Hopkins into writing one of the most stimulating and revealing bodies of correspondence in modern English literary history, while they also encouraged his flagging impulse to compose. By transcribing into a second album, MS. B, all the most important poems written before 1883, and sending them to Hopkins for checking, Bridges occasioned their revision, a process which the author

[1] John Ruskin, *The Works of John Ruskin*, ed. E.T. Cook and A.D.O. Wedderburn (London: G. Allen, 1903-12), iii.249.

[2] Claude Colleer Abbott, ed., *The Letters of Gerard Manley Hopkins to Robert Bridges* (London: Oxford University Press, 1935), pp. 13-17 (Oct. to Dec. 1866).

himself could not otherwise have attempted since he had kept few fair copies of his pieces. And finally, after Hopkins's premature death in 1889, Bridges acted swiftly in concert with the Jesuit's family to rescue some of his surviving manuscripts, including drafts and fair copies of the Sonnets of Desolation—if those had been lost his literary status today would have stood much lower. Also dispatched to Bridges from Dublin were his agonized meditation notes— one proposed new edition of the *Sermons* suggested that these ought really to be omitted.

No one who has had the weary task after a scholar's death of sorting through the dusty archaeological strata of his life—ephemeral shards, which after a few years might puzzle even their writer, mingled with important papers, fascinating letters along with others, the value of which are a worry to determine—can fail to sympathize with the "Minister" of a busy Jesuit house after a priest has died: he has to deal under pressure with disorganized masses of material in order to make a room available to another Father, transferred at short notice to replace in the college or parish the priest who has just passed away. Letters received may well contain confidences which ought to be buried with the recipient. In reducing the piles to manageable dimensions the Minister may all too easily make flash judgments which the hindsight of critics a hundred years later may deplore. That so much verse was rescued from Hopkins's Dublin study was in large measure due to the request sent by Robert Bridges to Father Thomas Wheeler. Hopkins's parents were too emotionally upset to make wise decisions immediately after the funeral when Father Wheeler invited their help in sorting the papers. Mrs. Kate Hopkins, writing from Haslemere on 13 June 1889, explained to a correspondent (one of whose letters to Hopkins had been found in Gerard's room) that "all the letters Gerard received during his illness—(and which he read and re-read)—were brought to me to look over and destroy."[3] She may have interpreted her mandate too drastically.

Hopkins was an unsystematic and conscience-troubled archivist of his own productions. As early as June 1865, while still an undergraduate, he recorded in his second tiny note-book that he had sent a friend revised copies of two sonnets on Oxford, composed only two months before, without noting his revisions in his rough drafts or being able to recapture them—the form in which he entered the sonnets "To Oxford," and in which they have descended to us, is therefore "not quite right."[4] His very last letter to Bridges, written at the onset of his fatal illness (29 April 1889), remarks on the difference between the two men in their feelings over making fair copies of their verses: "I find it

[3]Bodleian MS. Eng. Misc. a.8. ff.44,49.

[4]N.H. MacKenzie, ed., *The Early Poetic Manuscripts and Note-books of Gerard Manley Hopkins in Facsimile* (New York: Garland Publishing, 1989), C.II, 78; plates 118-119. This volume reproduces all valid manuscripts of Hopkins poems prior to "The Wreck of the Deutschland," along with note-books C.I. and C.II.

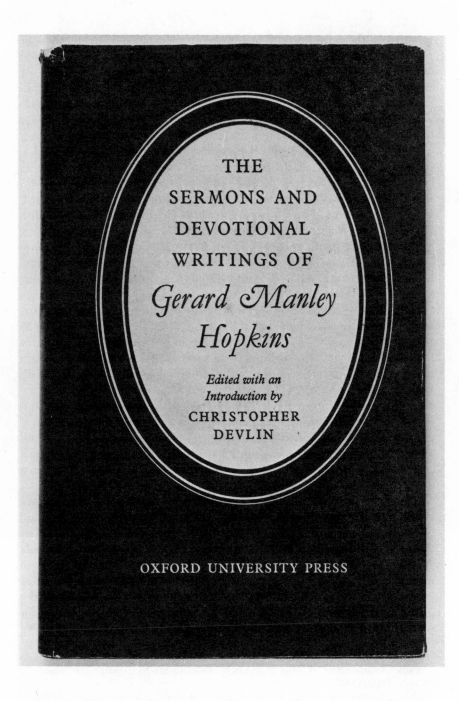

Item 154: Dust jacket of *The Sermons and Devotional Writings of Gerard Manley Hopkins* (1959).

repulsive"—the term is so strong as to invite speculation—"and let them lie months and years in rough copy untransferred to my book." His "book" was MS. B, which contained twenty-four of his best poems transcribed by Bridges, followed by fourteen poems inscribed by Hopkins and six autographs pasted in, possibly after his death. But out of all the deeply emotional poems written in Ireland, Hopkins, to the lasting regret of his editors, did not bring himself to enter more than four in the album which Bridges had begun.

Either through choice or inadvertence, Father Wheeler did not send to Bridges or the family all Hopkins's surviving material. When twenty years later Father Joseph Keating, assistant editor of the Jesuit journal the *Month*, issued an appeal in the Jesuit domestic quarterly, *Letters and Notices* (April, 1909), for the loan of any manuscript which would assist him to publish Hopkins's verse along with a prefatory biographical memoir, he received a few autograph poems with copies of some others, many letters addressed to Hopkins from Dixon, Newman, and Patmore, the poet's two tiny early note-books, and two out of the five extant later journals. In 1947, Father Anthony Bischoff, S.J., enormously enriched the records of the poet's nature observations and holidays by discovering three more journals in the Jesuit headquarters at Farm Street, London; but still missing today is one covering from 25 July 1866 to 30 August 1867, and all those beyond 7 February 1875, the entry for which ends in the middle of a sentence.[5] These, and others which subsequently surfaced, were eventually gathered together in Campion Hall, Oxford, by Father Martin D'Arcy when he was Master (1933-45). But from the early years of the century till the 1930s, tensions between the Jesuit and non-Jesuit admirers of Hopkins (e.g., between Father Joseph Keating and Robert Bridges) impeded all editorial efforts prior to those of Humphry House and W.H. Gardner. For my own part I have received nothing but the most generous support from both sides, but suspicions still lurk in the minds of a few scholars.

Bridges was undoubtedly wise in not attempting to introduce Hopkins (to a world still not completely ready for him in December 1918) in a complete and chronologically arranged edition—many of Hopkins's undergraduate pieces are only now beginning to be understood. On the other hand, Bridges's "Preface to Notes" was unnecessarily critical in his well-meant efforts to forestall the outright rejection of what even today some people brand as "oddities." Bridges seems to have underestimated the extent to which the global upheaval of the Great War had prepared many younger readers for what he himself felt were "rude shocks" of Hopkins's "artistic wantonness."[6]

[5]Father Anthony Bischoff, "The Manuscripts of Gerard Manley Hopkins," in *Thought* 26 (Winter 1951): 553-557.

[6]Robert Bridges, ed., *Poems of Gerard Manley Hopkins*, first edition (London: Oxford University Press, 1918), p. 97.

Nevertheless, the prestige of the Poet Laureate as editor attracted mostly favorable attention to the almost unknown poet.[7] Of the 750 copies printed, 50 were strategically given away, 180 sold at 12s6d in the first year, and 240 in the second. This was a rate very close to that for T.S. Eliot's less unconventional first book of poems, *Prufrock and Other Observations*, 500 copies of which were issued in June 1917 at the give-away price of one shilling (gradually raised to five shillings); however, Eliot's last copies, autographed, commanded 10s6d in 1920 and 1921.[8] Moreover, a thousand copies of Eliot's *The Waste Land* were bought in its first year and the book had to be reprinted, whereas the immediate market for Hopkins had been saturated by 1920: thereafter the sales of the First Edition fell to an annual average of only 30 over the next six years and the stock was not exhausted until 1928. The rise in Hopkins's status at the approach of his centenary may be roughly charted by the prices fetched when rare second-hand copies of the Bridges edition surface today. One sold for £45 in 1966; by 1972 the catalogue value was £118; and in the eighties another was priced at £250. Carl Sutton would be grateful if libraries and private owners of these valuable editions could tell him any interesting details of their provenance: a history of their distribution is being compiled by Margaret Bogan.

The Second Edition of 1930 was graced with a splendid complimentary Introduction by Charles Williams, who also ventured to include in an Appendix eleven more pre-"Deutschland" poems along with five later poems and translations. The reviews were mostly enthusiastic and fresh impressions were run off in 1933, 1935, 1937, 1938, 1940, 1941, 1943, and 1944. Hopkins had clearly come into his own. Williams, however, did not achieve the high editorial standards of Robert Bridges. The errors introduced into poems such as "Hurrahing in Harvest" (line 1, "the stooks *arise*") were copied by W.H. Gardner in the Third Edition of 1948 (Gardner did not work from the original manuscripts) and survived into the 1960s in anthologies. Most unfortunate was the dittography in "Godhead here in hiding" ("S. Thomae Aquinatis Rhythmus"), stanza 6, line 3, which has found its way into English versions of the Missal and translations of St. Thomas's writings: "Blood that but one drop of has the world [for 'worth'] to win / All the world forgiveness of its world of sin." But no editor can claim to have eliminated all slips, and apart from their imperfections the author's ambiguities and failure to provide clearly labelled final texts mean that a definitive text may never be possible.

Gardner's Third Edition was reprinted in 1949, 1950, and 1952, and then with additional poems in 1956, 1960, and 1964.[9] This edition owed a major

[7] See Elgin Mellown, "The Reception of Gerard Manley Hopkins' Poems, 1919-1930," *Modern Philology* 63, no. 1 (August 1965): 38-51; also Tom Dunne, *Gerard Manley Hopkins: a Comprehensive Bibliography* (London: Oxford University Press, 1976), pp. xvi-xix, 14-18.

[8] Donald Gallup, *T.S. Eliot, a Bibliography* (London: Faber, 1969), p. 23.

[9] Gerard Manley Hopkins, *Poems of Gerard Manley Hopkins*, third edition, ed. W.H. Gardner (London: Oxford University Press, 1948).

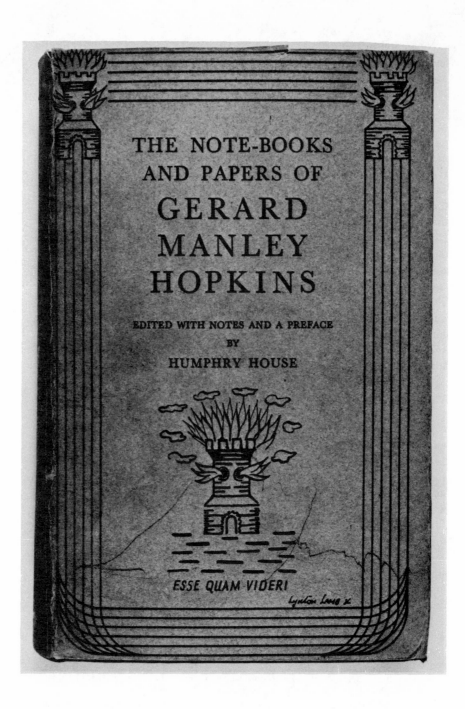

Item 150: Dust jacket of *The Note-Books and Papers of Gerard Manley Hopkins* (1937).

debt to Humphry House's *The Note-books and Papers of Gerard Manley Hopkins* (1937), which reproduced numerous early poems from the tiny note-books C.I and C.II in Campion Hall.[10] How difficult House's task was of producing readable consecutive versions from their tangled drafts may be assessed by studying the photocopies of the manuscripts in my first volume of *Facsimiles*.[11] Gardner also rearranged the poems into sections: the more important early poems in chronological order came first, followed by Bridges's main grouping of mature poems, these in turn by unfinished and minor poems, and finally translations. An Appendix, added in 1956, contained three poems imbedded in a letter to E.H. Coleridge, discovered since the edition was prepared (see *TLS*, 25 September 1948), three more supplied by Father Anthony Bischoff, and three by Humphry House and Father T. Corbishley.

The strength of the Third Edition lies in its helpful Introduction and commentary. For reasons which Gardner later explained in the Fourth Edition, he took over the text of the poems from his predecessors or from Humphry House without checking them by the manuscripts themselves: no suspicions of inaccuracy had arisen anywhere.[12] The metrical markings drew upon Gardner's learned two-volume *Gerard Manley Hopkins: a Study of Poetic Idiosyncracy in Relation to Poetic Tradition* (1944-49), still much respected today, but he did not differentiate Hopkins's prosodic marks clearly enough from his own conviction as to where stresses were meant to fall.[13]

Gardner's *Study*, and the Third Edition Introduction and commentary based upon it, had been enriched by the newly-available prose works of Hopkins—letters, journals, lecture-notes on rhetoric, sermons, and commentary on the *Spiritual Exercises of St. Ignatius*, all edited by C.C. Abbott or Humphry House, though none of these categories was yet complete. Still to come were: a) the expanded second edition of *Further Letters of Gerard Manley Hopkins* of 1956,[14] which, e.g., threw intimate light on Hopkins as an excited new student at Balliol and during the crisis of his conversion by printing 77 family letters just released (only 3 meagre letters to Kate and Arthur Hopkins were in the original edition); b) *The Sermons and Devotional Writings* (1959) edited by Father Christopher Devlin, S.J.;[15] and c) that

[10]Humphry House, ed., *The Note-books and Papers of Gerard Manley Hopkins* (London: Oxford University Press, 1937).

[11]MacKenzie, *The Early Poetic Manuscripts and Note-books . . . in Facsimile.*

[12]Gerard Manley Hopkins, *The Poems of Gerard Manley Hopkins*, fourth edition, ed. W.H. Gardner and N.H. MacKenzie (London: Oxford University Press, 1967), pp. xv-xvi.

[13]W.H. Gardner, *Gerard Manley Hopkins, 1844-1889, A Study of Poetic Idiosyncracy in Relation to Poetic Tradition* (London: Oxford University Press, 1944, 1949).

[14]Claude Colleer Abbott, ed., *Further Letters of Gerard Manley Hopkins: Including His Correspondence with Coventry Patmore*, second edition (London: Oxford University Press, 1956).

[15]Father Christopher Devlin, ed., *The Sermons and Devotional Writings of Gerard Manley Hopkins* (London: Oxford University Press, 1959).

remarkable work of scholarship and sympathetic editing, surely among premier modern editions, Humphry House's *The Journals and Papers of Gerard Manley Hopkins*, completed after his untimely death by Graham Storey and published by Oxford in 1959.

All five volumes of Hopkins's collected prose have long been out of print. Surely to mark his centenary Oxford University Press should reprint them (with or without corrections) or permit one of the reprint companies to do so.

The Penguin *Poems and Prose of Gerard Manley Hopkins*, selected and edited by Will Gardner, has proved an unflagging success.[16] First issued in 1953, it has been reprinted at least twenty-five times, with the text revised after the Fourth Edition was submitted for publication. The story of this revised text involves my own work with the Hopkins manuscripts.

Although my research area after World War II remained among seventeenth-century manuscripts, the field of my pre-war London doctorate, I became increasingly enmeshed in the engrossing task of presenting to advanced university students modern poetry, particularly the work of Hopkins, W. B. Yeats, and T. S. Eliot. In 1946 there were comparatively few books expounding any of these writers, each of whom was "difficult" in a special way. By the early 1960s, Yeats and Eliot were better served, while Hopkins seemed to have attracted fewer scholars prepared to undertake fundamental research. When, therefore, around 1962, A. Norman Jeffares, who was about to launch the Writers and Critics series for Oliver and Boyd, visited me and asked which of those three major poets I would most like to write about, I chose Hopkins. A sabbatical in Britain enabled me to inspect the manuscripts in the possession of Robert Bridges's son, Edward, First Baron Bridges, as well as those in Jesuit hands. Unfortunately, the unique manuscript of my study, complete except for its last chapter, was stolen on my way back to Rhodesia, along with all the research on which it was based, my annotated editions of Hopkins, and the accumulated notes of fifteen years. The effect on me was disturbingly like a personal bereavement.

Among the sympathetic suggestions I received from Hopkins scholars at a time when I wondered how I could ever retrace my investigations (the book was eventually rewritten and published in 1968), was one by Graham Storey, who pointed out the need for a new edition of Hopkins's poetry. During my work with the manuscripts I had become aware of the extent to which the printed texts had strayed from autograph authority, but I had also been impressed by the liveliness of the many preliminary drafts which preceded the final version and which often lit up its obscurities. I therefore proposed to Oxford University Press that I should prepare for them a variorum edition which would also restore the text in the many places where it was corrupt. As no hints of error had reached the Press or (with the exception of a single

[16]Gerard Manley Hopkins, *Poems and Prose of Gerard Manley Hopkins*, ed. W.H. Gardner (London: Penguin Books, 1953).

challenged comma) Will Gardner himself, my proposal provoked an emergency meeting. I learned that Gardner had already in fact just submitted the completed manuscript of a fourth edition with some additional poems and extended commentary, but that his texts remained almost unchanged. The upshot was that instead of proceeding with an independent edition, I was asked to cooperate with Gardner as coeditor in purifying his versions.

My contribution to the Fourth Edition lay in refining the chronological sequences within the different sections (which Gardner had retained from the Third Edition), correcting the readings, removing from the commentary any unauthorized prosodic marks, and writing a long "Foreword on the Revised Text and Chronological Rearrangement." Although I checked Gardner's descriptions of the manuscripts and his commentary, I left these much as they had stood in his original copy for the Press, merely inserting a few textual notes identified by my initials, and scrutinizing the many variants which Gardner kept adding from his microfilms. The collaboration entailed several years of correspondence, but eventually the edition appeared in 1967. Gardner died two years later. By then I was busy on my own Oxford English Texts edition, and formulating a more complex procedure for approximating to the author's uncertain intentions.[17] Further places where the text was corrupt struck me in the eye—it is humiliating to realize how familiarity begets optical lapses. Major corrections I wanted to save for the OET, but others entailing very minor changes were fed into the Fourth Edition, in the new impressions of 1970 (Oxford Paperback with a note on revisions), 1972, 1975, 1980, 1982, 1984 (a significant number of changes), and 1986, the total run exceeding 60,000 copies. Hopkins's growing influence in the literary world was obvious. Textual improvements, from 1972 to the OET inclusive, marking the struggle towards unattainable perfection, are listed in appendices to the two volumes of my *Facsimiles*.

Textual errors had escaped notice during the first forty-four years following the First Edition because no editor of the poems since Robert Bridges had enjoyed the privileges which the great kindness of Lord Bridges and of the Society of Jesus made possible—the chance of sitting down to edit each poem with all the extant manuscripts themselves on their stands before me. However, the generous placing of Manuscript A (the main body of autographs for the mature poems collected by Robert Bridges and owned by his son) in the Bodleian Library on loan for my special use proved a key factor in my research. The Jesuits also took so warm an interest in the project that they gave me a standing invitation to stay in Campion Hall whenever I was working on the manuscripts.

[17]Gerard Manley Hopkins, *The Poetical Works of Gerard Manley Hopkins*, ed. Norman H. MacKenzie (Oxford: Clarendon Press, 1989). This volume is part of the Oxford English Texts Series.

Such consideration should have resulted in the speedy production of the Oxford English Texts volume. In an appendix to Volume I of the *Facsimiles*, I have given a brief account of some of the impeding factors which defeated this hope, and I will therefore not repeat them here. Basically, there was disagreement with my desire to produce an exhaustive variorum edition, and objections were raised against each alternative proposal for setting out those variants. As one after another of my editors left the Press, I was asked each time to submit a new sample, which my new editor circulated with, to me, exasperating slowness to the members of a new advisory panel, all cloaked in anonymity. I was myself burdened with such administrative duties as those of Director of Graduate Studies in English and then Chairman of the Council for Graduate Studies and Research for the whole of Queen's University; moreover, I had many personal students to supervise, whose masters' and doctoral theses concerned a range of authors from the seventeenth century to today. I put the OET edition aside for several lengthy spells while I produced two other books, and I quietly continued to embody my ongoing research in numbers of conference papers and articles. Eventually the single OET volume grew into three when Garland Publishing undertook to produce two volumes of manuscript facsimiles reproducing in some 530 folio plates every extant poetic autograph and every transcript worthy of attention, with marginal references to assist readers in following the evolution of each line from the first draft to the finished poem. The copy for the Oxford English Texts volume was submitted in July 1986. Copy for Volume I of the *Facsimiles* edition reached Garland in November 1987. Volume II will contain the manuscripts of the mature poems from the "Wreck" onwards.

Catherine Phillips's Oxford Authors edition, published in October 1986, marks a new advance in Hopkins scholarship by arranging all his verse in chronological order.[18] As many of his drafts and fair-copies are undated or bear only the date when the poem was first begun, this involved a highly detailed examination of their handwriting to establish tables of evolution—an undertaking which she generously embarked upon many years ago at my request in order that the OET might be chronological in the sequence of its texts. Hers is a specially useful volume in that the complete poems are followed by a selection of Hopkins prose, chosen from his journals, correspondence, and sermons to illuminate his poetry and life. All the texts were edited from the manuscripts. Phillips improved the readings of various poems from the Fourth Edition revised impression of 1984; and where these changes were not already part of the OET manuscript, I took advantage of the copy-editing stage to incorporate them. Phillips also has provided a fresh introductory survey, and her commentary, though necessarily succinct, makes excellent use in

[18]Catherine Phillips, *Gerard Manley Hopkins*, The Oxford Authors Series (Oxford: Oxford University Press, 1986).

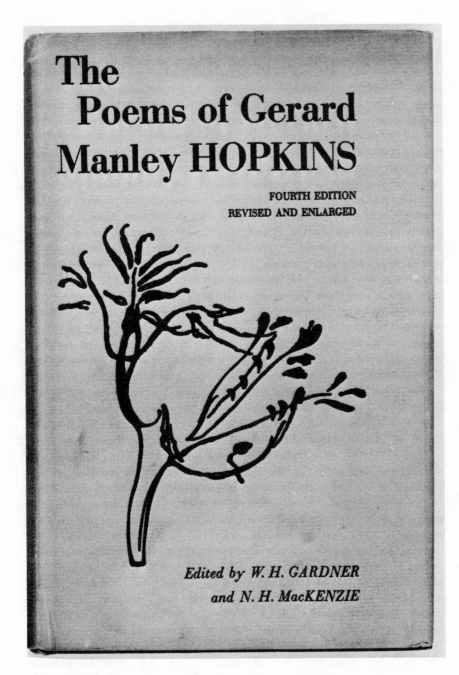

The
Poems of Gerard
Manley HOPKINS

FOURTH EDITION
REVISED AND ENLARGED

Edited by *W. H. GARDNER*
and *N. H. MacKENZIE*

Item 147: Dust jacket of the Fourth Edition of *The Poems of Gerard Manley Hopkins* (1967), edited with additional notes, a foreword on the revised text, and a new biographical and critical introduction by W.H. Gardner and N.H. MacKenzie.

places of her critical and biographical research at Cambridge University on Hopkins's friend and first editor, Robert Bridges.

My Oxford English Texts edition gratefully relies on Catherine Phillips's work in estimating the dates of manuscripts, with some minor modifications in sequence due to my own research or desire to group together, e.g., the different lyrics on St. Dorothea. The edition introduces a number of special features. Where two or more versions of a poem are of particular interest (as with "The Habit of Perfection," "Penmaen Pool," and "St. Alphonsus Rodriguez"), they are all given. Whenever Hopkins could not decide which of several alternative versions of a line to prefer, instead of printing only the last afterthought among undeleted competitors as we did in the Fourth Edition, the OET brackets them together as the poet did himself. Special prosodic effects from Sprung Rhythm, Counterpoint, and Outrides are indicated in the text as simply as possible, with further particulars in the notes. Every manuscript draft and fair copy of a poem has been separately identified by manuscript album letter and page or folio number, with details of its layout, title, dating, etc. Then follow the principal variants with cross-references to the plates in the two volumes of *Facsimiles* which reproduce the manuscripts. Attention is drawn to noteworthy articles on each particular poem, and finally comes my line-by-line commentary, more extensive than in any previous edition. There is a lengthy bibliography of books and articles covering more than a single poem. Classicists will be amused at the clever Latin versions of "Three blind mice!" and "Sing a song of sixpence" in an Appendix: though plausibly ascribed to Hopkins they cannot yet be considered part of the canon. The Introduction includes a critical study of the variant prosodic signs to be found in different autographs of certain poems (sometimes raising queries as to the validity of the author's distinctions between them). There are also accounts of each of the major manuscript collections of Hopkins poems, albums A, B, H.I and H.II. The history of these manuscripts deserves a glance.

Manuscript A was gradually built up by Robert Bridges, from about 1878 onwards, with autographs as they reached him from Hopkins. Bridges used red ink, or later black ink sloping backwards, to amend the pieces where revisions were made, thus clearly differentiating the changes from the original autograph. Hopkins, fearing that the manuscript of "The Wreck of the Deutschland" might be lost like its ill-fated subject, unfortunately did not entrust Bridges with its safe-keeping but circulated it himself. He had one period of anxiety when the sole manuscript was mislaid, but even this did not induce him to keep a systematic record of the manuscript's whereabouts. When in March 1880 Canon Dixon returned it with other sonnets after holding on to it for nearly a year, the author did not even open the envelope containing them to assure himself that the "Wreck" was safely back in port. Only when he needed a sizable envelope for some other purpose some ten weeks later did he bother to slit it open—and found an enthusiastic letter

attached praising his poems.[19] Hopkins had enjoyed enough spare time both at Mount St. Mary's and at Farm Street to have made another autograph copy of the "Wreck" and his other poems. His indifference may be interpreted as sanctity, but since the original autograph of the "Deutschland" did disappear before his death and he had no duplicate autograph, the poem might today be known only from a few fragmentary quotations if Bridges—who quickly overcame his first reaction that he would "not for any money" read it again— had not exerted himself to transcribe it, first into Manuscript A and from there into B. In the absence of a full autograph, his editors, unable to settle some troublesome discrepancies between A and B in punctuation, hyphens, and capitals, could wish that the author's indifference to fame had not taken so hampering a form.[20]

Manuscript B, the album now in the Bodleian Library on permanent exhibit, was also created by Bridges, who as a generous literary custodian copied into it Hopkins's main poems during the last few months of 1883, in order that he might circulate the poems among friends without endangering the originals. He sent the album to the author for him to "point" (i.e., to check the punctuation). Hopkins did so rather inefficiently, also entering corrections and revisions with such misplaced neatness that only by invoking the aid of the Infra-red Image Converter, used by Scotland Yard to detect forgeries, have I been able to decide in certain cases whether a deviation in Manuscript B from the autograph in Manuscript A (where one exists) is a revision by the author or a slip by the transcriber. In many instances a definitive text seems impossible of attainment. Commas and periods are sometimes indistinguishable.

The poems which Bridges referred to as in "H"—a statement repeated in notes from the First to the Fourth Editions—have long since been broken up into two separate albums, which for clarity I have in the OET and *Facsimiles* differentiated as H.I and H.II.

Manuscript H.I., a modern album, was professionally assembled by the Bodleian to house the loose autographs which they purchased (along with Manuscripts B and H.II) from the Hopkins family in 1953.[21] Among them are seven early poems written before Hopkins's decision to become a Jesuit— another proof that his often quoted statement that he burned the poetry he had written before he entered the Society of Jesus is not to be taken as implying a total holocaust.[22]

[19]Claude Colleer Abbott, ed., *The Correspondence of Gerard Manley Hopkins and Richard Watson Dixon* (London: Oxford University Press, 1935), pp. 32-33.

[20]Norman H. MacKenzie, "The Lost Autograph of 'The Wreck of the Deutschland' and Its First Readers," *Hopkins Quarterly* 3, no. 3 (October 1976): 91-115.

[21]MS. H.I. in Bodleian Library, MS. Eng. Poet. c.48.

[22]Abbott, *The Letters . . . to Robert Bridges*, p. 24; *The Correspondence*, p. 14; *Further Letters*, pp. 256-7; and Humphry House, ed., *The Journals and Papers of Gerard Manley Hopkins* (London: Oxford University Press, 1959), p. xix.

Manuscript H.II., a modern album, was originally created by Bridges after the poet's death to hold the best of the drafts and fair copies recovered from Dublin.[23] It contains some of the most tangled working papers to confront a Hopkins editor, such as the very rough and chaotic installments, after-thoughts, and vacillations from which Bridges contrived to reconstruct the unfinished "Epithalamion," in addition to "The Woodlark," the piece mis-called "On a Piece of Music," and "Margaret Clitheroe," all of which require tentative editorial rearrangement to produce intelligible versions.

The autographs in all three manuscripts, and many more poetic drafts from the little vest-pocket note-books C.I and C.II, and on individual sheets, will be reproduced in facsimile by Garland Publishing. To facilitate a study of the steps by which each poem attained its final wording, all drafts and fair copies for that poem are grouped together, the sequence and numbering of the poems being keyed to the Oxford English Texts edition of which the *Facsimiles* volumes were once parts. For those who wish to try out their skill as cryptographers, there are numbered specimens of Hopkins's handwriting to decipher. Each plate is accompanied by notes that transcribe deleted words, or reveal writing which can be read only by the use of instruments applied to the original document. It is hoped that these three volumes, along with Norman White's new biography of the poet, will help to stimulate a new era of Hopkins research and commentary.

Two sources of new information, not hitherto easily accessible to scholars, should be mentioned. As Part II of her Ph.D. thesis for Queen's University (1987), "Hidden Harmonies: Walter Pater and Gerard Manley Hopkins," Lesley Higgins prepared a complete edition of Hopkins's undergraduate essays, composed for the Master of Balliol (Robert Scott), or for Benjamin Jowett, William Newman, Edward Woollcombe, T.H. Green, and Walter Pater. The essays are illuminated by some 40 pages of notes, and are followed by a new and more detailed catalogue than has been hitherto attempted of all the other manuscripts in Campion Hall, Oxford. Part II is available separately on microfilm from the National Library of Canada in Ottawa, but it is hoped that the essays will also soon be printed on their own. Lesley Higgins was of great assistance in having the loose Campion manuscripts professionally mounted in fascicles and acid-free archival boxes, a project initiated by Father Peter Hackett, Master of Campion Hall, who has shown special concern for the Hopkins collection. She is also preparing a general study of the essays as a key to Hopkins's intellectual development.

The second body of hitherto unpublished material consists of the ab-breviated notes of "Sins" (such as "Laughing at Herclots," the victim of

[23]MS. H.II in Bodleian Library, MS. Eng. Poet. d.150.

Hopkins's epigram "On one who borrowed his sermons"),[24] which were penciled down in the little vest-pocket note-book C.II, in preparation for periodic confession to either Dr. Pusey or Henry Liddon, leading High-Church Anglicans of Oxford. These are interspersed among his other memoranda, along with drafts of poems or plays. Since each self-examination is dated, they provide an invaluable if only approximate method of dating the installments of poetry. The note-book was begun on 9 September 1864,[25] and the "Sins" were entered from 25 March 1865 to 23 January 1866. Mainly because the general entries are so interesting, the note-book has been handled since Hopkins's death in 1889 by many people—so many in fact that in some places the texts of the poems are hard to recover. The spiritual notes are barely legible, being written so small, and with so many abbreviations (e.g. "No l.," i.e., "No lessons," scriptural passages appointed for each day in the Prayer Book); furthermore, Hopkins crossed them through, apparently after he transferred the very repetitious daily "Sins" into another note-book in which he classified his faults for confession to Pusey or Liddon at irregular intervals.

For some while, a number of scholars have been impatient to see the spiritual notes made available by publication, though others, myself among them, have been reluctant for this to happen because it seemed an invasion of privacy. However, suppression often merely provokes exaggerated rumors. Since a full transcription, which I had not seen, has recently been in circulation, the British Province of the Society of Jesus concluded after careful deliberation at the highest levels that the time had come to publish the notes. Also, the many interesting biographical insights provided by the daily self-scrutinies were a further reason for bringing them into print in an authoritative edition.

The handwriting in the spiritual notes is so difficult that the Society thought it best that the entries should be published in facsimile with a transcription as complete as the state of individual pages allowed. Since I was, with the approval of the Society, already engaged in preparing facsimiles of all the passages of verse in C.I and C.II, it was decided that I should be requested to include both early note-books entire in the first volume of the *Facsimiles*. This also involved the preparation of a lengthy Introduction, to explain the Society's decision and to point out the value of the self-analyses in helping us to interpret the poems scattered between the notes, and in illuminating Hopkins's relationship with his fellow students, his family, and Digby Dolben. For this purpose I stipulated that I should be allowed to invite the cooperation of Dr. Felix Letemendia, Professor of Psychiatry and Psychology at Queen's University, who had practiced as a psychiatrist in Oxford from 1960

[24]Hopkins, *Poems*, fourth edition, p. 133; Phillips, *Gerard Manley Hopkins*, p. 33; and Hopkins, *The Poetical Works*, no. 32g.

[25]House, *The Journals*, pp. 43-73.

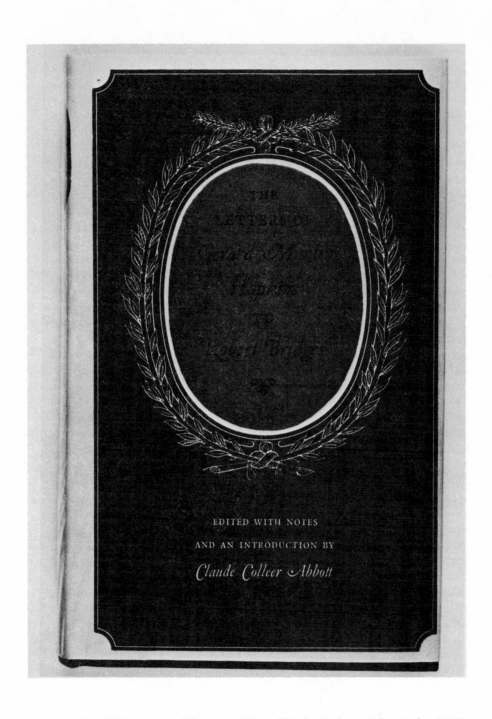

Item 148: Dust jacket of *The Letters of Gerard Manley Hopkins to Robert Bridges* (1935).

to 1977. This proved a most helpful collaboration. My Introduction was thoroughly discussed between us over a period of some months, and Dr. Letemendia has also contributed his own Medico-psychological Commentary.

If Hopkins had felt very sensitive about these memoranda for confession, he could have placed them beyond reach by the familiar practice of overlaying them with looping lines, by erasing them, or by cutting out sections. He did tear out of his two little note-books many pages which probably carried the early drafts of poems and some rough sketches later improved upon. But not a single day's entry appears to be missing from his spiritual notes. Nor, during his long final illness, did he give instructions for them to be destroyed. Moreover, the flyleaf of C. II simply bears his signature and the date on which the note-book was brought into use, whereas the next note-book, A I, is marked "Private . . . Please not to read."[26]

Dr. Letemendia and I have tried to assess the objective reliability of Hopkins's self-accusations by measuring them against other sources of information. There is strong evidence that he suffered from an over-sensitive scrupulosity: day after day, for example, he wrote himself down as guilty of laziness and of wasting time, yet the evidence of his First in both Mods and Greats, and the term-by-term assessment by his tutors for the same period, as recorded in the Master's Report Book kept by Robert Scott, indicate that he was "very steady," "very industrious," and "very creditable" as judged by the exacting standards of Balliol.

As a result of studying these spiritual notes I have had to alter my interpretation of various early poems. So far from reflecting his actual state of mind, some of them are attempts to compensate for his spontaneous feelings. "The Alchemist in the City," for example, which seems steeped in failure and isolation, was written when he was privately castigating himself for proud thoughts: "Conceited talking to Geldart (as often) about Ilbert and Art, and to Coles. Conceited things."[27]

Another misleading sonnet is "Myself unholy, from myself unholy / To the sweet living of my friends I look." Hopkins in his mature verse maintained that what concerned himself, in the "Wreck of the Deutschland" for instance, was literally true,[28] but so far from this sonnet's being surrounded by admissions of envy induced by the immaculate character of his friends, he shows concern

[26]Notebook AI was discovered in 1947 by Father Anthony Bischoff and first published by him in the Jesuit domestic journal *Letters and Notices*, and later by Humphry House in *Journals and Papers*, pp. 133-147.

[27]MacKenzie, *The Early Manuscripts and Note-books . . . in Facsimile*, plates 113-14. Courtenay Ilbert, a brilliant scholar who had won the Ireland, the most prestigious classical scholarship, as well as the Craven, and obtained a First in both Mods and Greats, was librarian of the Oxford Union and about to become its president.

[28]Norman H. MacKenzie, *A Reader's Guide to Gerard Manley Hopkins* (London: Thames and Hudson, 1981), pp. 170-171.

over his own censoriousness, his overt or silent judgments of M'Neill, Coles, Myers, and Gallop.[29] Interesting sidelights abound. Only from the daily notes do we learn that Hopkins shortly after his First in Mods entered for the Ireland Scholarship himself, and although he did not win it was afterwards congratulated on having done very well. Only in these notes do we hear that "Miss Tennyson" had made flattering remarks about him to his family, presumably after having been shown some of his verse.[30]

Mention has been made above of pages torn from the little note-books (I am almost certain by Hopkins himself), of journals which have not been found, and the missing autograph of the "Wreck." What other gaps in his canon remain in this centenary year? His letters mention poems either embarked upon or being plotted but of which no vestige has survived: some may have been burned in the "Slaughter of the Innocents" when other poems were spared which the poet considered might some day contribute to the Faith. Thus we hear of an old style ballad to be called "Fause Joan," of "a thing I may send you [Baillie] called *Grass is my garland*," which is unlikely to have been merely another St. Dorothea version; a *Judas* ("beyond me at present"); a *Matthew Wakefield* which had "not made much progress"; "Linnington Water, an Idyll," of which two-thirds had been written by September 1862; and a play called "Enzio" (imitating Professor Hopkins's Dublin exam questions, readers might well ask "Who or where was Enzio?"). We lack any beginnings he made towards preparing an entry on *Dantis Exsilium* for the Latin Verse Prize of 1865, and any trace of the painful twenty-four Greek iambics offered under duress to Bishop Herbert Vaughan.[31]

Among ambitions which haunted him were a "great ode on [St] Edmund Campion," the Jesuit martyr whose tercentenary was approaching, and a tragedy on Margaret Clitheroe.[32] "Beyond the Cloister" sounds like some form or extension of "A Voice from the World."[33] His "Ode on the Vale of Clwyd," begun there and continued in Oxford, has ended among the missing.[34]

Then there are the musical settings alluded to in letters but not so far located: John Stevens had to base his discussion of Hopkins as a musician and composer on only half of them.[35]

New letters have cropped up from time to time and a number of these will, very usefully, be included in a new *Selected Letters of Hopkins* being edited for Oxford University Press by Catherine Phillips. But many for which Claude

[29]MacKenzie, *The Early Manuscripts and Note-books . . . in Facsimile*, plates 117-18.

[30]Ibid., i, plates 103, 136.

[31]Abbott, *Further Letters*, pp. 8, 13, 14, 41, 209, 213, 214, 238.

[32]Abbott, *The Letters . . . to Robert Bridges*, pp. 92, 135, 147, 150, 227, and *The Correspondence*, pp. 32, 76.

[33]Abbott, *Further Letters*, p. 36; spiritual notes for 22 and 23 December 1865 in C.II; and MacKenzie, *The Early Manuscripts and Note-books . . . in Facsimile*, plate 145.

[34]Abbott, *The Letters . . . to Bridges*, pp. 30, 54, 87.

[35]House, *The Journals*, p. 464.

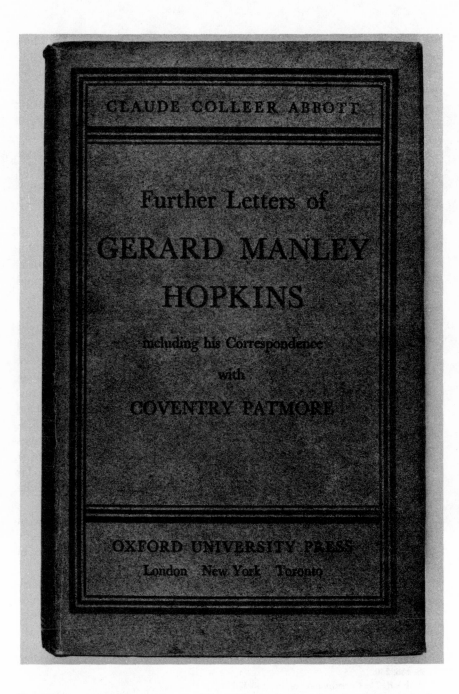

CLAUDE COLLEER ABBOTT

Further Letters of

GERARD MANLEY

HOPKINS

including his Correspondence

with

COVENTRY PATMORE

OXFORD UNIVERSITY PRESS
London New York Toronto

Item 151: Dust jacket of *Further Letters of Gerard Manley Hopkins: Including His Correspondence with Coventry Patmore* (1938).

Abbott searched fruitlessly must either have been destroyed or they lurk unrecognized—letters to Andrew Lang, to Alexander Wood in Tasmania, to the Paravicinis, to "my blackguardly aunts and other kinsfolk" who were in his debt as correspondents, a "colossal letter in four movements" to his sister Grace, the note to Father Henry Coleridge, editor of the *Month*, enclosing the "Wreck of the Deutschland" (we have only a summary of his self-assured pleasantries), to John Lightbound whose political views he had shocked in a railway-carriage.[36] Not a single letter to a parishioner or one of his students seems to have broken surface. And how interesting it would be to have any expositions of his poems which he may well have sent to Father Francis Bacon, who was a staunch admirer of his verse but who must have needed some daylight thrown upon the darker stretches of the "Deutschland."

One very small item is likely to elude the vigilance even of Professor Carl Sutton who has marshalled this impressive legion of Hopkinsiana: *The Bible Birthday Book* edited by Canon R.W. Dixon in 1887.[37] This volume contains under May 25 a version of the first stanza of Hopkins's "Morning, Midday, and Evening Sacrifice," but there is some uncertainty as to the form in which this was printed. The only copy which anyone has ever traced used to be in the British [Museum] Library, but disappeared between 1955, when James Sambrook (as he tells me) used it in preparing his thesis on Canon Dixon, and the mid-sixties when Tom Dunne and I both wished to consult it. One convenient explanation of holdings which have vanished from the British Library is that they were destroyed by bombs during World War II, but this cannot be the truth here. Edmund Sutcliffe's version reads "Eye, all is [*sic*] fellowship" in line 4, and ends "Only for this one day": he classifies the book as 32mo (B.L. has 16mo)—an absolutely minute format, though it was 252 pages thick.[38] There must still be some neglected copies hidden in vicarages or moated granges, but all efforts by a number of scholars to find one have so far been stultified. However, the more people there are aware of this loss, the more chance there is of our capturing one of these rare specimens.

As for drawings and watercolors, the "cows and horses in chalk done in Wales" and the "watery Chinese-white employed on the ox in the Phoenix Park" were last seen in Dublin, but they appear now to have strayed out of sight—unless they are among the Hopkins Family Papers.[39]

Among all the missing items the ones most likely even in their rudimentary stages to deepen our respect for the range of Hopkins's enquiring intelligence are those attempts at articles and books which were to reveal the "great light" on various recondite subjects which had brightened his Dublin gloom. He

[36]Abbott, *The Letters . . . to Bridges*, p. 161, and *Further Letters*, pp. 56, 63, 118, 120, 123, 138, 156, 240.

[37]Abbott, *The Correspondence*, pp. 130-132.

[38]*Bibliography of the Society of Jesus, 1773-1953* (London, 1957), item 208.

[39]Abbott, *Further Letters*, pp. 165, 189.

admitted to Dixon in August 1886 that though he had "a fagged mind and a continual anxiety" and could work "only by snatches . . . I am writing (but I am almost sure I never shall have written) a sort of popular account of Light and the Ether."[40] His "great discovery" about the Dorian Measure is mentioned repeatedly, with implications which rippled out so widely that on 20 January 1887 he boasted to Patmore (despite misgivings) "I believe that I can now set metre and music both of them on a scientific footing which will be final like the law of gravitation."[41] Although gravitation has in our day, after investigation on a cosmic scale, exhibited discrepancies from Newton's simple formula which we cannot yet completely explain, Hopkins's proposed paper for the physical and mathematical science club (which met at the Royal Dublin Society) might have been exciting.

The index to *Further Letters* lists some of the many topics which occupied his tired but powerful intellect, such as Homer's Art, the Argei and Pontifices, an edition of St. Patrick's confession, Greek Lyric Art, and a Commentary on Newman's *The Grammar of Assent*. This sort of scholarly enquiry was expected of him and encouraged, yet he feared that the Jesuit censors would turn his efforts back.[42] We do not yet have nearly enough solid information about Hopkins's excursions into such difficult foreign territory as the psychological aspects of Welsh mutation, and a new theory concerning the "Welsh pitch of final syllables": these and other suggestions are praised by Dr. John Rhys, but Celtic specialists cannot assess them today because the letters in which Hopkins propounded them have not yet been recovered.[43] One of my hopes is that more people may become so familiar with his handwriting through the *Facsimiles* and other volumes that some of the missing manuscripts will be recognized and added to the already substantial body of his works in Campion Hall.

"All my world is scaffolding"—his lament to Bridges—has long since been proved as gloriously false a self-composed epitaph as that requested by John Keats, "Here lies one whose name was writ in water."[44] The evidence of this great centenary exhibition surely demonstrates that the "scaffolding" Hopkins so modestly underestimated has become part of the framework of English literature.

[40]Abbott, *The Correspondence*, p. 139.
[41]Abbott, *Further Letters*, pp. 376 -377.
[42]Abbott, *The Letters . . . to Bridges*, p. 200.
[43]Abbott, *Further Letters*, pp. 414ff.
[44]Abbott, *The Letters . . . to Bridges*, p. 228.

141 Gerard Manley Hopkins. *Poems of Gerard Manley Hopkins*. Edited with notes by Robert Bridges, Poet Laureate. London: Humphrey Milford, 1918.

142 _____. *A Vision of the Mermaids: A Prize Poem Dated Christmas, 1862*. London: Humphrey Milford at the Oxford University Press, 1929.

143 _____. *Poems of Gerard Manley Hopkins*. Edited with notes by Robert Bridges. Second edition with an Appendix of Additional Poems, and a Critical Introduction by Charles Williams. London: Humphrey Milford at the Oxford University Press, 1930.

144 _____. *Poems of Gerard Manley Hopkins*. Third edition. The first edition with preface and notes by Robert Bridges, enlarged and edited with notes and a biographical introduction by W.H. Gardner. London: Oxford University Press, 1948.

145 _____. *Poems and Prose of Gerard Manley Hopkins*. Selected with an introduction and notes by W.H. Gardner. London: Penguin Books, 1953.

146 _____. *Poems of Gerard Manley Hopkins*. Third edition. The first edition with preface and notes by Robert Bridges, enlarged and edited with notes and a biographical introduction by W.H. Gardner. London: Oxford University Press, 1956. Third edition, fifth impression, revised, with additional poems.

147 _____. *The Poems of Gerard Manley Hopkins*. Fourth edition based on the first edition of 1918 and enlarged to incorporate all known poems and fragments; edited with additional notes, a foreword on the revised text, and a new biographical and critical introduction by W.H. Gardner and N.H. MacKenzie. London: Oxford University Press, 1967.

148 _____. *The Letters of Gerard Manley Hopkins to Robert Bridges*. Edited with notes and an introduction by Claude Colleer Abbott. London: Oxford University Press, 1935.

149 _____. *The Correspondence of Gerard Manley Hopkins and Richard Watson Dixon*. Edited with notes and an introduction by Claude Colleer Abbott. London: Oxford University Press, 1935.

150 _____. *The Note-Books and Papers of Gerard Manley Hopkins*. Edited with notes and a preface by Humphry House. London: Oxford University Press, 1937.

151 _____. *Further Letters of Gerard Manley Hopkins: Including His Correspondence with Coventry Patmore*. Edited with notes and an introduction by Claude Colleer Abbott. London: Oxford University Press, 1938.

152 _____. *Further Letters of Gerard Manley Hopkins: Including His Correspondence with Coventry Patmore*. Edited with notes and an introduction by Claude Colleer Abbott. Edition revised and enlarged. London: Oxford University Press, 1956.

153 _____. *The Journals and Papers of Gerard Manley Hopkins*. Edited by Humphry House and completed by Graham Storey. London: Oxford University Press, 1959.

154 _____. *The Sermons and Devotional Writings of Gerard Manley Hopkins*. Edited by Christopher Devlin. London: Oxford University Press, 1959.

155 _____. *Gerard Manley Hopkins*. The Oxford Authors Series. Edited by Catherine Phillips. Oxford: Oxford University Press, 1986.

156 Lesley Higgins. *Hidden Harmonies: Walter Pater and Gerard Manley Hopkins, Part II*. An unpublished Ph.D. thesis for Queen's University, Kingston, Ontario, Canada, 1987.

157 A copy of the "full transcription" of Hopkins's "spiritual notes" from the archives of the British Province of the Society of Jesus.

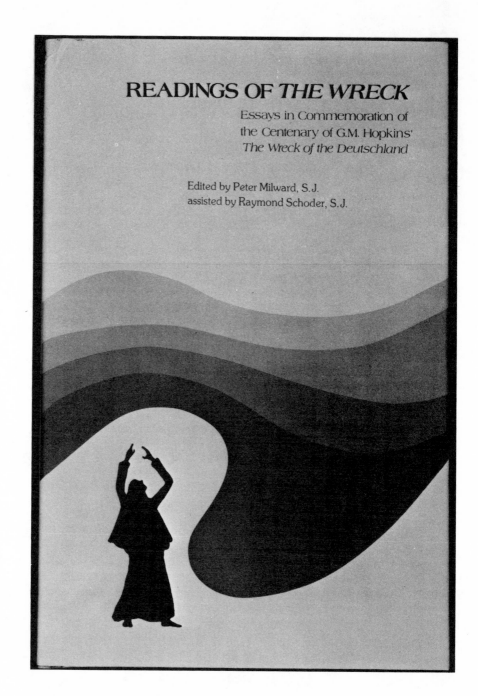

Item 215: Dust jacket of *Readings of "The Wreck": Essays in Commemoration of the Centenary of G.M. Hopkins' "The Wreck of the Deutschland"* (1976).

Significant Books on Gerard Manley Hopkins, 1944-1988

By Richard F. Giles

During the twentieth-century equivalent of Gerard Manley Hopkins's life-span (1844-1889), from near the end of the Second World War to the present-day mixture of imminent peace and war, approximately 78 significant books devoted wholly or in large part to studies of the life, works, and milieu of the poet have appeared. In one sense, however, all books on Hopkins are significant, and if all books were counted (including, for example, books in Japanese, books in English published in Poland, or books of translations of some or all of the works into foreign languages), the total would no doubt exceed 150. Such a large number and such a diversity of languages and cultures show not only a sustained interest in the life and work of the poet, but also an equally sustained interest in sharing insights and information with other readers: those who follow the changing critical response to Hopkins, those who wish further insight on a particular aspect of his life or work, or those who simply wish to know more about the man whose death we mark in this centenary year.

Of course, "significant" is a term laden with subjective values, for if any five Hopkinseans were polled on the ten most significant books in the history of Hopkins criticism, there would likely be much divergence of choice. Epithets like "ground-breaking," "comprehensive," "judicious," "balanced," or "penetrating" could be equally—and fervently—applied to at least three-quarters of the books to be mentioned in this survey. And, of course, each of these epithets is itself value-laden and, ultimately, subjective, for one reader's idea of a "penetrating" study of Hopkins might consist of no more than a re-hashing of the more orthodox critical comments made on the poet over the last half-century, while another reader might not use that term unless the book in question attempted to psychoanalyze the poet based on the extant writings. Hopkins himself would, I think, have been astounded at the variety of words used to describe him in the books and the even greater variety used to describe those books themselves! Critical dapple seems infinite.

Faced with the daunting task of surveying and commenting upon these many books on Hopkins, I chose to avoid a strictly chronological or geograph-

ical approach in favor of categories into which most—but certainly not all—of the works will fit. Inevitably, these categories are loose enough to allow for the inclusion of books that do not strictly fit, and tight enough that what may be a good example in one category can yet be moved into another where it more properly belongs. As with all such categories, these are arbitrary and more for the convenience of the author who had to try to make some coherence out of what is, in perspective, a somewhat random scattering of critical studies of Hopkins.

The eleven categories I have chosen are as follows: (1) BIOGRAPHIES—six books that deal totally or in large part with the life of Hopkins; (2) CRITICAL STUDIES—twenty books that deal with certain aspects of Hopkins or his works but do not attempt to cover his whole lifespan or his oeuvre; (3) COMMEN-TARIES AND HANDBOOKS—a section further subdivided into six comprehensive (long) commentaries and handbooks, and six short, usually introductory, commentaries; (4) GENERAL INTRODUCTORY ESSAYS—two books and a mono-graph that contain long essays of a general nature designed to introduce new readers to the poet and his works; (5) SPECIFIC TOPICS—four books that deal primarily with Hopkins's poetic language and five that deal with his prosody (needless to say, any of these books could adequately be listed under the Critical Studies heading); (6) SINGLE POEMS—seven books that deal exclu-sively with one poem, all but two of which are on *The Wreck of the Deutschland*; (7) COLLECTIONS OF VARIOUS ESSAYS—eight collections of essays by different authors; (8) FOREIGN BOOKS—six books published in countries other than England or America that are of special interest; (9) BIBLIOG-RAPHIES—three standard bibliographies of Hopkins; (10) CONCORDANCES—the two concordances to Hopkins; and (11) ICONOCLASTIC WORKS—five books whose aim, I perceive, is to alter sharply the conventional thinking about the poet, four of which appear in previous categories as representative of more specific kinds of studies.

The great temptation in a survey such as this is to indulge in extended commentary on many of the books that have, for a myriad of reasons, struck me positively or negatively. However, I shall attempt in my comments to be, above all, brief and fair. I shall leave to the pages of academic journals the critical struggles that seem to be intensifying regarding Hopkins and his place as assigned by twentieth-century criticism.

BIOGRAPHIES

Books devoted to a study of the life of Hopkins are, strangely, too few and too scant. Perhaps the problem lies in the life Hopkins led, a life that can all too easily be summed up in a few pages of outline; perhaps the problem is the lack of genuine drama in his life (he had, after all, few narrow escapes and took

few risks); or perhaps the problem is that Hopkins's life was, to a very large extent, the life of the mind, a brilliant mind, in his case, but also a troubled, sometimes cloudy mind. When we deal with such a mind, we seem to want either to purify it for future readers or to render it as a "wreck," to use the poet's term. Compounding and complicating this impulse is the problem of Hopkins's vocation: he was, after all, a priest, whose job it was to help solve others' problems, to point the way for troubled minds and souls, and to guide those seeking help.

Such a reconciliation is but one of the problems facing any biographer of Hopkins. The other problems are too numerous to exhaust, but they include access to papers by the poet, permission to publish such papers, reliability of secondary sources, lack of suitable material, and, of course, Hopkins's own extreme reticence about many aspects of his life. However, even when Hopkins is not so reticent, there is a problem of interpretation. Consider the following examples.

The first full-length biography of Hopkins was Father G.F. Lahey's *Gerard Manley Hopkins;*[1] the second, Eleanor Ruggles's *Gerard Manley Hopkins: A Life* (1944).[2] While Father Lahey attempted, through inclusion of much unpublished material and through an apparently biased perspective, to portray Hopkins always in the most favorable light, Ruggles seems to have undertaken an enhancement if not of the life of Hopkins, then certainly of the telling of the life of the poet. This is apparent on comparing the first two biographers in their treatment of a crucial moment in Hopkins's life: his departure for and arrival in Dublin in 1884. Here is Lahey's account:

> Into this assemblage [at University College] of choice spirits came Hopkins as a worthy complement. The conditions were trying on account of the national indifference of the Royal University, but his work itself was interesting and consoling, and his friends congenial and satisfying; then too, the monotony of routine was easily broken by the utmost freedom he had received from his superiors.[3]

Here is part of Ruggles's account:

> Instead, [Hopkins] felt within himself a prophetic sense of unfitness for this latest charge which led him at first to try to decline it. This attitude was the reverse of Newman's own when he, too, had been called to Dublin. As he stood at the rail of the steamer that plied its

[1]G.F. Lahey, S.J., *Gerard Manley Hopkins* (London: Humphrey Milford, Oxford University Press, 1930).

[2]Eleanor Ruggles, *Gerard Manley Hopkins: A Life* (New York: Norton, 1944; London: John Lane, The Bodley Head, 1947).

[3]Lahey, pp. 139-140.

course across the Irish Channel, Newman's spirits had soared at thought of the challenge to skill and strength that lay ahead of him. But to Hopkins the fast, too fast approaching coast of Ireland must have implied a warning rather than a welcome. He shrank from the fatality embodied there. 'I am not at all strong,' he insisted, 'not strong enough for the requirements. . . .'[4]

It seems clear that both versions of the same event in Hopkins's life suffer from a malady that is all too common in early biography of any writer: the failure to apply strict critical standards to pronouncements not based on fact. Father Lahey either chose to ignore Hopkins's own words and the several testimonies of those who knew him, or chose to whitewash the bleak picture Hopkins painted of himself at this juncture in his life. To say that Hopkins's work was interesting and consoling strikes me as an exaggeration to the point of fabrication. To my knowledge Hopkins never used such words in his notes or his letters, certainly not in his poems. How, then, did Father Lahey know what Hopkins felt about his work?

Likewise, how could Ruggles know that Hopkins's first emotions regarding his new posting in Dublin were *prophetic*? Where is the record that shows Hopkins knew he would encounter "fatality" in Dublin? Perhaps Hopkins did feel all that Ruggles says he did, with this citation being just one example of the rather carefree use of mindreading she sprinkles her book with, but I fear that a reader in 1989, one who has followed the career of Holmes, among other rationalists, will demand of a biographer a more precise accounting of sources and a more exact use of those sources. Ruggles's book, no doubt, corrected the hagiography that Father Lahey passed off as biography and rounded out the picture of Hopkins for that first generation of real lovers of the poet, but her sense of the (melo)dramatic mars the biography's integrity.

Bernard Bergonzi attempted to correct the wayward tendencies of these first two biographers of Hopkins in his *Gerard Manley Hopkins* (1977).[5] This is a very readable and interesting biography of Hopkins, but, as the author admits in his preface, anyone familiar with the published works "will find little that is new in what [he has] written."[6] Bergonzi refers to the notorious "general reader" as a major *raison d'être* for his book's existence. Nonetheless, the book contains useful accounts of those forces that seemed always ready to rend Hopkins's psyche and the appearance of those forces in the life and works of the poet—although sometimes the discussion is so descriptive as to be of little use (e.g., see the treatment of the question of Hopkins's sexuality and his comments on Whitman on pages 112-113).

[4]Ruggles, p. 190.
[5]Bernard Bergonzi, *Gerard Manley Hopkins* (New York: Macmillan, 1977).
[6]Ibid., p. xii.

GERARD MANLEY
HOPKINS

28 July 1844 – 8 June 1889

By G. F. LAHEY, *S.J.*

OXFORD UNIVERSITY PRESS
LONDON : HUMPHREY MILFORD
1930

Item 158: Title page of Father G.F. Lahey's 1930 biography, *Gerard Manley Hopkins*.

During the thirty years that lapsed between the appearance of the English edition of Ruggles's book and Bergonzi's, biographical works devoted to Hopkins consisted of only two, one in English on Hopkins's friendship with Bridges, *Robert Bridges and Gerard Hopkins, 1863-1889, A Literary Friendship* (1960), and one in French (still, sadly, not translated into English), *Le poète Gérard Manley Hopkins, s.j. 1884-1889, Sa vie et son Oeuvre* (1963), both by Jean-Georges Ritz.[7] The first volume remains the most detailed, the most comprehensive, and the most balanced account of the sometimes stormy, sometimes inscrutable friendship that existed between Hopkins and Bridges. Ritz is not afraid to speculate, when such speculation is appropriate, but he always grounds his speculation and allows his readers to agree or disagree knowingly. This biographical study may someday be supplemented, but I do not think it will ever be supplanted, so strong and so fair are its contents.

Ritz's 1963 account of Hopkins's life remains the most thoroughly documented of biographies.[8] In spite of some errors in fact and citation, this is the volume to which the reader, more aware than a "general reader" to whom Bergonzi addressed his study, should first turn for information about the life and for interpretation of that information. Again, Ritz shows himself to be simultaneously critical of and sympathetic to Hopkins the man, and does not attempt to make the poet into either a saint or a "scoundrel." Ritz writes with the weight of generally sound scholarship behind his words, coupled with profound consideration of the poet and his words. That this valuable study should remain inaccessible in English is a great pity. Perhaps in this centenary year, someone will undertake a critical updating and translation of this worthy volume.

The single most detailed volume of biography is Father Alfred Thomas's *Hopkins the Jesuit: The Years of Training* (1969).[9] Father Thomas was a Jesuit, and he relied on his own experiences, on those of other Jesuits, and on access to the richness of the various Jesuit archives to produce this valuable contribution to our understanding of the effects on Hopkins of his years in training as a Jesuit, specifically from his entering the Jesuits in 1868 until the completion of his tertianship in 1882. Thomas provides an astounding array of details about the daily life of a Jesuit, the routines and the free times, the duties and the pleasures, always with an eye to applying such information to an understanding of Hopkins the man. This too is a book not likely to be supplanted because of the sheer abundance and usefulness of the information it provides about this crucial period of Hopkins's life.

[7]Jean-Georges Ritz, *Robert Bridges and Gerard Hopkins, 1863-1889, A Literary Friendship* (London: Oxford University Press, 1960); *Le poète Gérard Manley Hopkins, s.j. 1844-1889, Sa vie et son Oeuvre* (Paris: Librairie Didier, 1963).

[8]The account of the poet's life occupies 274 pages of Ritz's 726-page study.

[9]Alfred Thomas, S.J., *Hopkins the Jesuit: The Years of Training* (London: Oxford University Press, 1969).

The most recent biography of Hopkins is Paddy Kitchen's *Gerard Manley Hopkins* (1978).[10] Kitchen attempts a great deal of probing in the single volume of her study, and in the process she achieves what her readers—whether they concur with her method or conclusions—would surely agree is a lively account that succeeds in imbuing Hopkins with a fullness of character the other biographies only come close to. A method such as Kitchen's—in the words of her Preface "a personal rather than an academic study"[11]—is bound to raise the ire of both the Society of Jesus, whose copyright of Hopkins's work she had to circumvent, and of those lovers of Hopkins who do not wish to be reminded of some of the less savory aspects of his character. However, Kitchen does, in my opinion, an admirable job of grappling with understanding her favorite poet, and such an achievement I take to be adequate reason for this book to exist.

CRITICAL STUDIES

It may seem appropriate that under this heading should occur all but biographies, concordances, and bibliographies, since, by definition, any book that studies Hopkins no doubt uses and studies the poetry and prose in a critical fashion. Indeed, it would be impossible to approach any understanding of the man without relying on his own artistic and personal writings. However, some of the studies included here do focus primarily on the words within the works rather than on the psyche that chose and uttered them. Therefore, I have further subdivided this section to include Religious Experience/Theology, Studies of the Poetry, and Studies of Hopkins as Victorian.

Religious Experience/Theology

James Finn Cotter's *Inscape: The Christology and Poetry of Gerard Manley Hopkins* (1972) stands at the head of this rather short line of books devoted to studies of the religious feeling, experience, and belief of Hopkins as such sentiment manifested itself in his written works, not just his poetry but also his prose.[12] Cotter's book has not only the distinction of being the first such book-length study devoted to Hopkins's Christology, it also remains one of the most densely packed books on the poet. Mixing close textual exegesis of both poetry and prose with sweeping theoretical background from the primary sources of Christian theology, Cotter creates the kind of book that, after the first reading,

[10]Paddy Kitchen, *Gerard Manley Hopkins* (London: Hamish Hamilton, 1978).
[11]Ibid., p. xi.
[12]James F. Cotter, *Inscape: The Christology and Poetry of Gerard Manley Hopkins* (Pittsburgh: University of Pittsburgh Press, 1972).

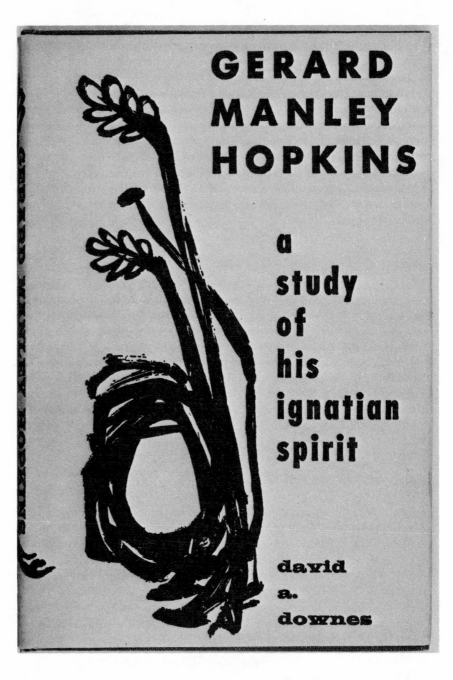

Item 167: Dust jacket of David A. Downes's *Gerard Manley Hopkins: A Study of his Ignatian Spirit* (1959).

proves its worth through numerous marginal markings, numerous cross-references, and numerous returns to the text for the author's comments on certain poems or even certain lines. A reader may not always agree with Cotter's interpretations—or immediately see the connection he attempts to establish between Christian tradition and Hopkins's verbal creations—but he or she will always be provided with a plethora of references and the opportunity to examine the primary sources firsthand.

Donald Walhout, a professor of philosophy, offers a highly philosophical—even, I would venture, a highly personal—study of Hopkins's religious experience in his *Send My Roots Rain: A Study of Religious Experience in the Poetry of Gerard Manley Hopkins* (1981).[13] Establishing as his approach the three-fold division of Encagement, Naturation, and Grace, Walhout turns to examine Hopkins's life and his poetry in light of this archetypal religious experience. On the whole, Walhout's book does not elucidate Hopkins's poetry as much as it quotes it extensively to substantiate the critic's thesis. The result is, if not always convincing, always interesting. The challenge in dealing with something as elusive as religious experience may be met as Walhout has done by categorization, and the richness of this approach holds value in itself as well as being a harbinger of other approaches that could be fruitfully applied in future works.

Three of the books in this section were written by David A. Downes: *Gerard Manley Hopkins: A Study of his Ignatian Spirit* (1959), *The Great Sacrifice: Studies in Hopkins* (1983), and *Hopkins' Sanctifying Imagination* (1985).[14] The first of these studies remains the most useful account of the influence of Ignatian spirituality on Hopkins and his work. Downes demonstrates what Hopkins would have learned as a Jesuit in his years of training, and then applies the Ignatian pattern of meditation and composition to many of Hopkins's works. While there is little doubt that Hopkins was influenced by Ignatius and the order he founded, some readers may doubt whether that pattern of perception and composition is *the* governing factor in many of Hopkins's remarkable creations. As with many single-thesis books, this one suffers at times from an attempt, in citing material in support of its thesis, to bend that material in unusual ways. The second book by Downes (1983) is a compilation of essays from various sources, lacking an overall theme but all roughly dealing with the question of what kind of person Hopkins was and whether or not he was a true Romantic (the longest essay in the volume, "Beatific Landscapes in Hopkins," deals especially with the latter question,

[13]Donald Walhout, *Send My Roots Rain: A Study of Religious Experience in the Poetry of Gerard Manley Hopkins* (Athens, OH: Ohio University Press, 1981).

[14]David A. Downes, *Gerard Manley Hopkins: A Study of his Ignatian Spirit* (New York: Bookman Associates, 1959); *The Great Sacrifice: Studies in Hopkins* (Lanham, MD: University Press of America, 1983); *Hopkins' Sanctifying Imagination* (Lanham, MD: University Press of America, 1985).

and examines Hopkins's religious experience from a Romantic perspective). The third book (1985) is another single-thesis work, but in this volume Downes expanded the Ignatian base to include the impact of Scotus, who was clearly of greater importance to Hopkins than was the founder of his order, and then proceeds to subsume both of these influences under the now-more-important rubric of "Romantic," for much of this work is devoted to proving that Hopkins was a true Romantic in the tradition and fashion of Blake, Wordsworth, and Coleridge.

One other book must be mentioned in this section: J. Hillis Miller's *The Disappearance of God: Five Nineteenth-Century Writers* (1963), one of the most-often-quoted studies of Hopkins.[15] As the title indicates, this volume examines the ways in which five nineteenth-century writers dealt with (or failed to deal with) the impact of the feeling that God had withdrawn from the workings of the world. Miller's essay on Hopkins, 89 pages long, is a masterful study of the means by which the poet attempted to counter this growing feeling in his milieu as well as, most significantly, in himself. Miller closely examines Hopkins's writings and convincingly argues that in both his poetry and prose Hopkins manifested this spiritual crisis of his age as it affected his own life and thought.

Finally, my last choice for this section is problematic, for it is not strictly a book on Hopkins's theology or his religious experience; in fact, it is a book on many different aspects of the man and the works. However, Alan Heuser's *The Shaping Vision of Gerard Manley Hopkins* (1958) is so filled with a sense of the connection between, say, sprung rhythm and theology that I felt its inclusion here appropriate.[16] This is a brief book (Heuser calls it an essay in his preface) of only 128 pages, with four chronological sections (from 1860-1889), further divided into fifteen separate chapters. On the surface, then, the book is a biography of Hopkins, at least a chronological survey of his development as a thinker and theoretician. However, each chapter stands on its own and provides a detailed but not excessively long discussion of a term or a theory that Hopkins employed at a given time, together with such considerations as the possible origin of that term, its meaning, its use in the works, and its effect on Hopkins personally. The result is a book that offers a wide perspective in a narrow volume, with each gem-like chapter contributing additionally to the work as a whole.

[15]J. Hillis Miller, *The Disappearance of God: Five Nineteenth-Century Writers* (Cambridge: The Belknap Press of Harvard University, 1963).

[16]Alan Heuser, *The Shaping Vision of Gerard Manley Hopkins* (London: Oxford University Press, 1958; Fort Hamden, Connecticut: Archon Books, 1968).

THE DISAPPEARANCE OF GOD

FIVE NINETEENTH-CENTURY WRITERS

ঙ ঙ ঙ ঙ

J. HILLIS MILLER

THE BELKNAP PRESS OF
HARVARD UNIVERSITY PRESS

Cambridge, Massachusetts, and London, England

Item 170: Title page of J. Hillis Miller's *The Disappearance of God: Five Nineteenth-Century Writers* (1963).

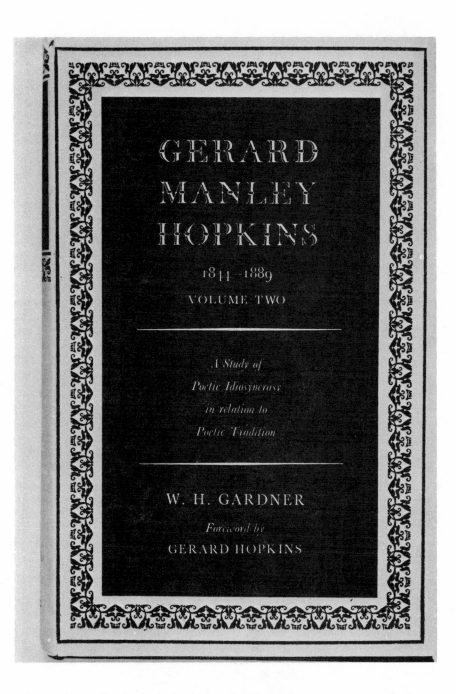

Item 172: Dust jacket of W.H. Gardner's *Gerard Manley Hopkins, 1844-1889, A Study of Poetic Idiosyncrasy in relation to Poetic Tradition*, Volume Two (1944, 1949).

There are two "elders" in the family of book-length studies of Hopkins's poetry that must begin this section of our discussion, without, however, implying that the remaining members of the family are in any way directly descended from these two books. Their prominence derives rather from the time of publication, the approach, and the general quality of the work.

The first of these is the massive, two-volume work, *Gerard Manley Hopkins, 1844-1889, A Study of Poetic Idiosyncrasy in relation to Poetic Tradition*, by W. H. Gardner, the editor of the third and coeditor of the fourth editions of Hopkins's *Poems* (1948, 1968).[17] The defensive tone indicated by the title of this *magnum opus* can be understood in retrospect by looking at the time in which the work was published and the general attitude toward obscure poems and toward modernism as a poetic movement. Gardner, interestingly, did not set out to make of Hopkins a "modern" poet; rather, as his title implies, he set out to examine Hopkins's works in relation to the time in which they were composed and the traditions upon which Hopkins drew during his education and training. Gardner does an admirable job of viewing Hopkins in these various contexts, and reading his study is in itself an education in Victorian poetics. Much of Gardner's commentary on various topics (e.g., sprung rhythm, and diction and syntax) remains vital to anyone interested in what Hopkins was attempting to do in his work and in why he might have been making such an attempt. Gardner's two volumes do suffer, however, from an unevenness that is to be expected in view of the span of years between publication of the two volumes and of their somewhat scattered organization. Nevertheless, this study deserves the label of indispensability it has earned during its forty years of existence.

The other *pater familias* (if a family may have two!) is Father W.A.M. Peters's *Gerard Manley Hopkins: A Critical Essay towards the Understanding of his Poetry* (1948), another book written largely to defend Hopkins against attacks of obscurity.[18] Father Peters's study is essentially an examination of the meaning of "inscape" and "instress" and the manifestation of these terms in the theory and practice of Hopkins's poetry. While the book is, indeed, a "critical essay," with a unity of focus and development, it is also a collection of individual essays, each self-contained, and each worthy of several readings. A great deal has been written since Father Peters undertook to explain Hopkins's style to a not-always-sympathetic audience, and some of the

[17]W. H. Gardner, *Gerard Manley Hopkins, 1844-1889, A Study of Poetic Idiosyncrasy in relation to Poetic Tradition*, with a Foreword by Gerard Hopkins (London: Martin Secker & Warburg, vol. I: 1944; vol. II: 1949).

[18]W.A.M. Peters, S.J., *Gerard Manley Hopkins: A Critical Essay towards the Understanding of his Poetry* (London: Geoffrey Cumberlege, Oxford University Press, 1948).

points in this book have been overturned or supplemented, but the greatest part remains eminently readable and useful today.

Having begun this section with two elders, I now turn to the more contemporary studies (if one surveys the chronology of publication, one will note that a decade lapsed between Father Peters's book and Alan Heuser's study discussed above; thereafter, the rate of publication increased dramatically).

Although three of the studies in this section do not attempt to deal with either one thesis or with all of Hopkins's poetry (in which case, obviously, they would be handbooks), they do share a trait that I find less than admirable: the sum of chapters does not equal a book—it equals a book-length collection of essays. For instance, Marylou Motto's *"Mined with a Motion": The Poetry of Gerard Manley Hopkins* (1984) examines the poetry for "motions of voice, mind, and language," for example, gestures of assent, bidding, and recurrence.[19] By the end of this book the reader is convinced of the existence of such "motions" in the poetry but is left with a larger question of just what those motions *in themselves* mean. The thematically episodic approach of this study is not finally integrated into a pleasing whole.

Jerome Bump's *Gerard Manley Hopkins* (1982) is another case of a fragmented approach, although the contents of the individual chapters compensate in part for the perceptible defect.[20] The essays in this book stress, variously, Hopkins's medievalism, his ecological sensitivity, his Pre-Raphaelite leanings, and his early influences, all of which are interconnected (the Pre-Raphaelites were also "medieval" and showed sensitivity to their environment, etc.). Not all of the interconnections, however, are elaborated by Bump, and this results in several superb essays that give greater understanding of specific aspects of Hopkins and his work but not in a book that leaves the reader with an impression of having gained insight into the total poet/priest.

The final book in this trio is Elisabeth Schneider's *The Dragon in the Gate: Studies in the Poetry of G.M. Hopkins* (1968).[21] The various chapters in this book deal with individual poems as well as with such topics as sprung rhythm and poetic styles. Each chapter, therefore, may be read separately by one interested in that particular subject—and each chapter bristles with Schneider's unique blend of quiet dogmatism and critical liberalism. While these chapters will be found to be of much use, the book as a whole will also strike one as a unified study of Hopkins's poetic theory and practice, and Schneider sometimes goes to great pains to demonstrate her theories with practical

[19]Marylou Motto, *"Mined with a Motion": The Poetry of Gerard Manley Hopkins* (New Brunswick, NJ: Rutgers University Press, 1984).

[20]Jerome Bump, *Gerard Manley Hopkins* (Boston: Twayne Publishers, 1982).

[21]Elisabeth Schneider, *The Dragon in the Gate: Studies in the Poetry of G.M. Hopkins*, Perspectives in Criticism (Berkeley and Los Angeles: University of California Press, 1968).

applications and examples. As a critic, Schneider displays a sensitive ear to the sounds of Hopkins in his verse, and a sensitive eye to the many layers of meaning embedded within single words. Her sensitivity does not, however, extend always to opposing critical schools, and readers today should beware of her occasionally dismissive manner. Yet even when in sharp disagreement with one of her readings of a poem, her reader is aware at all times of the critical acumen that is present throughout this superb collection.

In a class unto itself is another collection of various essays bound together as a book-length study: Bernard E. Dold's *Wrecks, Racks, Rohrschach: The Poetry of G.M. Hopkins* (published in English in Italy in 1974).[22] After what is surely one of the more interesting titles in the Hopkins critical canon, the book begins with this bald statement: "Of Hopkins's life, little need be said" (p. 11). This study then tackles (metaphorically and literally) *The Wreck of the Deutschland*, "not so much a wreck for Hopkins as the joyous refloating of an abandoned ship, that is of his own poetry" (p. 15), as well as myths, various words, and, finally, polemics: "Hopkins was as pig-headed and self-opinionated as the best of them [Oxford Movement]" (p. 73). One who manages to read the whole of this unpalatable monograph may finally wish to apply these last two epithets to its author. This book serves one (and only one, to the best of my knowledge) purpose: it provides a lovely example of the difference between an individual creator of genius, as was Hopkins, and an individual creator.

The remaining books to be discussed in this section form something of a miscellany, each having distinctions that warrant individual discussion, although some pairing is possible. First to the individual volumes.

Todd K. Bender's *Gerard Manley Hopkins: The Classical Background and Critical Reception of his Work* (1966) is still valuable for its insight into the Pindaric qualities in Hopkins's poetry, especially in *The Wreck of the Deutschland*, and for its discussion of other methods that may have been suggested to Hopkins by the classics or the Metaphysicals.[23] The discussion of the critical reception of Hopkins's work supplements earlier essays on this subject by Elgin Mellown, and provides further insights. However, as has been noted, the coupling of these two somewhat disconnected topics into a book-length study results in a split focus that is not satisfactorily rejoined by the transitions between the chapters.

Two volumes that, as I see them, are loosely connected in their focus on the "literary" life of Hopkins are David Anthony Downes's *Victorian Portraits:*

[22]Bernard E. Dold, *Wrecks, Racks, Rohrschach: The Poetry of G.M. Hopkins* (Messina, Italy: Peloritana Editrice, 1974).

[23]Todd K. Bender, *Gerard Manley Hopkins: The Classical Background and Critical Reception of his Work* (Baltimore, MD: The Johns Hopkins University Press, 1966).

Hopkins and Pater (1965)[24] and Michael Sprinker's *"A Counterpoint of Dissonance": The Aesthetics and Poetry of Gerard Manley Hopkins* (1980).[25] Neither of these books is a biography of the poet, and neither is a strict study of the poetry and prose. Both deal instead with that inner life of a writer that we all seem to feel exists apart from the literal words the writer creates and the biological existence he or she endures. Downes compares Hopkins with Pater, his tutor, as individuals with distinct inner lives, and focuses primarily on their aesthetic theory and critical writings as manifestations of their literary lives. The reader of this book gains a greater understanding of the ideas and ideals behind much of the ex- and interchange between these two figures, the way in which their attitude toward the letter and the word in part defined their very existence.

Michael Sprinker carries this notion to an even greater length in a book that, I must confess, on first reading proved to be perplexing, confusing, even angering. Sprinker offers a kind of literary life of Hopkins that paints a portrait of a failed artist—barren, bereft, and frustrated—who was able to offer the God he loved so dearly only the tokens of his failure: his own poems, still-birthed and doomed to the fate of "misreading" that awaits all things that must go through the medium of language. When I first read Sprinker's book I was angered on behalf of the Hopkins I had created in my mind after years of study and reading and thinking about the man, the poet, the priest. However, Sprinker's contentions could not always be dismissed, and the more I referred to the book, the more closely I looked at what its author was saying, and the more closely I looked at Hopkins, the more I became aware of my growing discomfort: I had to admit that in most ways Sprinker was right. When a book of criticism can so arrest the mind as to force a re-reading of its subject *and* dramatically shift some long-held assumptions, it must qualify as successful. For all else that I may feel about this book, I hold it to be just such a success.

Another recent study that paints Hopkins as a failure is John Robinson's *In Extremity: A Study of Gerard Manley Hopkins* (1978).[26] Below the surface of this book there runs—and all too often erupts—a sniggering condescension toward Hopkins, as a man who could not really be a man, a priest who was not really a good priest, and—the unkindest cut of all?—a poet who was not even a good poet; in fact, Robinson goes so far as to say: "The speaking voice can afford to pay less regard to grammar, for it resolves difficulties by way of intonation; the tape-recorder would have given Hopkins a useful aid. However, it is doubtful if it would necessarily have improved his poetry" (p.

[24]David Anthony Downes, *Victorian Portraits: Hopkins and Pater* (New York: Bookman Associates, Inc., 1965).

[25]Michael Sprinker, *"A Counterpoint of Dissonance": The Aesthetics and Poetry of Gerard Manley Hopkins* (Baltimore, MD: The Johns Hopkins University Press, 1980).

[26]John Robinson, *In Extremity: A Study of Gerard Manley Hopkins* (Cambridge: Cambridge University Press, 1978).

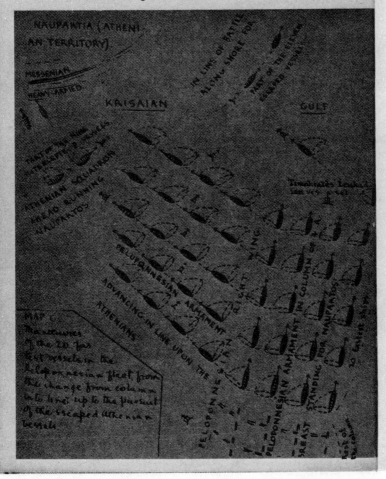

Item 178: Dust jacket of Todd Bender's *Gerard Manley Hopkins: The Classical Background and Critical Reception of his Work* (1966).

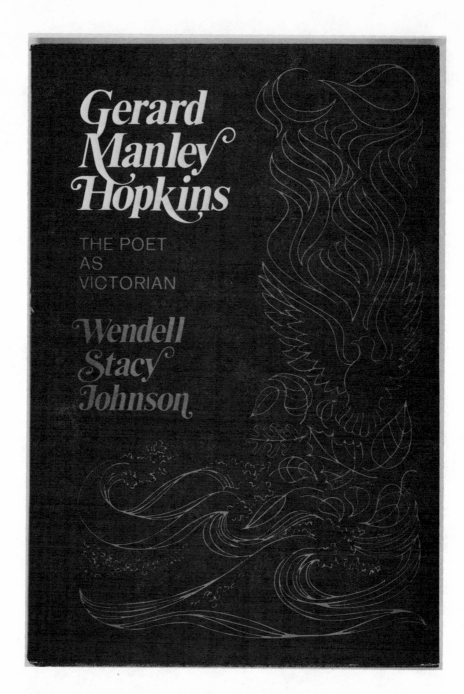

Item 183: Dust jacket of Wendell S. Johnson's *Gerard Manley Hopkins: The Poet as Victorian* (1968).

69). Unlike Robinson, I do not assume that Hopkins's poetry needs improving—by a technology, by another poet, or by a critic. And I recoil from a book that appears to me to be based on such a subjective assumption.

An interesting study devoted entirely to the "Terrible Sonnets" is Daniel A. Harris's *Inspirations Unbidden: The "Terrible Sonnets" of Gerard Manley Hopkins* (1982).[27] Combining close textual reading with a close—but not always reliable—scrutiny of the manuscripts of these sonnets, Harris offers a cogent reading of the works as an integrated group, indeed, as a single thematic unit, with common forms, structures, even inspirations. The book continues, in a way, the recent depiction of Hopkins as a failure: in this case, it is a failed priest who acutely feels the absence of God and can find no comfort in the Christian tradition he ironically is employed to serve. Some readers may balk at some of Harris's contentions, or at the way he arrives at them, but his ideas are forcefully expressed and worthy of any reader's consideration.

Studies of Hopkins as Victorian

I have saved for the last section two books that are closely linked in time and in theme: Wendell Stacy Johnson's *Gerard Manley Hopkins: The Poet as Victorian* (1968)[28] and Alison G. Sulloway's *Gerard Manley Hopkins and the Victorian Temper* (1972).[29] Both of these books, as their titles imply, were written in part to correct the overstated attempt by earlier critics to make of Hopkins a modern—a man who could have fit comfortably into the first several decades of this century. Johnson, primarily through readings of individual poems, shows just how Victorian the tenets and practices of Hopkins really were. Johnson's success warrants the attention of anyone who still harbors the notion that Hopkins was a true child of our—rather than his—century.

Sulloway goes about demonstrating Hopkins's Victorianism in a different fashion. Her approach is more through the milieu into which Hopkins was born and from which—no matter how much he tried—he could not completely escape, although at the same time she does provide interesting and close readings of many poems. Sulloway offers one of the best accounts of Hopkins and Ruskin, and her discussion of how the school days of Hopkins must surely have affected him throughout his life is only one of many such topics treated in this profound study.

Both Johnson and Sulloway realized the futility of interpreting a paradox as necessarily out of step with the times. Hopkins was just such a paradox: a

[27]Daniel A. Harris, *Inspirations Unbidden: The "Terrible Sonnets" of Gerard Manley Hopkins* (Berkeley: University of California Press, 1982).

[28]Wendell Stacy Johnson, *Gerard Manley Hopkins: The Poet as Victorian* (Ithaca, NY: Cornell University Press, 1968).

[29]Alison G. Sulloway, *Gerard Manley Hopkins and the Victorian Temper* (London: Routledge & Kegan Paul, 1972).

conservative who espoused communist ideals, an empirist who recognized the necessity of Home Rule for Ireland, a classicist who "read and did otherwise," and a priest who seems to have suffered from a prolonged crisis of faith. But such contradictions are humanly common—they were then, they are now—and much of the effort expended in the critical studies surveyed above have gone a long way in recovering those contradictions and paradoxes in Hopkins.

COMMENTARIES AND HANDBOOKS

Hopkins and his readers have been well served by the several excellent commentaries on his poetry, one of which is, technically, not a published book but is available as a paperbound from University Microfilms and two of which are handsome "visual" commentaries that incorporate contemporary and contemporaneous illustrations to complement the written explanation.

Margaret Cleveland Patterson's two-volume dissertation, "The Hopkin's Handbook" (1970), is included in this section because of its comprehensiveness, its sensitivity, and its continuing usefulness to someone interested in a particular poem or subject.[30] The first volume offers an extensive chronology of Hopkins's life and then, in chronological order, commentary on all the poems, with useful references to "standard" critical essays and notes. The second volume is an alphabetical listing of a variety of topics, ranging from individual friends and acquaintances of the poet to specific kinds of imagery. Patterson's work, although now almost twenty years old, still commands the attention of serious students of Hopkins, and still yields great rewards for that attention.

Paul L. Mariani's *A Commentary on the Complete Poems of Gerard Manley Hopkins* (1970) combines the elements of a commentary with those of a book-length essay on the poet into a work that "reads" like an essay and avoids the excessive and sometimes off-putting compartmentalization of the other comprehensive commentaries.[31] Mariani adopts a chronological approach, and treats the poems separately within temporal groupings. Documentation is full but not excessive. The commentary is sound, and the critical insights interesting and occasionally provocative.

Two commentaries adopt a poem-by-poem approach: Donald McChesney's *A Hopkins Commentary* (1968),[32] which deals with the "main" poems from 1876-1889, and Norman H. MacKenzie's *A Reader's Guide to Gerard Manley*

[30]Margaret Cleveland Patterson, "The Hopkin's [*sic*] Handbook" (University Microfilms, 1970).

[31]Paul L. Mariani, *A Commentary on the Complete Poems of Gerard Manley Hopkins* (Ithaca, NY: Cornell University Press, 1970).

[32]Donald McChesney, *A Hopkins Commentary, An Explanatory Commentary on the Main Poems, 1876-89* (London: University of London Press, 1968).

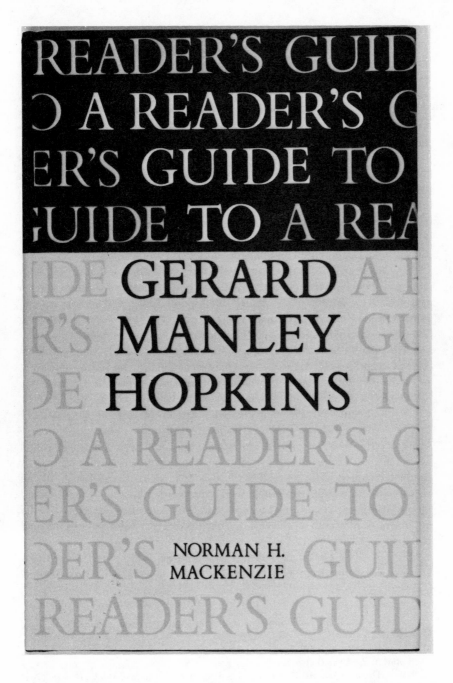

Item 188: Dust jacket of Norman H. MacKenzie's *A Reader's Guide to Gerard Manley Hopkins* (1981).

Hopkins (1981),[33] which follows the order and keying of the fourth edition of *Poems*. McChesney is liberal—and helpful—in citing passages from Hopkins's prose to elucidate the poems he comments on, and quite often offers subtle but significant insights into the workings of the poem or of the poet's mind. MacKenzie is especially helpful in citing from other poems to show what Hopkins was attempting or to draw parallels, and in finding sources or antecedents in earlier writers from the classics onward. These two commentaries complement each other remarkably.

Two "visual" commentaries were published in 1975: Fathers Peter Milward and Raymond Schoder's *Landscape and Inscape: Vision and Inspiration in Hopkins's Poetry*[34] and R.K.R. Thornton's *All My Eyes See: The Visual World of Gerard Manley Hopkins.*[35] Father Milward's commentary on fifteen of Hopkins's poems or fragments is accompanied by full-color photographs by Father Schoder. Milward's comments are wide-ranging and perceptive, but they are not documented and they do not involve the work or words of other critics. These are, in a sense, "personal" commentaries, but that quality does not in any way diminish the beauty of this volume. Thornton's volume is not a comprehensive commentary, as such, but I believe it fits well into this section because of the nature and quality of its contents. Five writers, including Thornton, deal with portraits of Hopkins, impressions of him by contemporaries, people and places he knew, his drawings, his art criticism, and his critical reception. Each essay or chapter is filled with illustrations that immediately give the reader a visual context for the words of commentary. This too is an incredibly handsome and striking volume.

The other commentaries in this section—with one exception that I will save for last—were written as volumes in a series, usually a series designed to introduce the reader to Hopkins and his world, and aimed at the so-called "general" reader but most probably at the advanced undergraduate or graduate student. The longest of these is 160 pages; the shortest, 64; all measure under 5 inches by 8 inches. In other words, the kind of commentary is physically restricted by the size and qualitatively restricted by the audience. And, of course, the writer of each book greatly determines the final worth.

Of these five books, two are remarkable achievements: Norman H. MacKenzie's *Hopkins* (1968)[36] and R.K.R. Thornton's *Gerard Manley Hop-*

[33]Norman H. MacKenzie, *A Reader's Guide to Gerard Manley Hopkins* (London: Thames and Hudson, 1981).

[34]Peter Milward, S.J., and Raymond Schoder, S.J., *Landscape and Inscape: Vision and Inspiration in Hopkins's Poetry* (London: Paul Elek, 1975).

[35]R.K.R. Thornton, ed., *All My Eyes See: The Visual World of Gerard Manley Hopkins* (Tyne and Wear: Ceolfrith Press, Sunderland Arts Centre, 1975).

[36]Norman H. MacKenzie, *Hopkins* (Edinburgh, London: Oliver and Boyd, 1968).

kins: The Poems (1973).[37] MacKenzie manages to squeeze a great deal of knowledge about Hopkins into his brief volume and yet to avoid the feeling of density in such tightly packed writing. This little book contains numerous snippets, some of which MacKenzie was able to elaborate on later in his *Reader's Guide* or elsewhere, and these stand as signposts to further investigation and closer reading of the poet. This book is a source of pleasureful reading and worthy of periodic reference. Likewise, in the volume Thornton wrote for the Studies in English Literature series, he manages to include many interesting points about various poems within the few pages he was allotted. Necessarily without *any* elaboration, his comments reveal his long-time interest in and knowledge of the poet and his works, and provide an excellent starting-point for someone embarking on the rough sea of Hopkins for the first time.

J.F.J. Russell's *A Critical Commentary on Gerard Manley Hopkins's "Poems"* (1971) is an adequate introduction for an undergraduate, but it suffers from that genre's usual overload of extensive quotations and "breast-beating" exclamations of the beauty and life in a poem.[38] Jim Hunter's *Gerard Manley Hopkins* (1966) has a more ambitious aim and a more varied content.[39] Hunter surveys the poetry, comments on the drawings and prose, and offers brief chapters on versification, imagery, and diction, and on critical reception. The commentary is generally sound—perhaps too tame at times—but the book retains its usefulness as an introduction to the poet.

The most recent volume is Graham Storey's *A Preface to Hopkins* (1981), which is specifically designed for the first-time student reader of Hopkins.[40] This aim, in part, accounts for the organization of the book into chapters on the poet's life, family and literary background, and friends, and a separate critical survey of some of the major poems, with the text of a poem supplied at the head of each discussion. For its purpose, this volume of lively commentary is quite suitable.

The final entry in this section is Father Peter Milward's *A Commentary on the Sonnets of G.M. Hopkins* (1969).[41] This little book offers the text of and commentary on thirty-one sonnets by Hopkins. The commentary ranges from citations of other poems to dictionary definitions of words to possible sources in such works as the writings of Shakespeare and the Bible. Often there is material of use and interest, but too often (as, for example, in the notes on "To

[37]R.K.R. Thornton, *Gerard Manley Hopkins: The Poems*, Studies in English Literature 53 (London: Edward Arnold, 1973).

[38]J.F.J. Russell, *A Critical Commentary on Gerard Manley Hopkins's "Poems"* (London: Macmillan, 1971).

[39]Jim Hunter, *Gerard Manley Hopkins* (London: Evans Brothers Limited, 1966).

[40]Graham Storey, *A Preface to Hopkins* (London: Longmans, 1981).

[41]Father Peter Milward, S.J., *A Commentary on the Sonnets of G.M. Hopkins* (Tokyo: The Hokuseido Press, 1969; London: C. Hurst and Company, 1970).

A Commentary on

THE SONNETS OF
G.M. HOPKINS

by

Peter Milward, S.J.

LONDON
C. HURST & COMPANY
1970

Item 196: Dust jacket of Father Peter Milward's *A Commentary on the Sonnets of G.M. Hopkins* (1970).

R.B.") the commentary is far too brief to be of great value. Nonetheless, this little book should be consulted by anyone studying these sonnets individually or as a group, for Father Milward's comments are always worthy of notice.

GENERAL INTRODUCTORY ESSAYS

Two brief monographs contain long essays that serve as introductions to the poet without attempting a comprehensive survey of the poetry and without unduly elaborating a single thesis. Francis Noel Lees's *Gerard Manley Hopkins* (1966) looks primarily at Hopkins's modern traits (in keeping with the series in which this monograph was published),[42] while Geoffrey Grigson's *Gerard Manley Hopkins* (1962) focuses primarily on Hopkins as a "nature" poet, although Grigson, with his usual excellence and sensitivity, does not use the term in a dismissive way.[43] Grigson's essay remains one of the best treatments of Hopkins's relationship with nature and the signs of that relationship in his poetry.

A recent monograph by Father W.A.M. Peters, *Gerard Manley Hopkins: A Tribute* (1984), is a highly personal, and highly readable, response from one Jesuit to another, one friend to another, and a devoted reader to his favorite poet.[44] Although not designed as a general introduction to the poet, this monograph provides an apt way to lead a reader into the complexities of the personality and work of Hopkins. Father Peters does not attempt to be scholarly in this essay, but the result should, nonetheless, be read by every scholar interested in Hopkins: the effect is like that of overhearing a conversation between Peters and Hopkins, and such an experience is valuable to all readers of the poet.

SPECIFIC TOPICS

In this section I have grouped together nine books, four of which deal essentially with the language Hopkins employed for poetic or other purposes, and five of which deal with aspects of his prosody. There is, of course, much overlapping in these categories, for it would be difficult to discuss Hopkins's

[42]Francis Noel Lees, *Gerard Manley Hopkins* (New York and London: Columbia University Press, 1966).

[43]Geoffrey Grigson, *Gerard Manley Hopkins*, Bibliographical Series, Writers and their Work 59 (London: Published for the British Council and the National Book League by Longmans, Green & Company, 1955; revised 1962).

[44]W.A.M. Peters, S.J., *Gerard Manley Hopkins: A Tribute* (Chicago: Loyola University Press, 1984).

poetic language without some mention of his theory of rhythm or his stanzaic patterns. However, as artificial as they may be, these categories serve the purpose of providing a framework for discussion.

One of the truly indispensable books on Hopkins is James Milroy's *The Language of Gerard Manley Hopkins* (1977).[45] In the first part, Milroy offers an interesting and fruitful discussion of Hopkins's "everyday Victorian" language: what it was, how it sounded, how it developed, why it developed as it did, what he and his contemporaries thought about it, and where it originated. In the second part, Milroy examines in great detail the poetic language Hopkins used, grounding the discussion thoroughly and soundly in the poet's own words and theories. In short, Milroy paints a broad—but enticingly specific—canvas of Victorian English on which he then details the exact uses by Hopkins. This superb book has but one fault, one that I hope will be corrected in subsequent editions: it has no index!

Two of the books in this section—Howard W. Fulweiler's *Letters from the Darkling Plain: Language and the Grounds of Knowledge in the Poetry of Arnold and Hopkins* (1972)[46] and Margaret R. Ellsberg's *Created to Praise: The Language of Gerard Manley Hopkins* (1987)[47]—have very similar aims: to relate Hopkins's poetic language to his private or religious thought. Fulweiler clearly states his motivation in that part of his study devoted to the poet-priest: "I believe that Hopkins's language and his private conflicts are more intimately related than has hitherto been thought" (p. 91). Fulweiler proceeds to examine Hopkins's poetic language as an embodiment of those conflicts, and as his attempt at resolving such conflict. Fulweiler's comments are sensitive to the tension that so many readers have perceived in Hopkins's poetry. Ellsberg states that after a chapter on the conflict between Hopkins's vocations—priest and poet—she hopes "to show in three consecutive and related arguments that Hopkins's poetic language was a direct function of his religious thought" (p. 15). The three chapters discuss Hopkins's sacramental language, his theology of the particular, and his baroque qualities. Ellsberg does not, at least for me, use these chapters to produce a coherent case. Her examination of Hopkins's language is, I find, quite fragmented.

The three books discussed above, and those to be discussed below, owe a great deal to the ground-breaking study by Father Robert Boyle, *Metaphor in Hopkins* (1960).[48] Father Boyle offers a methodology and its application in this

[45]James Milroy, *The Language of Gerard Manley Hopkins*, The Language Library (London: André Deutsch, 1977).

[46]Howard W. Fulweiler, *Letters from the Darkling Plain: Language and the Grounds of Knowledge in the Poetry of Arnold and Hopkins*, University of Missouri Studies 48 (Columbia: University of Missouri Press, 1972).

[47]Margaret R. Ellsberg, *Created to Praise: The Language of Gerard Manley Hopkins* (New York, Oxford: Oxford University Press, 1987).

[48]Robert Boyle, S.J., *Metaphor in Hopkins* (Chapel Hill: The University of North Carolina Press, 1960).

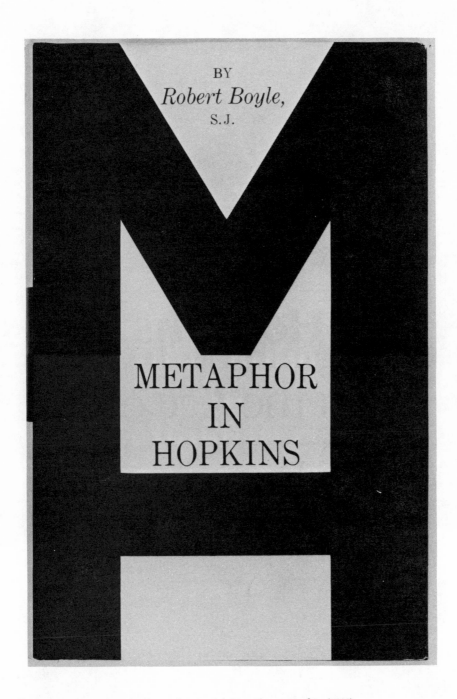

BY
Robert Boyle,
S.J.

METAPHOR
IN
HOPKINS

Item 203: Dust jacket of Father Robert Boyle's *Metaphor in Hopkins* (1960).

Hopkins

in the Age of

Darwin

By Tom Zaniello

Item 206: Dust jacket of Tom Zaniello's *Hopkins in the Age of Darwin* (1988).

study of Hopkins's metaphors—indeed, of Hopkins as a metaphorical poet. Boyle looks closely at the dynamics within the metaphors, their role within the poem, and often compares metaphors from other poems. Boyle also emphasizes the aural quality of Hopkins's poetry, going so far as to insist on an onomatopoeic relation between metaphor and meaning. His discussion of individual poems merits the attention of anyone pursuing general meaning or specific aspects within the work. Boyle's grasp of Hopkins, his shared Jesuit experiences, and his knowledge of the classics and of the critics combine to make this a deservedly respected and often-cited work.

Kunio Shimane's *The Poetry of G.M. Hopkins: The Fusing Point of Sound and Sense* (1983) applies modern linguistics and phonetics to Hopkins's poetry with often interesting results.[49] Shimane continues some of the work begun by Boyle, but goes far beyond the immediate combination of words into the realm of sound and silence as units of meaning within a work of art. Shimane's study is enhanced by its author's firsthand knowledge of the manuscripts of Hopkins's works. This is an exciting book of criticism, not only for its sometimes provocative conclusions, which will not find universal acceptance among Hopkinseans, but for the directions of enquiry to which it points. Anyone familiar with Hopkins's notions of sound and meaning—and his many musings on this subject in his letters and journals as well as his poetry—will agree that the poet himself would have been pleased to read such a volume of criticism as this.

In 1981 Father Walter Ong delivered the Alexander Lectures at the University of Toronto. Published in 1986 as *Hopkins, the Self, and God*, these lectures offer some of Father Ong's most sensitive criticism of Hopkins.[50] In great detail and with remarkable background supplied, the lectures deal with Hopkins's creation of self within the context of various nineteenth-century currents. Actually, a more accurate description of this book would be a study of Hopkins's "creations of selves," for Ong demonstrates convincingly the various aspects of self that Hopkins grappled with and eventually integrated into a relatively successful whole. Ong finally shows—and strongly believes— that Hopkins was successful in melding the various selves into his life as priest/ poet/person. The careful analyses and the comprehensive contextual studies in this book offer a much-needed corrective to some of the recent books on Hopkins that depict him in terms of a total failure.

Tom Zaniello's *Hopkins in the Age of Darwin* (1988) is the product of the author's extensive research into the scientific milieu of the nineteenth century and how Hopkins was affected by the conflicting strains of his religion and the many discoveries that were then challenging the foundation of much of his

[49]Kunio Shimane, *The Poetry of G.M. Hopkins: The Fusing Point of Sound and Sense* (Tokyo: The Hokuseido Press, 1983).

[50]Walter Ong, S.J., *Hopkins, the Self, and God*, The Alexander Lectures (Toronto: University of Toronto Press, 1986).

belief.[51] Zaniello traces the development of the natural sciences and provides details of the background into which Hopkins stepped at Oxford and through which he walked for the remainder of his life. Zaniello looks closely at what Hopkins would have been taught, what he would have read, what he might have heard about, and, finally, what he actually or probably thought about the emerging sciences. This study does not, however, conclude simply with this kind of examination; rather, it cites examples from Hopkins's poetry and prose of ways in which the scientific progress entered Hopkins's consciousness and was transformed by the poet's extraordinary verbal skill. This book is a valuable study and an equally valuable sourcebook for anyone interested in science in the nineteenth century. And there is one other aspect that makes this book especially appealing: its design by the University of Iowa Press. There are no footnote numbers in the text or footnotes at the bottom of pages; rather, references are cited by the introductory phrases and page number in a section in the back of the book. Throughout the text, there are "boxes" of sidelights: information that could easily have been relegated to the rear of the book but which, for its connection to the text, demands a more immediate position. The result is a book that is both pleasing to the eye and a pleasure to read.

Two monographs of a relatively technical nature conclude this section: Sister Marcella Holloway's *The Prosodic Theory of Gerard Manley Hopkins* (1947)[52] and Edward Stephenson's *What Sprung Rhythm Really Is* (1987).[53] Sister Holloway's study was a welcome supplement and elaboration of Gardner's extensive chapters in the second volume of his study, but Holloway's was not merely a supplement, for in her technical treatise she devises original ideas and explanations that make her study, although now over four decades old, still vital and useful. Stephenson's monograph, even more technical, looks at Hopkins's knowledge of and ideas about Anglo-Saxon versification, examines minutely the theories Hopkins derived, and then painstakingly analyzes the poems themselves to see if they embody the theory Hopkins intended. Stephenson draws many new conclusions in his study, and caps it with a reading of "The Windhover" based in large part on its metrical qualities. Although Stephenson is careful to show that Hopkins was not always successful in practicing the theories he espoused, Stephenson is always fair and judicious in his assessment.

[51]Tom Zaniello, *Hopkins in the Age of Darwin* (Iowa City: University of Iowa Press, 1988).

[52]Marcella Holloway, C.S.J., *The Prosodic Theory of Gerard Manley Hopkins* (Washington, D.C.: The Catholic University of America Press, 1947; rpt. 1964).

[53]Edward A. Stephenson, *What Sprung Rhythm Really Is*, with the assistance of Carolyn Hudgins, The International Hopkins Association Monograph Series 4 (Alma, Ontario, Canada: The International Hopkins Association, 1987).

In this section, all but two books focus on Hopkins's longest poem, *The Wreck of the Deutschland*. These two exceptions are John Pick's collection of essays and notes, *Gerard Manley Hopkins: The Windhover* (1969),[54] and Stephan Walliser's *That Nature is a Heraclitean Fire and of the Comfort of the Resurrection: A Case-Study in G.M. Hopkins's Poetry* (1977).[55] Pick's collection is still a handy source for many of the "standard" readings of Hopkins's most-often-explicated poem, although it is by now dated and in need of revision. The selection, however, is rich and varied, and shows quite clearly and quickly just how critical taste about Hopkins has sometimes been polarized. Walliser's book is a splendid example of what exhaustive study of a single poem by Hopkins can reveal. In fact, Walliser not only reads the poem but places it in the Hopkins canon, looks at its classical background, examines its form, and discusses its imagery and theology. This book, which is unfortunately not well known or widely available in North America, should be read by all those interested not only in this dense, beautiful sonnet but in Hopkins in general.

The remaining five books in this section treat Hopkins's *The Wreck*, but two of these are in the form of essays: Philip M. Martin's *Mastery and Mercy: A Study of Two Religious Poems* (1957)[56] and James Dickey's introductory essay to an edition of the poem (1971).[57] Canon Martin's aim in discussing *The Wreck* and Eliot's *Ash Wednesday* was, in part, to make the poetry more accessible to the still-present "general reader"; for that reason, Martin adopted an orderly exposition of the poem, moving from stanza (or group of stanzas) to stanza, commenting on the poetic and religious aspects of each. Martin's comments retain some interest today, but they occasionally strike one as much too restrained for a work that sets out to demonstrate the vibrancy of the religious experience as embodied in Hopkins's poem. I include Dickey's essay here because, as brief as it is, it perfectly complements the lovely edition it introduces and it remains one of my favorite statements on the extraordinary qualities of Hopkins's poem.

Like Canon Martin's book, two other commentaries on *The Wreck* employ stanza-by-stanza expositions: John E. Keating's *The Wreck of the Deutsch-*

[54]John Pick, ed., *Gerard Manley Hopkins: The Windhover*, The Charles E. Merrill Literary Casebook Series (Columbus, Ohio: Charles E. Merrill Publishing Company, 1969).

[55]Stephan Walliser, *That Nature is a Heraclitean Fire and of the Comfort of the Resurrection: A Case-Study in G.M. Hopkins's Poetry*, The Cooper Monographs 26 (Basel, Switzerland: Francke Verlag Bern, 1977).

[56]Philip M. Martin, *Mastery and Mercy: A Study of Two Religious Poems* (London: Oxford University Press, 1957).

[57]Gerard Manley Hopkins, *The Wreck of the Deutschland*, Introduction by James Dickey (Boston: David Godine, 1971).

land: An Essay and Commentary (1963)[58] and Father Peter Milward's A Commentary on G.M. Hopkins's "The Wreck of the Deutschland" (1968).[59] Both are excellent works and should be consulted by anyone embarking on a study of the poem or by anyone puzzled by a specific line or stanza. Each commentary shows an intimate knowledge of the poet and his work, and each reveals something new and different about the poem; there is, in fact, remarkably little duplication in the contents of these two books, even though much would be expected because of their common subject and approach. The difficulty, of course, is that a quarter-century's work has been done on this poem since the commentaries' publication, and an updating would prove extremely beneficial.

The final volume in this section is a collection of essays by various people: Readings of "The Wreck": Essays in Commemoration of the Centenary of G.M. Hopkins's "The Wreck of the Deutschland" (1976), edited by Father Peter Milward, assisted by Father Raymond Schoder.[60] This is a lovely book, illustrated with contemporaneous accounts of the actual wreck, and filled with a diversity of approaches to the poem: from personal memoirs to linguistic analyses to discussions of imagery, diction, structure, and myth. Several of these essays have already made their way into the mainstream of Hopkins criticism, as witnessed by the frequency with which they are cited in contemporary writings. Such is the clear strength of this collection of 14 essays by some of the finest critics of Hopkins.

COLLECTIONS OF VARIOUS ESSAYS

There are two types of collections in this section: those books that reprint essays from other sources and those books that print for the first time works commissioned for a particular collection. There are four volumes of the first type: Gerard Manley Hopkins (1969), edited by James F. Scott and Carolyn D. Scott;[61] Hopkins: A Collection of Critical Essays (1966), edited by Geoffrey H. Hartman;[62] Gerard Manley Hopkins: Poems (1975), edited by Margaret

[58]John E. Keating, The Wreck of the Deutschland: An Essay and Commentary, Research Series 6 (Kent, OH: Kent State University Bulletin, 1963).

[59]Peter Milward, S.J., A Commentary on G.M. Hopkins's "The Wreck of the Deutschland" (Tokyo: The Hokuseido Press, 1968).

[60]Peter Milward, S.J., and Raymond Schoder, S.J., eds., Readings of "The Wreck": Essays in Commemoration of the Centenary of G.M. Hopkins's "The Wreck of the Deutschland" (Chicago: Loyola University Press, 1976).

[61]James F. Scott and Carolyn D. Scott, eds., Gerard Manley Hopkins, The Christian Critic Series (St. Louis, Missouri: B. Herder Book Company, 1969).

[62]Geoffrey H. Hartman, ed., Hopkins: A Collection of Critical Essays, Twentieth-Century Views (Englewood Cliffs, New Jersey: Prentice-Hall, Inc., 1966).

Bottrall;[63] and *Gerard Manley Hopkins: The Critical Heritage* (1987), edited by Gerald Roberts.[64]

The volume edited by the Scotts consists of a rather haphazard collection of essays from numerous sources, and lacks any real focus or thematic unity. The only common element binding these disparate essays is the religion of the various critics. This volume appeared in The Christian Critic Series, but most of the works are readily accessible in their original sources.

The volumes by Hartman and Bottrall make a complementary pair. Hartman's collection ranges from Bridges to modern European responses to the poet, and contains some of the "standard" essays on Hopkins (Leavis, Winters, Wain, Miller). Bottrall's collection is especially strong in selections by English critics and is arranged chronologically to allow the reader to perceive the development of Hopkins criticism over the years.

While Bottrall's volume presents a limited selection of Hopkins criticism, Roberts's recent collection carefully and exhaustively assembles a great variety of criticism from the early decades of this century and reprints not only the readily available works but also many that are virtually inaccessible to most readers. As a result, Roberts's volume is an intriguing collection that makes for exciting reading: not only can one trace the development of Hopkins criticism and make note of what his earliest critics chose to emphasize and ignore, but one can also gauge the development of twentieth-century criticism as a whole and see how many of the issues expressed about other writers made their way into and out of much that was written about Hopkins.

Four volumes remain in this section: two are recent collections and two are by-now classics in the Hopkins canon. The latter works are *Immortal Diamond: Studies in Gerard Manley Hopkins* (1949), edited by Father Norman Weyand, with the assistance of Father Raymond Schoder,[65] and *Gerard Manley Hopkins* (1944) by the Kenyon Critics.[66] Both of these volumes were intended as centenary celebrations of the birth of Hopkins, but the former was delayed by the complications of wartime and post-war scarcity. The Kenyon Critics remains one of the best small collections of essays on Hopkins, with sensitive biographical essays and insightful studies of the language and rhythm of the poetry. It is little wonder that this is one of the very few volumes of Hopkins criticism from the forties still in print.

Immortal Diamond is also available as a reprint—and rightly so, for this important collection of essays by Jesuits about their fellow Jesuit contains

[63]Margaret Bottrall, ed., *Gerard Manley Hopkins: Poems*, Casebook Series (London: Macmillan, 1975).

[64]Gerald Roberts, ed., *Gerard Manley Hopkins: The Critical Heritage*, The Critical Heritage Series (London: Routledge and Kegan Paul, 1987).

[65]Norman Weyand, S.J., with the assistance of Raymond V. Schoder, S.J., eds., *Immortal Diamond: Studies in Gerard Manley Hopkins* (London: V. Sheed and Ward, 1949).

[66]Kenyon Critics, *Gerard Manley Hopkins*, The Makers of Modern Literature Series (Norfolk, CT: New Directions Books, 1945; originally published in *The Kenyon Review*, 1944).

some pieces yet to be supplanted. There are valuable—and sometimes ground-breaking—studies of sprung rhythm, a glossary of difficult words in *The Wreck*, studies of style and content, and studies of other individual poems, including "The Windhover" and "The Loss of the Eurydice." Not all of the essays are equally excellent, but overall this is a very strong collection of essays, most of which retain their interest four decades later.

Two recent collections round out this section: *Vital Candle: Victorian and Modern Bearings in Gerard Manley Hopkins* (1984), edited by John S. North and Michael D. Moore,[67] and *Hopkins among the Poets: Studies in Modern Responses to Gerard Manley Hopkins* (1985), edited by Richard F. Giles.[68] The former collection prints the papers given at the 1981 conference, Gerard Manley Hopkins: The Poet in His Age. There are 9 essays that examine, in broad terms, Hopkins in his time, his similarities with other poets and possible influence thereon, and his theories and use of language. There are some excellent works in this brief volume, although several of the essays cover ground that has by now been well trod. My own collection of essays, *Hopkins among the Poets*, brings together 26 short studies of various poets' responses to Hopkins, from his contemporary Bridges to our contemporary African poets, from Eliot and Pound to Heaney and Plath. As would be expected in such a collection, the insights vary, as does the quality of the pieces. However, the collection makes for an interesting study of how ambivalent many of this century's major poets were and are to Hopkins's presence in the English canon.

FOREIGN BOOKS

I have included this section to show the ever-expanding interest in Hopkins in areas other than the United Kingdom and North America and in languages other than English. Mention is made here of only a few of the many fine books published in the past several decades. Of course, many of the books I have discussed above were published in other countries, which is a further indication of the wide and growing interest in Hopkins.

Interest in Hopkins is especially high in Japan. In addition to several books already discussed that were published there, mention should be made of Hideo Yamaguchi's recent *Language and Poetry* (1984),[69] which contains

[67]John S. North and Michael D. Moore, eds., *Vital Candle: Victorian and Modern Bearings in Gerard Manley Hopkins* (Waterloo, Ontario, Canada: University of Waterloo Press, 1984).

[68]Richard F. Giles, ed., *Hopkins among the Poets: Studies in Modern Responses to Gerard Manley Hopkins*, The International Hopkins Association Monograph Series 3 (Hamilton, Ontario, Canada: The International Hopkins Association, 1985).

[69]Hideo Yamaguchi, *Language and Poetry* (Tokyo: Meirin Shuppan, 1984).

HOPKINS AMONG THE POETS

STUDIES IN MODERN RESPONSES TO GERARD MANLEY HOPKINS

Edited by Richard F. Giles

Item 223: Cover of Richard F. Giles's edition of *Hopkins among the Poets: Studies in Modern Responses to Gerard Manley Hopkins* (1985).

GERARD MANLEY HOPKINS
ANTOLOGÍA BILINGÜE

Traducción y estudio preliminar
por
MANUEL LINARES MEGÍAS

Item 228: Cover of Manuel Linares Megías's edition of *Gerard Manley Hopkins: Antología Bilingüe* (1978).

extensive discussion of Hopkins's diction and syntax, and of the several translations of English critical books on Hopkins into Japanese, and, of course, of the several original critical works in Japanese. (Readers interested in this latter aspect of modern Hopkins criticism should consult *Hopkins Research*, the bulletin of the Hopkins Society of Japan.)

René Gallet's recent *G.M. Hopkins ou l'excès de présence* (1984) continues the fine critical work in French begun by Jean-Georges Ritz in his masterful 1963 study, discussed above.[70] Gallet incorporates much contemporary criticism of Hopkins in his study and offers engaging insights as well as translations into French of Hopkins's often difficult wording.

In 1981 Franco Marucci published his splendid study of Hopkins as a medieval poet: *I fogli della Sibilla: Retorica e medievalismo in Gerard Manley Hopkins*.[71] Marucci's study is especially valuable for its discussion of the signic aspects of rhetoric and of Hopkins's embrace and practice of a medieval kind of rhetoric. The second part of this study is an extended treatment of Hopkins within his culture and the influences that exerted themselves on him. A useful project would be an English translation of this Italian work.

Also in Italian is Paola Bottalla Nordio's edition of *The Wreck of the Deutschland* (1979), with a lengthy introductory essay, the text, and a comprehensive commentary.[72] This is a useful sourcebook, even for someone who does not have command of Italian.

Two recent works in Spanish show the interest in Hopkins in Spain: Manuel Linares Megías's *Gerard Manley Hopkins: Antología Bilingüe* (1978)[73] and María del Pilar Abad García's *La unidad en la obra de Gerard Manley Hopkins: Su literatura epistolar* (1984),[74] a dissertation handsomely printed and bound by the University of Valladolid. Father Linares provides a lengthy introductory section that covers Hopkins's life and aesthetics, and a bilingual anthology of selected poems. The texts are on facing pages, and the Spanish translations are annotated. Abad García's lengthy study is the definitive treatment of Hopkins's epistolary writing, with virtually every aspect of the letters covered in this thoroughly annotated volume.

[70]René Gallet, *G.M. Hopkins ou l'excès de présence* ([Paris]: FAC-éditions, 1984).

[71]Franco Marucci, *I fogli della Sibilla: Retorica e medievalismo in Gerard Manley Hopkins*, Biblioteca di Cultura Contemporanea 141 (Messina-Firenze, Italy: Casa Editrice G. D'Anna, 1981).

[72]Gerard Manley Hopkins, *The Wreck of the Deutschland*, ed. and intro. by Paola Bottalla Nordio (Parma: Casa Nova Edizioni Universitarie, 1979).

[73]*Gerard Manley Hopkins: Antología Bilingüe*, traducción y estudio preliminar por Manuel Linares Megías (Sevilla, Spain: Imp. y Pap. Raimundo, 1978).

[74]María del Pilar Abad García, *La unidad en la obra de Gerard Manley Hopkins: Su literatura epistolar* (Valladolid, Spain: Universidad de Valladolid, 1984).

The final work in this section is K.R. Srinivasa Iyengar's *Gerard Manley Hopkins: The Man and the Poet* (1948).[75] This highly derivative study in English, which dates mainly from the thirties, is of value simply as an indication of the interest in Hopkins in India at the time of its publication.

BIBLIOGRAPHIES

There are three book-length bibliographies of Hopkins. The first is Edward H. Cohen's *Works and Criticism of Gerard Manley Hopkins: A Comprehensive Bibliography* (1969), which for several years was the standard reference work for Hopkins scholars.[76] Ruth Seelhammer's *Hopkins Collected at Gonzaga* (1970) is a comprehensive listing of Gonzaga University's extensive Hopkins collection.[77] This book has a very helpful index and is especially valuable for its listing of obscure reviews and works on Hopkins's circle: Bridges, Patmore, and Dixon. An updating in a second volume of this work would be a most worthy project.

Tom Dunne's *Gerard Manley Hopkins: A Comprehensive Bibliography* (1976) is the definitive bibliography of Hopkins and Hopkins criticism, even though it should be updated, since its coverage ends at 1970.[78] In itself, this is one of the most significant books ever published on the poet. Useful, interesting, and always informative, the volume should be on every serious Hopkinsean's shelf.

CONCORDANCES

There are two concordances to Hopkins's poetry, both computer-generated and both based on the fourth edition of *Poems*: Alfred Borrello's *A Concordance of the Poetry in English of Gerard Manley Hopkins* (1969)[79] and Robert J. Dilligan and Todd K. Bender's *A Concordance to the English Poetry of*

[75]K.R. Srinivasa Iyengar, *Gerard Manley Hopkins: The Man and the Poet*, With a Foreword by Jerome D'Souza, S.J. (New York, NY: Haskell House Publishers Ltd., 1971; first published in 1948).

[76]Edward H. Cohen, *Works and Criticism of Gerard Manley Hopkins: A Comprehensive Bibliography* (Washington, D.C.: The Catholic University of America Press, 1969).

[77]Ruth Seelhammer, *Hopkins Collected at Gonzaga* (Chicago: Loyola University Press, 1970).

[78]Tom Dunne, *Gerard Manley Hopkins: A Comprehensive Bibliography* (London: Oxford University Press, 1976).

[79]Alfred Borrello, *A Concordance of the Poetry in English of Gerard Manley Hopkins* (Metuchen, NJ: The Scarecrow Press, 1969).

Gerard Manley Hopkins (1970). [80] Having used only the latter, I cannot vouch for the quality of the former. The Dilligan and Bender volume is quite useful and quite accurate, although I quibble with the decision to delete some words that are of greater significance to Hopkins's poetry than the compilers think.

ICONOCLASTIC

I begin this final section of my survey with mention of a book on Hopkins, but not a book of criticism: Philip Dacey's *Gerard Manley Hopkins Meets Walt Whitman in Heaven and Other Poems* (1982). [81] Dacey's poems present a very human Hopkins, one void of many of the defensive covers produced over the decades by many of his critics who, for whatever reason, chose to highlight sides of the poet other than those shown rather clearly in these pages. But the picture of Hopkins that emerges here, at least for me, is a much more endearing one than many that exist in the sometimes arid pages of academic studies. Dacey's lines—accompanied by striking woodcuts by Michael McCurdy—make the spirit of Hopkins live, and any book that can accomplish this is worthy of inclusion in the present survey. Partly because it suits my title for this section and partly because of its intrinsic value, I include Dacey's book here as a revisionist version of Hopkins that many readers will not recognize or embrace.

I will not repeat here the comments I have made above on the books that I consider to be iconoclastic—at least in part—in their intent; I merely list them by author and date: Dold (1974), Kitchen (1978), Robinson (1978), Sprinker (1980), and Harris (1982). Each of these books is a kind of assault on the commonly held (and too often unchallenged) notion of Hopkins as a priestly poet, a poetic priest, a saintly man, a sinless person, or what have you. Most of these books look at Hopkins intensely and minutely, and find fault with what they see there: some writers indict the works as major failures in taste or effect while other writers indict the person, as a repressed, tension-ridden figure unable even to live simply and graciously in the relative calm and sanctuary of his order. These books demand of those who love Hopkins an accounting for some traits—in the works and in the person—that can no longer be dismissed or ignored.

As with any such movement that demands a revision of long-held assumptions, this movement has met with resistance from many other critics, some of whom have gone back to the old—and antiquated—notion of Hopkins as a "sexless saint" who could not have entertained the thought of much of what the

[80]Robert J. Dilligan and Todd K. Bender, *A Concordance to the English Poetry of Gerard Manley Hopkins* (Madison, WI: The University of Wisconsin Press, 1970).

[81]Philip Dacey, *Gerard Manley Hopkins Meets Walt Whitman in Heaven and Other Poems* (Great Barrington, MA: Penmaen Press, 1982).

revisionists say about him, let alone the deed. A few other critics have gone to an extreme beyond even the revisionists' notions and have produced work that echoes some of the harsher judgments uttered in the thirties and the sixties of Hopkins as a person. In short, what continues in much of Hopkins criticism is the polarization that disallows meaningful contact in a neutral middle-ground.

I end this section by identifying my own prejudice, perhaps a gesture I should have made at the beginning of this survey. Hopkins is my favorite poet: I read him with pleasure, I thrill at what he achieves in his works of prose and poetry, and I delight in much about the person he was. I do not share his beliefs and I reject much of what he held dear; I therefore find some aspects of his person to be unattractive. But in my devotion to this man I want to learn more of what he felt, why he felt it, and why he expressed his feelings as he did. I want my enquiry to lead where it may, and not be determined—or predetermined—by my own belief or lack thereof. All critics owe their subjects at least that much objectivity—and all critics owe each other that same objectivity.

CONCLUSION

I began this survey by saying that, in a way, all books on Hopkins are significant, and, even after this lengthy exercise, I still hold to that position. In general, Hopkins has been well served by book-length studies of the man, the poet, and his works. As the number of books has steadily increased, so too their sophistication, their insights, and their value—which is not to say, as I have tried to make clear, that earlier works are without value. Quite the contrary, much of what Hopkins's first readers saw in him excites us today, or even still annoys us. And much of what those critics writing about Hopkins in the aftermath of the Second World War had to say remains relevant and apropos today. As our knowledge of Hopkins increases and our study of language and its role in our lives becomes more complex and more "political," Hopkins remains a beacon: a Victorian to the bone who manages to elicit the interest of moderns of various and varying ideologies and sentiments. Each one of the books mentioned in this survey is itself a light that guides us to the beacon of Hopkins's original works, and each is, therefore, significant.

158 G.F. Lahey, S.J. *Gerard Manley Hopkins*. London: Oxford University Press, 1930.

159 Eleanor Ruggles. *Gerard Manley Hopkins: A Life*. London: John Lane, The Bodley Head, 1947.

160 Bernard Bergonzi. *Gerard Manley Hopkins*. New York: Macmillan, 1977.

161 Jean-Georges Ritz. *Robert Bridges and Gerard Manley Hopkins, 1863-1889, A Literary Friendship*. London: Oxford University Press, 1960.

162 _____. *Le poète Gérard Manley Hopkins, s.j. 1844-1889. Sa vie et son Oeuvre*. Paris: Didier, 1963.

163 Alfred Thomas. *Hopkins the Jesuit: The Years of Training*. London: Oxford University Press, 1969.

164 Paddy Kitchen. *Gerard Manley Hopkins*. London: Hamish Hamilton, 1978.

165 James F. Cotter. *Inscape: The Christology and Poetry of Gerard Manley Hopkins*. Pittsburgh: University of Pittsburgh Press, 1972.

166 Donald Walhout. *Send My Roots Rain: A Study of Religious Experience in the Poetry of Gerard Manley Hopkins*. Athens, OH: Ohio University Press, 1981.

167 David A. Downes. *Gerard Manley Hopkins: A Study of his Ignatian Spirit*. New York: Bookman Associates, 1959.

168 _____. *The Great Sacrifice: Studies in Hopkins*. Lanham, MD: University Press of America, 1983.

169 _____. *Hopkins' Sanctifying Imagination*. Lanham, MD: University Press of America, 1985.

170 J. Hillis Miller. *The Disappearance of God: Five Nineteenth-Century Writers*. Cambridge, MA: Harvard University Press, 1963.

171 Alan Heuser. *The Shaping Vision of Gerard Manley Hopkins*. London: Oxford University Press, 1958.

172 W.H. Gardner. *Gerard Manley Hopkins, 1844-1889, A Study of Poetic Idiosyncrasy in relation to Poetic Tradition*. London: Martin Secker & Warburg, 1944, 1949.

173 W.A.M. Peters, S.J. *Gerard Manley Hopkins: A Critical Essay towards the Understanding of his Poetry*. London: Oxford University Press, 1948.

174 Marylou Motto. *Mined with a Motion: The Poetry of Gerard Manley Hopkins*. New Brunswick, NJ: Rutgers University Press, 1984.

175 Jerome Bump. *Gerard Manley Hopkins*. Boston: Twayne, 1982.

176 Elisabeth Schneider. *The Dragon in the Gate: Studies in the Poetry of G.M. Hopkins*. Berkeley, CA: University of California Press, 1968.

177 Bernard Dold. *Wrecks, Racks, Rohrschach: The Poetry of G.M. Hopkins*. Messina, Italy: Peloritana Editrice, 1974.

178 Todd Bender. *Gerard Manley Hopkins: The Classical Background and Critical Reception of his Work*. Baltimore, MD: The Johns Hopkins University Press, 1966.

179 David A. Downes. *Victorian Portraits: Hopkins and Pater*. New York: Bookman Associates, 1965.

180 Michael Sprinker. *"A Counterpoint of Dissonance": The Aesthetics and Poetry of Gerard Manley Hopkins*. Baltimore, MD: The Johns Hopkins University Press, 1980.

181 John Robinson. *In Extremity: A Study of Gerard Manley Hopkins*. Cambridge: Cambridge University Press, 1978.

182 Daniel A. Harris. *Inspirations Unbidden: The "Terrible Sonnets" of Gerard Manley Hopkins*. Berkeley, CA: University of California Press, 1982.

183 Wendell S. Johnson. *Gerard Manley Hopkins: The Poet as Victorian*. Ithaca, NY: Cornell University Press, 1968.

184 Alison G. Sulloway. *Gerard Manley Hopkins and the Victorian Temper*. London: Routledge & Kegan Paul, 1972.

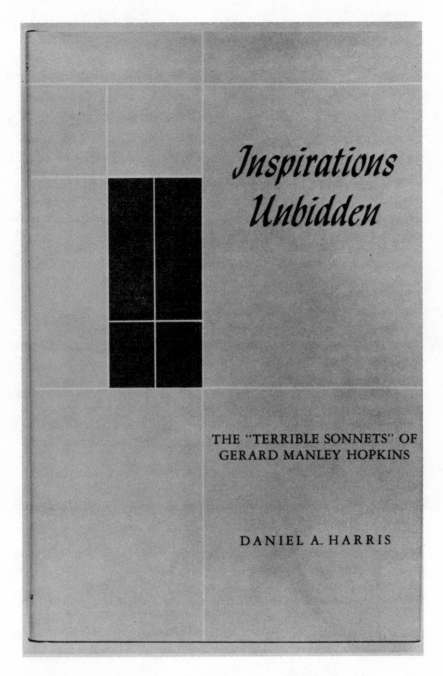

Item 182: Dust jacket of Daniel A. Harris's *Inspirations Unbidden: The "Terrible Sonnets" of Gerard Manley Hopkins* (1982).

185 Margaret Patterson. "The Hopkin's [*sic*] Handbook." Diss.: University of Florida, 1970.

186 Paul L. Mariani. *A Commentary on the Complete Poems of Gerard Manley Hopkins*. Ithaca, NY: Cornell University Press, 1970.

187 Donald McChesney. *A Hopkins Commentary*. London: University of London Press, 1968.

188 Norman H. MacKenzie. *A Reader's Guide to Gerard Manley Hopkins*. London: Thames and Hudson, 1981.

189 Peter Milward, S.J., and Raymond Schoder, S.J. *Landscape and Inscape: Vision and Inspiration in Hopkins's Poetry*. London: Paul Elek, 1975.

190 R.K.R. Thornton, ed. *All My Eyes See: The Visual World of Gerard Manley Hopkins*. Sunderland, England: Ceolfrith Press, 1975.

191 Norman H. MacKenzie. *Hopkins*. London: Oliver & Boyd, 1968.

192 R.K.R. Thornton. *Gerard Manley Hopkins: The Poems*. London: Edward Arnold, 1973.

193 J.F.J. Russell. *A Critical Commentary on Gerard Manley Hopkins's "Poems."* London: Macmillan, 1971.

194 Jim Hunter. *Gerard Manley Hopkins*. London: Evans Brothers, 1966.

195 Graham Storey. *A Preface to Hopkins*. London: Longmans, 1981.

196 Peter Milward, S.J. *A Commentary on the Sonnets of G.M. Hopkins*. London: C. Hurst and Company, 1970.

197 Francis N. Lees. *Gerard Manley Hopkins*. New York: Columbia University Press, 1966.

198 Geoffrey Grigson. *Gerard Manley Hopkins*. London: Longmans, 1962.

199 W.A.M. Peters, S.J. *Gerard Manley Hopkins: A Tribute*. Chicago: Loyola University Press, 1984.

200 James Milroy. *The Language of Gerard Manley Hopkins*. London: André Deutsch, 1977.

201 Howard Fulweiler. *Letters from the Darkling Plain: Language and the Grounds of Knowledge in the Poetry of Arnold and Hopkins*. Columbia, MO: University of Missouri Press, 1972.

202 Margaret Ellsberg. *Created to Praise: The Language of Gerard Manley Hopkins*. New York: Oxford University Press, 1972.

203 Robert Boyle. *Metaphor in Hopkins*. Chapel Hill, NC: University of North Carolina Press, 1960.

204 Kunio Shimane. *The Poetry of Gerard Manley Hopkins: The Fusing Point of Sound and Sense*. Tokyo: Hokuseido, 1983.

205 Walter J. Ong, S.J. *Hopkins, the Self, and God*. Toronto: University of Toronto Press, 1986.

206 Tom Zaniello. *Hopkins in the Age of Darwin*. Iowa City, IA: University of Iowa Press, 1988.

207 Sr. Marcella Holloway. *The Prosodic Theory of Gerard Manley Hopkins*. Washington, DC: The Catholic University of America Press, 1947.

208 Edward Stephenson. *What Sprung Rhythm Really Is*. Alma, Ontario: The International Hopkins Association, 1987.

209 John Pick, ed. *Gerard Manley Hopkins: The Windhover*. Columbus, OH: Charles E. Merrill, 1969.

210 Stephan Walliser. *That Nature Is a Heraclitean Fire and of the Comfort of the Resurrection: A Case-Study in G.M. Hopkins's Poetry*. Basel, Switzerland: Francke Verlag Bern, 1977.

211 Philip Martin. *Mastery and Mercy: A Study of Two Religious Poems*. London: Oxford University Press, 1957.

212 Gerard Manley Hopkins. *The Wreck of the Deutschland*, Introduction by James Dickey. Boston: David Godine, 1971.

213 John E. Keating. *The Wreck of the Deutschland: An Essay and Commentary*. Kent, OH: Kent State University Bulletin, 1963.

214 Peter Milward, S.J. *A Commentary on G.M. Hopkins's "The Wreck of the Deutschland."* Tokyo: Hokuseido, 1968.

215 Peter Milward, S.J., and Raymond Schoder, S.J., eds. *Readings of "The Wreck": Essays in Commemoration of the Centenary of G.M. Hopkins' "The Wreck of the Deutschland."* Chicago: Loyola University Press, 1976.

216 James F. Scott and Carolyn D. Scott, eds. *Gerard Manley Hopkins.* St. Louis, MO: B. Herder, 1969.

217 Geoffrey H. Hartman, ed. *Hopkins: A Collection of Critical Essays.* Englewood Cliffs, NJ: Prentice-Hall, 1966.

218 Margaret Bottrall, ed. *Gerard Manley Hopkins: Poems.* London: Macmillan, 1975.

219 Gerald Roberts, ed. *Gerard Manley Hopkins: The Critical Heritage.* London: Routledge & Kegan Paul, 1987.

220 Norman Weyand, S.J., ed. *Immortal Diamond: Studies in Gerard Manley Hopkins.* London: Sheed & Ward, 1949.

221 Kenyon Critics. *Gerard Manley Hopkins by the Kenyon Critics.* New York: New Directions, 1944.

222 John North and Michael Moore, eds. *Vital Candle: Victorian and Modern Bearings in Gerard Manley Hopkins.* Waterloo, Ontario: University of Waterloo Press, 1984.

223 Richard F. Giles, ed. *Hopkins among the Poets: Studies in Modern Responses to Gerard Manley Hopkins.* Alma, Ontario, Canada: The International Hopkins Association, 1985.

224 Hideo Yamaguchi. *Language and Poetry.* Tokyo: Meirin Shuppan, 1984.

225 René Gallet. *G.M. Hopkins ou l'excès de présence.* Paris: FAC-éditions, 1984.

226 Franco Marucci. *I fogli della Sibilla: Retorica e medievalismo in Gerard Manley Hopkins.* Messina: Casa Editrice G. D'Anna, 1981.

227 Paola Bottalla Nordio, ed. *The Wreck of the Deutschland.* Parma: Casanova Edizioni Universitarie, 1979.

228 Manuel Linares Megías, translator. *Gerard Manley Hopkins: Antología Bilingüe.* Sevilla: Raimundo, 1978.

229 María del Pilar Abad García. "La unidad en la obra de Gerard Manley Hopkins: Su literatura epistolar." Diss.: Universidad de Valladolid, 1984.

230 K.R. Srinivasa Iyengar. *Gerard Manley Hopkins: The Man and the Poet.* London: Oxford University Press, 1948.

231 Edward H. Cohen. *Works and Criticism of Gerard Manley Hopkins: A Comprehensive Bibliography.* Washington, DC: The Catholic University of America Press, 1969.

232 Ruth Seelhammer. *Hopkins Collected at Gonzaga.* Chicago: Loyola University Press, 1970.

233 Tom Dunne. *Gerard Manley Hopkins: A Comprehensive Bibliography.* London: Oxford University Press, 1976.

234 Alfred Borrello. *A Concordance of the Poetry in English of Gerard Manley Hopkins.* Metuchen, NJ: Scarecrow Press, 1969.

235 Robert J. Dilligan and Todd K. Bender. *A Concordance to the English Poetry of Gerard Manley Hopkins.* Madison, WI: University of Wisconsin Press, 1970.

236 Philip Dacey. *Gerard Manley Hopkins Meets Walt Whitman in Heaven and Other Poems.* Great Barrington, MA: Penmaen Press, 1982.

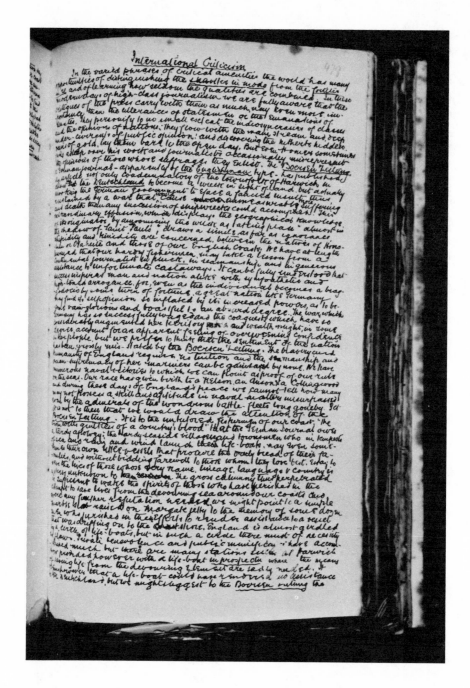

Item 248: Page on the wreck of the *Deutschland* in G.W. Bullen's *Essays: Social and Political,* 1874-76.

Significant Association Items

Although this section of the catalogue is the briefest, it is significant in gathering a number of items that are generally contemporaneous with Hopkins but for one reason or another do not fit neatly into any other category. Small as it is, the section has been divided into three parts: primary items, published during Hopkins's lifetime, that are not among the holdings of the HRHRC; photographic copies of contemporary materials for which the originals were not available; and a series of drawings by Gerard's brother Arthur, who was a successful book illustrator.

Primary Items

The most important items in the primary section are two manuscripts: a greeting card and a letter. The Passion Week greeting card from Henry Parry Liddon to the twenty-one-year-old Oxford student is, according to the nineteenth-century book specialist Charles Cox, likely the first written correspondence from Liddon to Hopkins. It was to Liddon that the Hopkins family turned in an effort to convince Gerard at least to postpone his conversion decision. The three-and-one-half page letter from Hopkins to W.A.C. MacFarlane, dated 15 July 1866, is significant more for its date than for any information it contains, for, according to an entry in Hopkins's journals, the letter was written within a day or two of the poet's conclusive decision to enter the Roman Catholic church.

The books by John Keble and Jeremy Taylor are from the Hopkins family library, one inscribed by Gerard's father, the other by his mother; both books are mentioned by Hopkins in his prose works. Since the Marie Lataste book is an exact facsimile, it does not properly belong here; but because it is the edition that Hopkins quotes at length in preparing his sermons and since it is difficult to come by, I have decided to include it among the primary items. The two books of poems by Manley Hopkins (one inscribed to his brother-in-law) contain poems probably read by Gerard, as does *Lyra Sacra*, which includes one poem by his father.

A Son of Belial bears out the remarkable impact Gerard had on his young contemporaries, as will be seen also by two of the photographic-copy items

(251-C), for in these three books (all published during his lifetime) the poet clearly appears as a fictional character.

G.W. Bullen was keeper of the printed books at the British Museum; his extraordinary journal for the years 1874-1876 contains a contemporary defense of the British naval forces (which had come under heavy press and diplomatic attack for inaction) for their behavior in December of 1875 in the *Deutschland* calamity, the event which led Hopkins to unleash his long-pent-up poetic genius in one of the religious masterpieces of the English language. Once he had been inspired by the *Deutschland* tragedy to resume his writing of poems, never again was Hopkins able to suppress his creative urge.

The Rossetti *Whitman* is included here because, heavily expurgated though it is (as a result of what now can only be called British prudery), it is the first edition of Whitman in England. Hopkins admits in a letter to Bridges his simultaneous admiration for and repugnance to the American poet. This latter fact remains one of interest to Hopkins scholars, for although he never—to our knowledge—elaborated upon his opinion of Whitman and although we do not know what works of Whitman he read—or when or from what publications (Whitman was being circulated widely in England before the Rossetti edition)—Hopkins's "Epithalamion" (one of his last and unfinished poems) bears obvious "Song of Myself" influence.

Volume two of the three-volume Shakespeare, first issued by Cassell in 1866, is included because it contains a full-page illustration of *Henry VIII* by Arthur Hopkins. The publishers write that since their records were destroyed by bombs in World War II, they cannot tell when this copy was printed but from the fact that a set of full-page original engravings have by some previous owner been bound into it, it is likely an early printing. Also, because Arthur has four full-page illustrations in the Shakespeare set, the publishers believe that it is possible Gerard may have seen the edition.

Photographic Copies

The photographs included here are copies of documents the originals of which could not be shown in the exhibition, but which should prove of interest because of their pertinence to the life of the poet. The microfilm and the photocopies of the Bodleian and Campion Hall archives represent a large percentage of Oxford University's holdings. In these manuscripts the poet's processes of revision are especially enlightening: Some of the mature poems go through as many as five revisions, with the revisions occurring at times on the same manuscript sheet. The Cyril Hopkins manuscript, which is a biographical sketch of Marcus Clarke, who was a childhood friend of the older Hopkins boys (particularly Gerard and Cyril) contains many references to Gerard. Strangely, this manuscript has never been printed. Most of the other

photographs described below in effect trace Hopkins from his birth to notices of his death in 1889.

The seven obituaries are of special interest in view of the fact that, although some of them mention Hopkins's talents in drawing and in music, incredibly not a single one of the notices mentions Hopkins as a poet.

Drawings

The eleven original drawings by Arthur Hopkins are noteworthy for a number of reasons. They are, to my knowledge, unpublished. Except for the pen-and-ink piece, which is signed but undated, these drawings were all produced between 1876 and 1879, which represent the period of the poet's mature years. Arthur, on occasion, submitted his drawings to Gerard for criticism, so that it is possible that the poet actually handled some of these particular pieces. On their own, the sketches reveal Arthur's skill, his sense of humor, and his wide interests with regard to subject matter.

—CARL SUTTON

Detailed bibliographical descriptions of the following items are recorded in essentially chronological order, except for the drawings by Arthur Hopkins, which are grouped together at the end of the other entries in this section.

237 Manley Hopkins. *The Philosopher's Stone, and Other Poems*. London: G.W. Nickisson, 1843.

238 Jeremy Taylor. *The Rule and Exercises of Holy Living*. London: W. Pickering, 1844.

239 [John Keble]. *The Christian Year: Thoughts in Verse for the Sundays and Holydays Throughout the Year*. Oxford: John Henry Parker, 1853.

240 Charles and Mary Cowden Clarke, eds. *The Plays of William Shakespeare*. 3 vols. Illustrated by various artists. London: Cassell Petter & Galpin, 1864.

Arthur Hopkins illustrated four of the plays: *King John, King Richard III, King Henry VIII*, and *Hamlet*. The illustration for *Henry VIII* was directly pressed from the metal engraving plate.

241 Gerard Manley Hopkins. An autograph letter signed Gerard M. Hopkins to MacFarlane and dated 15 July 1866; written on stationery of King's Head Hotel, Horsham.

242 Henry Parry Liddon. A Greeting Card to Gerard Manley Hopkins During Passion Week, 1866.

The obverse is a metal engraving illustration of Christ as the good pastor. On the reverse side is a prayer in Latin asking Christ to have mercy on us. The prayer was translated for the exhibition by Joseph J. Feeney. The card measures 4¾ x 3¼ ins.

243 William Michael Rossetti, ed. *Poems by Walt Whitman*. London: John Camden Hotten, Piccadilly, 1868.

244 Orby Shipley, ed. *Lyra Mystica: Hymns and Verses on Sacred Subjects, Ancient and Modern*. London: Longmans, Green, and Co., 1869.

245 Pascal Darbins. *Marie Lataste: vie et oeuvres*. 5th ed. Paris: Bray et Retaus, Successeurs, 1872.

This copy is a photographic facsimile of the original book.

246 Frederick Walker. Untitled: boys fighting. Pencil drawing. 4 x 3 ins. Undated.

This original pencil drawing is included in the exhibition because it was drawn during Hopkins's lifetime by one of his favorite artists.

247 Photocopy of a commemorative card (in Gothic type) for the five Franciscan nuns who died in the wreck of the *Deutschland*, December 1875, listing their names, ages, and the circumstances of their death, and commending them to the prayers of the faithful. Published at Salzkotten, Germany; text in German; dimensions: 4½ x 2½ ins.; on loan from Leo van Noppen.

248 G.W. Bullen. *Essays: Social and Political, 1874-76*. Privately printed.

While the index is handwritten in ink (smeared in places), the text of the book itself, though in cursive script, was apparently lithographed.

249 Nitram Tradleg. *A Son of Belial*. London: Trubner & Co., 1882.

250 Manley Hopkins. *Spicilegium Poeticum*. London: The Leadenhall Press, Ltd., n.d.

This copy was given by the author to his wife's brother, Edward Blount Smith (see inscription on first leaf and on p. 136 n.). The inscription is dated July 1892.

251 A collection of microfilm relevant to Hopkins:
 a. of all manuscripts in the Hopkins collection at the Bodleian Library, Oxford;
 b. of a selection of manuscripts in Campion Hall, Oxford (on loan from Todd K. Bender);
 c. of Marcus Clarke's *Holiday Peak and Other Tales* (1873) and *Chidiock Tichbourne* (1893) (from the State Library of South Australia, Sydney);
 d. of the manuscript of Cyril Hopkins's biographical notice of the life and work of Marcus Clarke (from the Mitchell Library, Sidney, Australia).

252 Photographic copies of Hopkins's manuscripts:
 a. of the entire Hopkins holdings at the Bodleian Library, Oxford;

b. of a selection of Hopkins's manuscripts in Campion Hall, Oxford (on loan from Todd K. Bender).

253 A xerox copy of the true copy of a birth certificate entry in the St. Francis Xavier baptismal register for Mercedes Ophelia Walsh, signed by Hopkins on 21 November 1880 (supplied by Margaret Bogan).

254 A photocopy of the baptism entry for Gerard Manley Hopkins.

This is a true copy of the baptism entry supplied by the Newham Library Service.

255 Certificate of Baptism.

This is a true copy of the baptismal register of Gerard Manley Hopkins supplied by the parish of Westham at St. John's Chapel at Ease, Stratford, in the County of Essex. The copy is dated 19 July 1983.

256 Photographic copy of Hopkins's final vows in his handwriting, taken at Roehampton, 15 August [?] 1882.

This copy was supplied to the exhibition by the archivist of the Vatican in Rome.

257 A photocopy of the certified copy of the death certificate of Gerard Manley Hopkins. This copy, dated 31 March 1966, was supplied by Margaret Bogan, who obtained it from the official records agency in Dublin, Ireland.

258 An obituary headed "Death of Rev. Gerard Hopkins, S.J."

This photocopy, supplied by Joseph J. Feeney, is of the notice which appeared on Saturday, 15 June 1889, in the Roman Catholic journal *The Tablet*.

259 A series of photostatic copies of obituaries of Hopkins:
Freeman's Journal, 10 June 1889, p. 5; *Freeman's Journal*, 12 June 1889, p. 6; *The Nation*, 15 June 1889, p. 8; and *Irish Times*, 12 June 1889, p. 3.

These copies were supplied by Joseph J. Feeney, who obtained them from the papers of the late Alfred Thomas at Church Street, London.

260 An obituary in *The Cholmeleian* 16, no. 67 (Oct. 1889): 179—the journal of Hopkins's old school, Highgate, London.

This copy was supplied by Joseph J. Feeney, who obtained it from the papers of the late Alfred Thomas at Church Street, London.

261 A six-page obituary appearing in the Roman Catholic journal *Letters and Notices* 20 (1889-1890): 173-179.

This copy was supplied by Rev. Eugene Rooney, Librarian, The Woodstock Library, Georgetown University, Washington, D.C.

262 Arthur Hopkins. *A Licensed Victualer*. Pencil drawing. 7 x 5½ ins. Unsigned. Dated: "24 Sept. 71."

DEATH has removed another of the Catholic Fellows of the Royal University. It is only a couple of months since we announced the death of Professor Ormsby, a distinguished English convert, who had laboured long for Irish Catholic Education. Rev. Gerard Hopkins, S.J., whose sad death occurred on Saturday, had not only as long a record in Ireland as his colleague, but he has a brilliant one in his own land. He was a distinguished graduate of Balliol College, Oxford, and a profound classical scholar. The free opinions of Professor Jowett drove him from the Anglican Church, and into the fold where he closed a short but distinguished career. After his conversion he joined the Jesuit Order. He was for a short period on the mission in Liverpool, but on the transfer of University College to its present management he found congenial work within it. As a professor, he aimed at culture as well as the spread of the knowledge of the facts of philology. His tastes were not confined to literature. He was a discriminating art critic, and his aesthetic faculties were highly cultivated. One would have said, before his fatal illness came upon him, that he was just ripe in mind with all his work before him, for he was only forty-four years of age. He will be missed even from the ranks of the learned Order of which he was a member.

Item 259: Photostatic copy of obituary of Hopkins from *The Nation*, 15 June 1889, p. 8.

263 _____. *In the grounds of Guy's Cliff.* Pencil drawing. 6 x 10 ins. Signed: Arthur Hopkins. Dated: "1st Sept., [*sic*] 1877."

264 _____. *Part of an Old Oak Cabinet at Guy's Cliff.* Pencil drawing. 6¾ x 5¼ ins. Unsigned. Dated: "1 Sept. 1877."

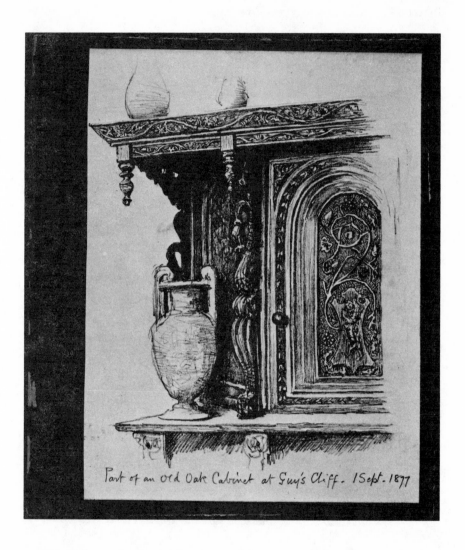

Item 264: Arthur Hopkins's pencil drawing, entitled *Part of an Old Oak Cabinet at Guy's Cliff*, dated: "1 Sept. 1877." 6¾ x 5¼ ins.

265 _____. *Up the Leam*. Pencil drawing. 5 x 9½ ins. Unsigned. Dated: "6 Sept. 1877."

266 _____. *Leycester's Hospital at Warwick*. Pencil drawing. 7 x 9¼ ins. Unsigned. Dated: "4 Sept. 77."

267 _____. *In the Deer Park / Stoneleigh Abbey*. Pencil drawing. 7 x 16 ins. Signed: Arthur Hopkins. Dated: "4 Sept. 1877."

268 _____. *Emma Rudlin at Porthgwarah*. Pencil drawing. 3½ x 3 ins. Unsigned. Dated: "23 Oct. 79."

269 _____. *Johnnie Rowe of Porthgwarah*. Pencil drawing. 3½ x 3 ins. Unsigned. Dated: "15 Oct. 1879."

270 _____. Untitled: a bearded old man with a long stick in his left hand. Pencil drawing. 7 x 4½ ins. Unsigned. Dated: "26 Feb. 1881."

271 _____. *Whitby*. Pencil drawing. 4¾ x 8½ ins. Unsigned. Dated: "13 Sept. 1887."

272 _____. *Blackberrying*. Pen-and-ink drawing. 10 x 9 ins. Signed: Arthur Hopkins. Undated.

273 _____. Pencil drawing. Severely damaged label in Arthur Hopkins's hand: ". . . Sketch Book / Arthur Hopkins / Hurstleigh / Arkwright Road / Hampstead." 3 x 6¾ ins. Undated.

274 _____. Damaged label from a pencil sketchbook in Arthur's hand: "No. 5 / Leaves from a Pencil Sketch Book / Arthur Hopkins / Hurstleigh / Arkwright Road / Hampstead." 4 x 6 ins. Undated.

Item 471: Ernst Wahlert's *The Sea and the Skylark II* (1966), egg-tempera on canvas. 35 x 18 ins.

The Presence of Hopkins in the World Today

In view of the theme of this commemorative celebration, it is fitting that this should be the largest and most pertinent section of the exhibition. The pieces assembled here have as their purpose to present incontrovertible evidence that Hopkins, who died in effect unknown as a creative writer and who in his last years considered his life fruitless, has, since the belated publication of his "complete" poems in 1918, become a living influence in every conceivable medium of human communication. His writing has entered the fields of children's books, secondary school textbooks, and college and university courses, as well as being anthologized in every respectable collection of English-language poetry representing the best work of the nineteenth and twentieth centuries. In addition to his original English, Hopkins's poetry has been published throughout the world in a dozen different languages.

Two thriving serial journals are devoted entirely to Hopkins and to those figures who enjoy whatever fame they possess because of their relationships with the poet. One other journal—*The Hopkins Research Bulletin*—dissolved in 1976 after accomplishing during seven years of publication what was apparently its primary purpose: to foster the recognition of Hopkins with a marble slab in the Poet's Corner of Westminster Abbey (the first Roman Catholic to be so honored in more than two hundred years), placed most appropriately as a bridge linking the slabs of Tennyson and Browning with those of Eliot and Auden. Special issues of a number of important journals have been devoted entirely to Hopkins.

Almost every conceivable type of creative literature—poetry, drama, novels, satires, personal essays, television scripts, the list goes on—has drawn upon the work of Hopkins as source material. More recently his poetry has even found its way into the high-tech world, with two concordances of his poems having been computer generated. At least a score of the most eminent post-World-War II musical composers (as well as a like number of lesser composers) have created music—vocal and instrumental—based on his poetry and on his coined concepts of *instress* and *inscape*. Small private letterpress printers have created strikingly beautiful tributes to the poet: at least two of these presses—Inversnaid and Penmaen—are named for Hopkins poems; and if the prestigious Windhover Press is not named in his memory, it most surely conjures up one of his most famous poems.

133

Hopkins's manuscripts are listed in rare-book catalogues and now bring stunning prices at auctions.

In this exhibition—which is certainly not exhaustive—at least twenty-five different types of iconography (comprising more than one hundred and fifty different pieces of original art and representing forty-five different artists—from the amateur to the most highly professional) are on display, ranging from the photographically representational to the most abstract.

Hopkins, unknown to the general public in his lifetime, now is written about in newspapers—from the most prestigious, such as the London *Times Literary Supplement*, to the local, such as the *Fort Worth Star-Telegram*; in widely circulated magazines such as *Reader's Digest*; and even in Protestant church bulletins. Various ephemera quote and picture Hopkins (such as stationery, calendars, and greeting cards), some of it quite beautiful and worth exhibiting if there were space. Through his work the poet has enriched the English language, with the *Oxford English Dictionary* defining and ascribing to him at least seven terms: *inscape, instress, outride, outriding, outscape, overthought,* and *sprung rhythm.*

Innumerable conferences, symposia, public lectures, seminars, and other kinds of well-publicized celebrations of the poet have occurred since World War II. In this exhibition, no effort has been made to represent the hundreds upon hundreds of theses, dissertations, and articles appearing in academic journals theorizing about every facet of the man's personality, thought, and behavior. The rare exception to this is the inclusion of a few studies not in English.

Now, at last, whatever God there is has surely—one hundred years after the poet's untimely death—finally indeed sent Gerard's roots rain.

—Carl Sutton

In addition to the collections of works by Hopkins already discussed as establishing the poet's canon, those literary editions which appeared only after World War II number at least ten. While all of these are of importance as evidence of Hopkins's growing reputation and abiding popularity, most of them are also introduced by astute critical commentary, provoking re-examination and providing new insights into the poems themselves. Among this selection of books the most striking fact is that since the first appearance in 1953 of the Penguin edition of Hopkins's poems and prose, this volume has to date gone through thirty separate reprintings, representing, according to Penguin officials, one of the most popular poetry books the firm has ever published, with an estimated 30,000 copies in print.

275 Gerard Manley Hopkins. *Some Poems of Gerard Manley Hopkins.* Edited by Michael White. London: Michael White, 1945.

276 _____. *The Poets of the Year: Selections from the Note-Books of Gerard Manley Hopkins.* Edited by T. Weiss. Norfolk, CT: New Directions, 1945.

277 _____. *A Hopkins Reader.* Selected and with an introduction by John Pick. New York: Oxford University Press, 1953.

278 _____. *Selected Poems of Gerard Manley Hopkins.* Edited with an introduction and notes by James Reeves. Melbourne: William Heinemann Ltd., 1953.

279 _____. *Poems and Prose of Gerard Manley Hopkins.* Edited by W.H. Gardner. Harmondsworth, Middlesex, England: Viking Penguin, Inc., 1953.

280 _____. *New Oxford English Series.* General Editor: A. Norman Jeffares. *Hopkins Selections.* Edited by Graham Storey. London: Oxford University Press, 1967.

281 _____. *Look up at the Skies!* Poems and prose chosen and introduced by Rex Warner. Illustrated by Yvonne Skargon. London: The Bodley Head Ltd., 1972.

282 _____. *Poems by Gerard Manley Hopkins.* Selected and edited by Norman H. MacKenzie. London: The Folio Society, 1974.

283 _____. *Poetry and Prose.* Selected and edited with an introduction and notes by K.E. Smith. Exeter: A. Wheaton & Company, 1976.

284 _____ . *The Major Poems.* Edited, with an introduction and notes, by Walford Davies. London: J.M. Dent & Sons Ltd., 1979.

285 _____ . *Selected Prose.* Edited by Gerald Roberts. Oxford: Oxford University Press, 1980.

TRANSLATIONS

Because of the active Jesuit organization in Japan, Hopkins appears in Japanese translation in some eight volumes. He also appears voluminously in French. Although scholars from Spain, Chile, and Paraguay have rendered his works into Spanish, it is surprising how little attention has been paid the poet in Latin America, particularly in view of the number of Jesuit educational institutions of advanced learning in that part of the New World. For example, I have been unable to locate any work on Hopkins in Mexico. There are a number of German translations, and a young group of Dutch scholars is continuing to make Hopkins available in their language, following the attention paid the poet by the late eminent W.A.M. Peters. Other Hopkins translations include those into the Scots dialect and into Esperanto, but by far the most exotic is a translation into Urdu of an article by Norman H. MacKenzie about detective work with Hopkins manuscripts.

286 In Japanese: a) Hopkins's *Poems* (4th Ed.), translated by S. Yasuda and T. Ogata; b) Norman H. MacKenzie's *Hopkins*, translated by Y. Ibuki; c) *The Reception of Hopkins* [in Japan], edited by A. Tsutsumi; d) *Hopkins's Mind*, edited by S. Yasuda; e) Bernard Bergonzi's *Gerard Manley Hopkins*, edited by A. Tsutsumi; f) *The Hopkins Society in Japan*, by S. Omichi.

287 In French: a) *Carnets/Journal/Lettres*, translated by Hélène Bokanowski and Louis-René des Forêts; b) *Grandeur de Dieu et Autres Poèmes*, translated by Jean Mambrino; c) *Trois Poètes: Hopkins, Yeats, Eliot*, by Georges Cattaui; d) *Poèmes Accompagnés de Proses et de Dessins*, chosen and translated by Pierre Leyris; e) *Poèmes*, translated with an introduction and notes by Jean-Georges Ritz; f) *Reliquiae: Vers, Proses, Dessins*, compiled and translated by Pierre Leyris; g) *Le Poète Gerard Manley Hopkins, S.J., 1844-1889: L'homme et L'oeuvre*, by Jean-Georges Ritz.

288 In Italian: a) *I fogli della Sibilla: Retorica e medievalismo in Gerard Manley Hopkins*, by Franco Marucci; b) *The Wreck of the Deutschland*, edited by Paola Bottala Nordio.

289 In Spanish: a) *Gerard Manley Hopkins*, by José Antonio Muñoz Rojas; b) *Negado/Buscado/Revelado*, by Renato Hasche; c) *Antología Bilingüe*, introduced and translated by Manuel Linares Megías.

290 In German: *Gerard Manley Hopkins: Gedichte, Schriften, Briefe*, by Wolfgang and Ursula Clemen.

291 In Dutch: a) *Gevlekte pracht: de Poezie van Gerard Manley Hopkins*, by Leo van Noppen; b) *G.M. Hopkins Gedichten*, ed. W. Bronzwaer.

292 In Scots: *Translations into the Scots Tongue of Poems by Gerard Manley Hopkins*, by Edith Anne Robertson.

293 In Esperanto: *Poemoj*, by Kris Long.

294 In Urdu: A translation by an unidentified translator of Norman H. MacKenzie's article in the *Bodleian Library* relative to problems in deciphering Hopkins's manuscripts.

HOPKINS PUBLISHED IN ENGLISH OUTSIDE ENGLAND, THE UNITED STATES, AND CANADA

Further evidence of the world-wide interest in Hopkins is found among books in English published outside England, the United States, and Canada. Although I have been able to obtain copies of only two Polish books about the poet in English, which is a required language in Polish education, other books do exist with translations of Hopkins into the Polish language. One of the two Polish works in this exhibit is a textbook; the other is a critical study of the peculiarities of structure in Hopkins's poetry. A number of academic studies of the poet have appeared in South Africa, and at least two book-length studies of the poet have been published in India. Seamus Heaney, arguably the most important living Irish poet, both freely admits his great and enduring debt to the Englishman and writes with feeling about Hopkins's contribution to the world of poetry. By far the most prolific production of Hopkins studies in English outside of England comes from Australia.

295 Ireland: *The Fire i' the Flint: Reflections on the Poetry of Gerard Manley Hopkins*, by Seamus Heaney.

296 Poland: a) *Structural Principles of Gerard Manley Hopkins' Poetry*, by Krystyna Kapitulka; b) *English Poetry of the Nineteenth Century*, edited by Wanda Krajewska.

297 South Africa: a) "'No Worst There is None,' and King Lear: An Experiment in Criticism," by C.O. Gardner; b) "Gerard Manley Hopkins and the Poetry of Inscape," by W.H. Gardner.

298 India: a) *Understanding Hopkins*, by A. Devasahayam; b) *Gerard Manley Hopkins: The Man and the Poet*, by K.R. Srinivasa Iyengar.

299 Australia: a) *Unspeakable Stress*, by H.P. Heseltine; b) *The Poetry of Gerard Manley Hopkins*, by D.P. McGuire; c) *The Poetry of Gerard Manley Hopkins*, by Edgar Castle; d) "Gerard Hopkins and Marcus Clarke," by Brian Elliott; e) *Gerard Manley Hopkins: Priest and Poet*, by J.C. Reid; f) *Beauty and Belief*, by Hilary Fraser.

SCHOLARLY PUBLICATIONS DEVOTED ENTIRELY TO HOPKINS

While it was alive from 1970 into 1976, *The Hopkins Research Bulletin*, issued by The Hopkins Society and edited and published in London primarily by the late Alfred Thomas, did much to promote interest in and appreciation of Hopkins. The *Bulletin* published for the first time a number of newly-discovered Hopkins manuscripts, for seven years sponsored annually a public lecture delivered by a distinguished scholar, and for each of the same seven years commissioned a sermon in Hopkins's honor to be delivered by an eminent cleric. Through the aid of contributions from *Bulletin* subscribers, The Hopkins Society secured the Hopkins memorial in Westminster Abbey. Under the leadership of Richard Giles, the International Hopkins Association, which was founded to succeed The Hopkins Society (dissolved in 1976), furthered the fostering of Hopkins scholarship and interest in the poet by continuing to publish the *Quarterly*, which began in 1974 as an independent journal but became the official publication of the IHA in 1976. At irregular intervals, the IHA also issues newsletters and book-length monographs to its members. The other current journal devoted entirely to Hopkins studies is *Hopkins Research*, begun in 1972 and published in Japan. For the centennial year a number of scholarly periodicals are planning special issues devoted entirely to Hopkins. The two available at the moment are the spring 1988 issue of *Studies in the Literary Imagination* and the spring 1989 issue of *Texas Studies in Literature and Language*.

300 *New Verse*. No. 14 (April 1935). The entire issue is devoted to Hopkins.

Although this publication, because of its date, does not properly belong in this exhibition, it is included since, to my knowledge, it is the first serial publication to devote an entire issue to Hopkins.

POLSKA AKADEMIA NAUK

ODDZIAŁ W POZNANIU

KRYSTYNA KAPITUŁKA

STRUCTURAL PRINCIPLES
OF GERARD MANLEY HOPKINS'
POETRY

PAŃSTWOWE WYDAWNICTWO NAUKOWE

Item 296: Cover of Krystyna Kapitulka's *Structural Principles of Gerard Manley Hopkins' Poetry.*

301 *The Hopkins Research Bulletin.* London: The Hopkins Society. A complete run, 1970-76.

302 *Hopkins Research.* The Hopkins Society of Japan. A broken run, 1972-78.

303 *The Hopkins Quarterly.* A complete run from vol. 1, no. 1 (April 1974) to the present. Originally edited by John R. Hopkins and Richard F. Giles; now edited by Richard F. Giles with the assistance of Mary Jo Calarco. Originally described as "a journal devoted to critical and scholarly inquiry into the life and ways of Gerard Manley Hopkins"; now broadened to include articles concerned with Robert Bridges, Richard W. Dixon, and Coventry Patmore. Currently published at Mohawk College, Hamilton, Ontario, Canada.

304 Trevor Huddleston. *Gerard Manley Hopkins.* First annual Hopkins sermon; preached at St. John's Parish Church, Stratford, Essex, 18 October 1969, on the occasion of the celebration of the 125th anniversary of the birth of Gerard Manley Hopkins. London: The Hopkins Society, 1969.

305 Thomas D. Roberts. *Father Gerard Manley Hopkins, S.J.* Second annual Hopkins sermon; preached at St. John's Parish Church, Hampstead, London, 28 June 1970, on the occasion of the celebration of the 126th anniversary of the birth of Gerard Manley Hopkins. London: The Hopkins Society, 1969.

306 E.G. Rupp. *Gerard Manley Hopkins and the "Theology of the Cross."* Third annual Hopkins sermon; preached at St. Michael's Parish Church, Highgate, London, 6 June 1971, on the occasion of the celebration of the 127th anniversary of the birth of Gerard Manley Hopkins. London: The Hopkins Society, 1971.

307 Hugh Montefiore. *Gerard Manley Hopkins.* Fourth annual Hopkins sermon; preached at the Church of the Immaculate Conception, Farm Street, London, 4 June 1972, on the occasion of the celebration of the 128th anniversary of the birth of Gerard Manley Hopkins. London: The Hopkins Society, 1972.

308 Thomas Corbishley. *Gerard Manley Hopkins.* Fifth annual Hopkins sermon; preached at Holy Trinity Church, Roehampton, London, 3 June 1973, on the occasion of the celebration of the 129th anniversary of the birth of Gerard Manley Hopkins. London: The Hopkins Society, 1973.

309 Ulrich Simon. *Hopkins and Alienation.* Sixth annual Hopkins sermon; preached at St. John's Church, Hampstead, London, 9 June 1974, on the

occasion of the celebration of the 130th anniversary of the birth of Gerard Manley Hopkins. London: The Hopkins Society, 1974.

310 Martin D'Arcy. *Christ's Mastery*. Seventh annual Hopkins sermon; preached at the Church of The Immaculate Conception, Farm Street, London, 8 June 1975, on the occasion of the celebration of the 131st anniversary of the birth of Gerard Manley Hopkins. London: The Hopkins Society, 1975.

311 Barbara Hardy. *Forms and Feelings in the Sonnets of Gerard Manley Hopkins*. London: The Hopkins Society, 1970. The Hopkins Society First Annual Lecture.

312 F.R. Leavis. *Gerard Manley Hopkins: Reflections After Fifty Years*. London: The Hopkins Society, 1971. The Hopkins Society Second Annual Lecture.

313 Kathleen Raine. *Hopkins, Nature and Human Nature*. London: The Hopkins Society, 1972. The Hopkins Society Third Annual Lecture.

314 Winifred Nowottny. *Hopkins's Language of Prayer & Praise*. London: The Hopkins Society, 1973. The Hopkins Society Fourth Annual Lecture.

315 W.W. Robson. *Hopkins and Literary Criticism*. London: The Hopkins Society, 1974. The Hopkins Society Fifth Annual Lecture.

316 Bernard Bergonzi. *Hopkins the Englishman*. London: The Hopkins Society, 1975. The Hopkins Society Sixth Annual Lecture.

317 Norman H. MacKenzie. *Resources of Language & Imagery in "The Wreck of the Deutschland."* London: The Hopkins Society, 1976. The Hopkins Society Seventh Annual Lecture.

318 A complete run of the International Hopkins Association Monograph Series; edited by Richard F. Giles:

Edward Stephenson. *What Sprung Rhythm Really Is*. Monograph 4.
Leo M. van Noppen, *The Critical Reception of Gerard Manley Hopkins in the Netherlands and Flanders*; and René Gallet, *Hopkins en France*. Monograph 1.
W.A. Peters. *Gerard Manley Hopkins / A Tribute*. Monograph 2.
Richard F. Giles. *Hopkins among the Poets: Studies in Modern Responses to Gerard Manley Hopkins*. Monograph 3.

Item 324: Dust jacket of Anthony Burgess's *This Man and Music* (1982). An essay entitled "Nothing is so Beautiful as Sprung" discusses Hopkins's theories of music, and the musicality of his poetry.

319 *The International Hopkins Association Newsletter*. Ed. Richard F. Giles and Michael D. Moore. A complete run from 1979 to the present.

320 *Centenary Revaluation of Gerard Manley Hopkins*. Special issue of *Studies in the Literary Imagination*. Ed. Eugene Hollahan. Vol. 21, no. 1 (Spring 1988). Atlanta, GA: Georgia State University.

321 *Gerard Manley Hopkins: A Centenary Celebration*. Special issue of *Texas Studies in Literature and Language*. Ed. Jerome F. Bump and William J. Scheick. Vol. 31, no. 1 (Spring 1989). Austin, TX: The University of Texas at Austin.

CREATIVE LITERATURE BASED ON HOPKINS

There are, I believe, no types of creative literature for which Hopkins has not served as source material. Entire books of poetry have been written about him. Four plays—none of them yet commercially published but all four frequently performed throughout the British Isles and the United States—are concerned with different aspects of the poet. Aware of Gerard's own occasional ability to laugh at the foibles of humankind (including himself), there is no reason to suppose that he would not appreciate the parodies and satires directed at his work. Anthony Burgess has written an obscene—or hilarious, depending on the individual's point of view—novel based on *The Wreck*, as well as a cogent personal essay about the poet's efforts at musical composition. Single episodes of two popular television series have been built around Hopkins poems: official copies of the scripts of these shows are included here. Other creative efforts of significance because of their potential impact on the general public are discussed in the Popular Media section of the exhibition. Hopkins is alluded to and quoted in scores of novels. Some of these citations have been included, but their scarcity is a genuine weakness of this exhibition. There must be more than ample material for a number of graduate-student papers on the uses to which writers have put the poet in, especially, novels.

322 David Annett. "Gerard Manley Hopkins (1844-1889)." A poem in *The Brand-X Anthology of Poetry* [A Parody Anthology]. Burnt Norton Edition. Ed. William Zaranka, University of Denver. Cambridge: Apple-Wood Books, Inc., 1981.

323 Anthony Brode. "Breakfast with Gerard Manley Hopkins." A poem in *The Brand-X Anthology of Poetry* [A Parody Anthology]. Burnt Norton

Edition. Ed. William Zaranka, University of Denver. Cambridge: Apple-Wood Books, Inc., 1981.

324 Anthony Burgess. "Nothing is so Beautiful as Sprung." A personal essay in *This Man and Music*. London: Hutchinson, 1982.

325 _____. *The Clockwork Testament or Enderby's End*. A novel based on *The Wreck of the Deutschland*. New York: Alfred A. Knopf, 1975.

326 William Van Etten Casey. *Immortal Diamond–A Jesuit in Poets Corner*. An unpublished one-man play. Accompanied by a playbill.

327 Philip Dacey. *Gerard Manley Hopkins Meets Walt Whitman in Heaven and Other Poems*. Wood engravings by Michael McCurdy. Great Barrington, MA: Penmaen Press, 1982.

Each of the seventy-one poems in this volume is based on a quotation from Hopkins—some from his poems, some from his prose.

328 Ernest Ferlita. *Hopkins Proclaimed*. An unpublished one-man play.

329 Peter Gale. *"Hopkins!"* An unpublished one-man play. Accompanied by a playbill.

330 Monk Gibbon. *Seventeen Sonnets*. London: Joiner and Steele, 1932.

According to Gibbons, "These sonnets are dedicated to the memory of Gerard Manley Hopkins, the influence of whose work will be seen in some, if not in all."

331 Eugene Hollahan. "The Wind at Hopkins' Corner." A poem in *GSU Review*. Georgia State University, Fall 1987.

332 Marcella M. Holloway. *The Legend of St. Winefred (A Chancel Drama)*. An unpublished play.

333 A.D. Hope. "Alfred Lord Tennyson's Reply to Father Gerard Manley Hopkins." A poem in *A Book of Answers*. London: Angus and Robertson Publishers, 1978.

334 David Hovatter. *Gerard Manley Hopkins—The Caged Skylark*. An unpublished one-man play. Accompanied by a playbill.

Item 324: Page from Anthony Burgess's "Nothing is so Beautiful as Sprung," *This Man and Music* (1982). Burgess writes that the above is a "quasi-musical transcription of the sestet of *The Windhover*. It will not please literary academics, but musicians will understand."

335 T. Harri Jones. "A Rule of Three Sum Wrong." A poem in *The Collected Poems of T. Harri Jones*. Edited and with an introduction by Julian Croft and Don Dale-Jones. Llandysul, Dyfed, Wales: Gomer Press, 1977, 1987.

336 Joyce Kilmer. "Father Gerard Hopkins, S.J." A poem in *Joyce Kilmer*. Edited with a memoir by Robert Cortes Holliday. Vol. 1: *Memoir and Poems*. New York: George H. Doran Co., 1918.

337 Robert Lowell. "Hopkins's Sanctity." An essay in *Collected Prose*. Edited and with an introduction by Robert Giroux. New York: Farrar/Straus/Giroux, 1987.

338 Jimmy McGovern. *Felix Randal*. A fictional account of what might have prompted Hopkins to write his famous poem, "Felix Randal." Broadcast over BBC Radio at 2:30, Sunday, 9 November 1986.

Item 340: Samuel Barber's "A Nun Takes the Veil" from his *Four Songs for Voice and Piano* (1941).

This is a brilliant—but vicious—picture of Hopkins's activities in Liverpool. There is no documentary evidence to support Hopkins as the unsympathetic—even cruel—priest McGovern pictures him to be.

339 Edwin Morgan. "G.M. Hopkins in Glasgow (For J.A.M.R.)." A poem in *Sonnets from Scotland*. Glasgow: Mariscat, 1984.

MUSICAL SCORES

Most critics—but not all—of Hopkins's musical efforts (which, for whatever reasons, the poet experimented with more and more in his last few years, to the detriment of the quantity—but most emphatically not to the quality—of his poetic output) consider his compositions and his understanding of musical problems amateurish. Most certainly, however, eminent composers since World War II have been entranced by the musical potentials of Hopkins's poetry. No fewer than forty-five composers have created at least fifty musical settings for more than thirty different Hopkins poems. Two others have named works after Hopkins's concept of inscape. Every conceivable type of music has been used to interpret the poet. One piece of music by a young Texas composer will be given its world premiere during this exhibition. A sampling of these compositions is on display and is described in some detail in the bibliographical entries below.

340 Samuel Barber. *Four Songs for Voice and Piano*. Opus 13, no. 1. [N.Y.: G. Schirmer, Inc., 1941].

One of the songs in this composition is the musical setting for "*A Nun Takes the Veil / Heaven-Haven.*"

341 Lennox Berkeley. *Autumn's Legacy*. Opus 58. For high voice and pianoforte. Commissioned by the committee of the Cheltenham Festival, 1962. First performed by Richard Lewis and Geoffrey Parsons. London: Chester Music, 1961.

There are seven songs in this composition, one of which is "Hurrahing in Harvest."

342 Arthur Bliss. *The World is Charged with the Grandeur of God*. Sevenoaks, Kent: Novello, 1970. Vocal score of cantata for soprano, alto, tenor, and bass, with two flutes and brass. Written for the 1969 Aldeburgh Festival. Dedicated to Peter Pears, who selected the poems.

147

Three pieces in this composition are, as entitled by Bliss, *The World Is Charged with the Grandeur of God* (i.e., "God's Grandeur"), *I Have Desired to Go Where Springs Not Fail* (i.e., "Heaven-Haven"), and *Look at the Stars* (i.e., "The Starlight Night").

343 William Cleary. Revised versions of Cleary's music based on two Hopkins poems: *God with Honor / At the Wedding March* and *Margaret Are You Grieving / Spring and Fall: To a Young Child*. Unpublished.

344 Aaron Copland. *Inscape*. London: Boosey and Hawkes, 1968. Commissioned by the New York Philharmonic in celebration of its 125th anniversary season, 1842-1967. First performed at Ann Arbor, Michigan, 13 September 1967, conducted by Leonard Bernstein.

This composition is based, not on words by Hopkins, but on his theory of inscape—i.e., according to W.H. Gardner, suggesting a "quasi-mystical illumination, a sudden perception of that deeper pattern, order and unity which gives meaning to external forms."

345 Ray Dane. *Peace*. Unpublished, 1988. A holograph copy of a piano solo based on the Hopkins poem "Peace," specially composed for this exhibition.

346 Michael G.S. Dunham. *Eight Songs by Gerard Manley Hopkins*. Unpublished.

These songs are edited and arranged for performance with accompaniments reconstructed by Dunham according to Hopkins's own instructions. They were performed in a special broadcast in honor of Hopkins on Radio KNIK-FM Anchorage, Alaska, 1976. The eight compositions by Hopkins are these:

> *The Battle of the Baltic* (words by Thomas Campbell);
> *I Love My Lady's Eyes* (words by Robert Bridges);
> *Hero's Dirge* (words by William Shakespeare);
> *From "The Winter's Tale"* (words by William Shakespeare);
> *Past Like Morning* (words by John Bridges);
> *Fallen Rain* (words by Richard Watson Dixon);
> *Invitation to the Country* (words by Robert Bridges); and
> *What Shall I Do* (words by Hopkins himself).

347 Karl Heinz Fussl. *Concerto Rapsodico*. Vienna: Universal Edition, 1964. For mezzosoprano and orchestra.

This score is dedicated to Igor Stravinsky, and is a musical setting of the Hopkins fragment beginning "Repeat that, repeat."

348 Anthony Gilbert. *Inscapes*. London: Scott Music Publishers, [1975]. Composed for soprano and small instrumental ensemble. Commissioned for Jane Manning and Matrix by Ceolfrith Arts, Sunderland, with funds provided by the Arts Council of Great Britain.

This composition was given its world premiere on 8 June 1975, as part of the 1975 exhibition in London to celebrate the centenary of the "Wreck of the Deutschland." This copy is inscribed and signed by Gilbert.

349 Mary A. Joyce. A copy of the music sung in Marcella Holloway's chancel drama, *The Legend of St. Winefred*. Unpublished.

350 Ernst Krenek. *Four Songs*. London: Bärenreiter, 1947, 1970. Introduced in 1961 at a performance by the organization London Concert of New Music. For high voice and piano.

This composition consists of musical settings for "Peace"; "Patience, Hard Thing"; and "Moonrise."

351 Elizabeth Maconchy. *The Leaden Echo and the Golden Echo*. London: Chester Music, 1981. Commissioned by the William Byrd Singers of Manchester with funds provided by the Arts Council of Great Britain. First performed on 25 November 1978. For mixed choir with alto flute, viola, and harp.

352 _____. *Three Settings of Poems by Gerard Manley Hopkins*. London: Chester Music, n.d. For soprano and chamber orchestra.

In this composition, Maconchy sets to music "The Starlight Night," "Peace," and "The May Magnificat."

353 _____. *Two Settings of Poems by Gerard Manley Hopkins*. London: Chester Music, 1982. For choir and brass. Vocal score. Composed for the choirs of Salisbury, Chichester, and Winchester Cathedrals.

The two poems used are "Pied Beauty" and "Heaven-Haven."

354 John Paynter. *God's Grandeur*. London: Oxford University Press, 1975. Commissioned for the 1974 season of the Toronto Mendelssohn Choir and the Festival Singers of Canada. For mixed chorus, brass, and organ or chorus and organ. Vocal score. Dedicated to Elmer Iseler.

This composition consists of musical settings for six poems—four by George

Herbert, two by Hopkins: "That Nature Is a Heraclitean Fire" and "God's Grandeur."

355 Wayne Peterson. *Earth, Sweet Earth*. A cappella, for four-part chorus of mixed voices. Xerox copy. No place: Lawson-Gould Music Publishers, 1956. Supplied by Margaret Bogan.

This composition is a vocal setting of the Hopkins sonnet "Ribblesdale."

356 Daniel Pinkham. *Eight Poems of Gerard Manley Hopkins*. For baritone or tenor-baritone and viola. Boston: E.C. Schirmer Music Co., 1970.

The eight poems are "Jesus to Cast One Thought Upon"; "Spring"; "Heaven-Haven"; "Pied Beauty"; "Strike, Churl"; "Spring and Fall"; "Christmas Day"; and "Jesus That Dost in Mary Dwell."

357 Ned Rorem. *Spring*. New York: Boosey and Hawkes, Inc., 1953. Xerox copy supplied by Margaret Bogan.

The words are those of the Hopkins sonnet of the same title.

358 _____. *Spring and Fall*. [N.p.]: Mercury Music Corporation, 1947. Xerox copy supplied by Margaret Bogan.

The words are those of the Hopkins poem of the same title.

359 Edmund Rubbra. *Inscape*. Opus 122. Suite for mixed voices, strings, and harp (or pianoforte). South Croydon, Surrey: Alfred Lengnick and Co. Ltd., 1965. Commissioned for the Stroud Festival of Religious Drama and the Arts, 1965.

This composition sets to music "Pied Beauty," "The Lantern Out of Doors," "Spring," "God's Grandeur," and the fragment "Summa." This copy is autographed by Rubbra and Peter Gellhorn.

360 Michael Kemp Tippett. *The Windhover*. London: Schott and Co., Ltd., 1943. Rehearsal vocal score for soprano, alto, tenor, and bass, with piano.

The words are those of the Hopkins sonnet.

Small private presses have paid homage to Hopkins by producing hand-made or limited editions beautifully bound and, in most instances, illustrated with original art printed directly from the blocks or plates. The exhibition includes productions from twelve different printers, each unique in its own way. One of the most interesting is the volume of sonnets published by the Pterodactyl Press, which claims to be the only printing of Hopkins's long-line sonnets not to break the lines by using half foldout sheets for these poems. The rarest of these books are the fifteen handmade volumes by Frederic Prokosch: each exists in only five copies, each copy on a different kind of paper, and each decorated with a unique abstract watercolor by Prokosch. My interest in the Dacey book is so personal that I have devoted to it an entire display case. The private press editions are described in some detail in the bibliographical entries below.

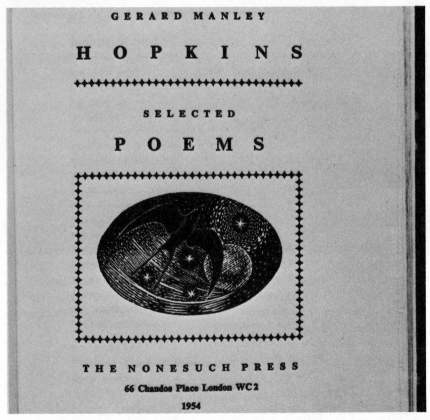

Item 362: Title page of the Nonesuch Press edition of Hopkins's *Selected Poems* (1954), illustrated by Kenneth Lindley.

151

361 Gerard Manley Hopkins. *The Vision of the Mermaids*. Illustrated by Hopkins himself. London: Oxford University Press, 1929.

This exact facsimile edition of the handwritten original, limited to 250 copies of which this is number 182, is the first complete edition of the poem. It is bound in paper boards, patterned in black and white, with a black cloth spine. Hopkins dates the poem "Christmas 1862."

362 _____. *Selected Poems*. Selected by Francis Meynell. Illustrated by Kenneth Lindley. London: The Nonesuch Press, 1954.

This book is number 393 of 1100 numbered copies, with a decorative binding and slipcase consisting of leaf motifs in tan, gold, and brown on a lighter brown background with tan rope-like stripes running vertically. Lindley's illustration in brown ink on the title page is apparently representative of a number of the poems but is dominated by a windhover.

363 _____. *Poems by Gerard Manley Hopkins*. Selected and edited by Norman H. MacKenzie. Frontispiece portrait specially engraved by Peter Reddick. London: The Folio Society, 1974.

This book is bound in light-blue cloth with a quarter leather dark-blue spine, printed in green and black, with each poem beginning on a separate page. The slender volume of 163 pages contains all of the major poems followed by editorial notes. There are decorative end papers in purple and white. The tops of the leaves are stained purple and the crinkled slip-case is of a blue closely matching the cloth binding.

364 _____. *Inversnaid*. Beaumont, TX: Inversnaid, [1977].

This letterpress printing of the poem is "By way of announcing the establishment of a private press—Inversnaid." The green paperback "announcement" contains an introduction quoting a Hopkins letter about Inversnaid, a reproduction of Hopkins's drawing of a beech tree, the poem itself, and an explanation of the intentions of the press. The booklet is enclosed in a green envelope. This copy is number 8 of 100.

365 _____. *Sonnets*. San Francisco: The Pterodactyl Press, 1980.

This book, one of 450 copies, is handset in 14-point centaur and printed on a Thomson letterpress. The cover papers are hand marbled, thus making the binding of each copy unique. Among the remarkable features of this edition is the fact that apparently for the first time, through the use of foldout pages,

Hopkins's long-lined sonnets are printed unbroken, as presumably the poet envisioned them.

366 _____. *Epithalamion*. Illustrated by linocuts by J. Martin Pitts. [London?]: The Kouros Press, 1982.

This publication is bound in light-blue paper with one linocut illustration on the cover and another on the verso of the title page, the subject of both being a group of nude males bathing in a natural swimming hole. Excluding the covers, the booklet consists of four unnumbered leaves and is printed in two colors by hand in a limited edition of 100 copies. This copy, number 23, is signed in pencil by the artist.

367 _____. A series of 15 handmade and handwritten books containing selections or excerpts of Hopkins's poetry executed by Frederic Prokosch. Each book has a tipped in, hand-painted, signed illustration by Prokosch. Plan de Grasse, France: Prometheus Press, 1982, 1983, 1984.

Each booklet measures 6 x 4½ ins. and is covered in a stiff orange cover with a pasted-on label in Prokosch's hand, naming the poem or excerpt and naming the author. There are only five copies of each booklet, each on a different kind of paper, each being assigned a number using the Greek alphabet, and each signed "F. Prokosch." These 15 copies apparently represent a complete set of the project, although Prokosch had originally intended for the series to consist of 20 different titles.

368 _____. *Penmaen Pool*. Letterpress; privately printed. One of 100 copies. Birmingham, England, 1985.

369 _____. *Poems of Gerard Manley Hopkins*. With an introduction by Ernest Ferlita. Nevada City, CA: Harold Berliner, 1986.

This clothbound book with a title label pasted on the spine was issued in 1986 to celebrate the centennial of Gonzaga University, Spokane, Washington. Of the 750 copies printed, this is numbered 327.

370 _____. *Inversnaid*. Colorado Springs, CO: The Press at Colorado College, [1988].

Item 366: Cover of the Kouros Press's edition of *Epithalamion* (1982), illustrated with linocuts by J. Martin Pitts.

Planned and executed by James Trissel, head of the Press, and six of his students, this book is "frankly experimental in character" and consists of ten panels. The first panel contains the author's name and the title; the last panel is the colophon. Each of the eight intervening panels contains two lines of the poem. Each of the ten panels is decorated with multi-colored abstract designs printed from zinc and linoleum blocks. The book is enclosed in a brown cloth slipcase imprinted *G.M.H.* Of 50 numbered copies, this is number 37.

CATALOGUES

Only five of the scores of rare-books catalogues listing Hopkins items—and none of the current publishers catalogues, which in themselves have promoted interest in the poet—are on display, because, again for the purposes of this exhibition, each of these shown needs to be opened to the Hopkins entries in order for the viewer to see the value now being assigned the manuscripts of this poet who feared that he had not bred "one work that wakes."

371 Bodleian Library. A xerox copy of a typescript list of the Bodleian's Hopkins holdings.

372 *British Heritage: An Exhibition of Books, Manuscripts & Iconography from The Collections at The University of Texas at Austin.* Dallas Public Library: October 9-21, 1967.

See item 75 for a description of the first edition of Hopkins's *Poems* and other items by Hopkins displayed in the exhibition.

373 Heather Child, ed. *The Calligrapher's Handbook.* London: A and C Black, 1985.

This book, sponsored by the Society of Scribes and Illuminators, contains a reproduction of *G.M.H.'s "Spring"* by Gaynor Goffe.

374 Christie's. *Modern Literature from the Library of James Gilvarry.* New York: Friday, 7 February 1986.

See items 80 and 81.

375 *Garnett College,* 1982.

This college, now a part of the Inner London Education Authority, has on its

campus two buildings, Manresa House and Mount Clare, which Hopkins would have entered frequently. Both buildings are depicted in the catalogue.

376 David J. Holmes. *Autograph Catalogue* describing the original Arthur Hopkins pencil drawings.

377 *Jesuit Spirit in the Arts 1986*. Saint Joseph's University Press, Philadelphia, October 1986.

Items 49 (by Ed Ross) and 60 (by Michael Tang) are based on Hopkins. Some of Ross's work is exhibited in *Hopkins Lives* as is some of Tang's, including item 377.

378 *London Borough of Newham Library Service*. Xerox copy of the material accompanying an exhibition (18-25 October 1969) illustrating *Stratford in the Nineteenth Century* "in connection with the 125th anniversary of the birth of the Stratford-born poet, Gerard Manley Hopkins."

379 *John Newberry: Exhibition of Oil Paintings*. Westgate Central Library, Oxford. 12 - 22 May 1987.

See item 21: *Spring GMH*, 1987, 25 x 25 ins., NFS, which is displayed in this exhibition.

380 *Regulations and Syllabuses. June 1987–January 1988. General Certificate of Education Examination*. Topics for study to prepare for advanced level examinations in Great Britain.

Students in Britain applying for admission to university-level study for the period indicated were subject to examination on Hopkins if his work fell into the category they were planning to study.

381 Diana J. Rendell, Inc. Catalog 4: *Autograph letters, Manuscripts, Documents*. 117 Collins Road, Waban, MA 02168.

Item no. 44: Description of four-page holograph letter signed by Gerard M. Hopkins, dated 15 July 1866; priced at $4,000.00.

382 Sotheby's. *English Literature and History*. London: Monday 22nd, July 1985; and Tuesday 23rd, July 1985.

See item 127 for description of an autograph letter, signed.

383 Sotheby's. *Catalog of Valuable Autograph Letters, Literary Manuscripts, Historical Documents and Literary Relics and Portraits July 5 & 6, 1977.*

See page 189, entry 356, for description of an autograph letter estimated to sell for £350 and £450; it sold for £460, when the pound sterling converted to $1.75.

384 Michael Taylor: *Contemporary British Lettering.* Contains reduced illustration of Gaynor Goffe's calligraphy of *G.M.H.'s "Spring."*

385 W. Thomas Taylor. *Sixty Interesting Books and Manuscripts.* 1985. Contains description of Hopkins letter.

The letter sold for $4,250.

386 *Twenty-seventh Antiquarian Book Fair.* The Park Lane Hotel, London. 24-26 June 1986. Stall thirty offers and illustrates (for £7000) four autograph letters, signed by Hopkins.

387 *The University of Texas at Austin.* Xerox copy of the University's card catalogue of Hopkins holdings in the General Libraries.

388 *The University of Texas.* Xerox copy of the Hopkins catalogue of the HRHRC holdings.

PHILIP DACEY

The Philip Dacey project is a remarkable tribute to Hopkins, and until an authentic biography derived from all existing documents is available, it is probably, even in its poetic brevity, as profound a portrait as exists of Gerard. In addition to being a beautiful book physically, enhanced by mystery-implying wood engravings by Michael McCurdy, it is filled with one felicitous poem after another, each based on some event or quotation from Hopkins's own works. The title poem is an ingenious invention. Dacey has taken three famous nineteenth-century pieces of creative art, all produced within a long generation of each other—a pertinent portion of Whitman's "Song of Myself," Eakins's *The Swimming Hole*, and Hopkins's "Epithalamion" (all centering around a swimming scene with nude males)—and has introduced into the Eakins painting two additional characters, Hopkins and Whitman. Dacey supposes, for the moment of his poem at least, that the swimming hole

157

represents heaven; and that the two great poets (who died within two years of each other and who, in their separate ways, were astonishing poetic revolutionaries) exchange in a philosophical dialogue their views on life. The title poem—along with the shorter companion pieces which help make up the slender volume—is an absolute triumph, a stunning combination of imagination, talent, and skill.

389 Philip Dacey. *Gerard Manley Hopkins Meets Walt Whitman in Heaven and Other Poems*. Wood engravings by Michael McCurdy. Great Barrington, MA: Penmaen Press, 1982.

There are three different issues of the Dacey book: the paperback edition, the unsigned cloth edition, and the cloth edition numbered and signed by both Dacey and McCurdy. This limited letterpress edition consists of 900 copies. The book is now out of print, although negotiations are underway for it to be photographically reproduced.

390 A facsimile copy of Walt Whitman's "Song of Myself" from the 1955 facsimile reproduction of the first edition of *Leaves of Grass*.

391 A full-size, full-color reproduction of the Thomas Eakins painting entitled *The Swimming Hole*.

392 A copy of one of the photographs of Eakins's art class bathing in the nude used by the painter in creating *The Swimming Hole*.

393 The original, first sketch box used by Eakins in constructing his painting, on loan from the Modern Art Museum of Fort Worth, is pocket-sized and shelves two copper plates on which Eakins made his very first sketches of *The Swimming Hole*.

394 A photostatic copy of the Bodleian Library manuscript copy of Hopkins's "Epithalamion."

Item nos. 390, 391, and 394 are the three pieces of creative art on which Dacey based the title poem of his book.

395 The four spiral manuscript notebooks Dacey compiled while writing his book.

396 A selection of the preliminary drafts of some of Dacey's poems.

397 A selection of galley proofs for the Dacey book.

PHILIP DACEY

GERARD MANLEY HOPKINS MEETS WALT WHITMAN IN HEAVEN AND OTHER POEMS

WOOD ENGRAVINGS BY MICHAEL McCURDY

PENMAEN PRESS GREAT BARRINGTON

Item 389: Title page of Philip Dacey's *Gerard Manley Hopkins Meets Walt Whitman in Heaven and Other Poems* (1982).

*On the occasion of Hopkins's centenary
Garland is pleased to announce a facsimile edition of his early works....*

THE EARLY POETIC MANUSCRIPTS
AND NOTEBOOKS OF
GERARD MANLEY HOPKINS
IN FACSIMILE

*Edited with Annotations,
Transcriptions of Unpublished Passages and an
Introduction by*
NORMAN H. MACKENZIE

GARLAND PUBLISHING

Item 424: An official flyer announcing the forthcoming facsimile edition of the early Hopkins manuscripts to be accompanied by editorial notes by Norman H. MacKenzie.

398 The Penmaen Press official announcement of the Dacey book.

399 The five original carved wood blocks by Michael McCurdy from which the illustrations in the Dacey book are printed.

400 Four different original prints—signed and numbered—from the wood blocks carved by Michael McCurdy.

401 One metal engraving plate by Michael McCurdy used in printing the Dacey book.

402 The original wood block entitled *The Poets' Heaven*, by Letterio Calapai, created after his reading of Dacey's book.

403 A numbered and signed original print from the wood block described in item no. 402.

404 The official announcement of the availability of Calapai's limited edition of prints of *The Poets' Heaven*.

Norman H. MacKenzie

Norman MacKenzie is also assigned a separate case for a number of reasons. First, of course, he deserves it, since he is and has been for the past twenty-odd years the premier editor of Hopkins's poems. But he has, in addition, loaned to the exhibition some of his handwritten manuscripts, his typescripts, page proofs of the Fourth Edition, as well as a number of his prized association items.

405 Page proofs of the preliminary materials—specifically the long introduction—for the Fourth Edition of Hopkins's *Poems* with corrections by MacKenzie.

406 Page proofs for the Fourth Edition of Hopkins's *Poems* with corrections by MacKenzie.

407 Typescript manuscript of MacKenzie's article, "Hopkins, Yeats, and Dublin in the Eighties," from the book *Myth and Reality in Irish Literature*.

408 MacKenzie's handwritten copy of the introduction of a paper he delivered, entitled *Hopkins, Robert Bridges, and the Modern Editor*, accompanied by a xerox copy of the typescript proofs of the entire article. Handwritten corrections indicated.

409 MacKenzie's handwritten copy of Chapter 2 of his book, entitled *Hopkins*, in the Writers and Critics Series.

410 MacKenzie's entire original handwritten manuscript of the Folio Society edition of *Poems* by Hopkins.

411 Geoffrey Bliss. "In a Poet's Workshop: An Unfinished Poem." *The Month*. Vol. 167, no. 860 (February 1936): 160-167.

412 _____. "In a Poet's Workshop, II: The Woodlark, by G.M. Hopkins." *The Month*. Vol. 167, no. 864 (June 1936): 528-535.

413 Christopher Devlin. "An Essay on Scotus." *The Month*. Vol. 182, no. 954 (Nov.-Dec. 1946): 456-466.

414 D. Anthony Bischoff. "The Manuscripts of Gerard Manley Hopkins." Reprinted from *Thought*. Fordham University Quarterly. Vol. 26, no. 103 (Winter 1951-52). Corrected on page 571 by Bischoff. Signed: "A. Bischoff."

415 M.C. D'Arcy. "A Note on Hopkins." *The Month*. New Series Vol. 11, no. 2 (February 1954): 113-115.

416 Claude Sumner. *Jalons de Lumiere Poèmes de Jeunesse de G.M. Hopkins*. Tract 98 (avril 1959). Nicolet (Quebec), Canada: Centre Marial Canadien.

When this tract was written, Sumner was professor at College Universitaire d' Addis-Abeba, Ethiopia, so that presumably his article circulated at least among the academics in that nation.

417 Norman H. MacKenzie. "Gerard and Grace Hopkins." *The Month*. Vol. 209, no. 1174; New Series Vol. 33, no. 6 (June 1965): 347-350.

418 _____. "Hopkins." Chapter 11 in *The Victorians* (Arthur Pollard, editor). London: Sphere Books Ltd., 1969, 1970.

419 Suzanne Kohl Weldon. *Colour Symbolism in Hopkins's Poetry*. Illustrated by D.L. Stewart. Privately printed in Montreal, 1971.

420 Joseph Ronsley, ed. *Myth and Reality in Irish Literature*. Waterloo, Ontario, Canada: Wilfred Laurier University Press, 1977.

421 Peter Reddick. The original carved wood block for the frontispiece portrait of Hopkins for the Folio Society edition of the *Poems*.

422 _____. Two original prints pressed from the wood block described in the preceding item: one, labeled "Artist's Proof," the other numbered; both signed.

423 One copy each of two different official announcements of the Hopkins centenary lectures delivered by MacKenzie at Oxford during the months of October and November 1988.

424 An official flyer announcing the forthcoming facsimile edition of the early Hopkins manuscripts to be accompanied by editorial notes by MacKenzie.

POPULAR MEDIA AND OTHER ITEMS

To demonstrate the widespread awareness of Hopkins, a collection of over one-hundred examples of popular media articles about the poet has been assembled. I cannot think of any mass medium which has not over the past forty years, but especially over the last twenty, accorded the man the attention due the genuinely great individual that he unknowingly was. Unfortunately because of space limitation, only a few of these items could be exhibited and unhappily for the same reason only a fraction of their number can be described in the catalog.

425 Newspapers and Non-academic Periodicals: *America, The Atlantic Monthly, Book News, Boston College Magazine, The [Boston] Pilot, Catholic Herald, The [Chicago] Daily News, The Christian Science Monitor, Crossroads, The Dallas Times-Herald, The Dorset Natural History and Archaeological Society, The Fort Worth Star-Telegram, The Jesuit Educational Quarterly, The Jesuit International Yearbook, Jubilee, Letters and Notices, The [London] Observer, The [London] Times Literary Supplement, The Month, The New York Review of Books, L'Osservatore Romano, The Reader's Digest, Resurgence, The Tablet, United Methodist Church Adult Bible Studies, The [Vermont] Vanguard, The Universe, The Xavier Athenaeum.*

426 Radio Broadcasts: A collection of radio broadcasts over BBC London, Radio Ireland, and Station KNIK-FM, Anchorage, Alaska.

427 Television and Films: Video cassettes of three BBC films: *Gerard Manley Hopkins, The Windhover,* and *To Seem the Stranger*; the Hollywood film *Vision Quest*, in which students in a classroom scene discuss "Spring and Fall"; and a privately recorded video cassette by Ernest Ferlita of his own one-man play entitled *Hopkins Proclaimed.*

163

428 Photographs and Slides: 120 slides by Raymond V. Schoder, so arranged that they form a pictorial study of Hopkins and his work; 18 slides by Philip Dacey to accompany his lecture about his book of poems based on Hopkins; 57 slides by Michael Dunham to accompany his lecture entitled "Introducing the Music of Gerard Manley Hopkins"; 22 slides by Edward Ross II, from his portfolio based on Hopkins and entitled *Inscapes*; 6 slides of the artwork of Mary Frances Judge; 1 slide by Gerald Fleuss of his calligraphy of "Hurrahing in Harvest"; a series of 25 transparencies by Richard Jennings of the interior and exterior of Manresa House; a transparency of Thomas Eakins's *The Swimming Hole*; 5 black-and-white photographs of the Westminster Abbey Ceremony unveiling the memorial slab in Poet's Corner; 1 photograph of the designers' consultant shop in Dublin named *Inscape*; a series of 20 photographs of the architectural details of Manresa House by Richard Jennings; 5 photographs of Eakins's sketch box, containing his first conceptions of *The Swimming Hole*; 12 photographs of the 1975 exhibition of Hopkins manuscripts at the University of North Texas; 12 photographs of Hopkins sites supplied by A. Devasahayam; 15 photographs of Hopkins sites supplied by Howard and Barbara Stearns; 6 photographs of the artwork in The Hopkins Book Shop based on Hopkins, supplied by Howard and Barbara Stearns; 2 photographic reproductions (1 of a contemporary engraving and 1 of a contemporary watercolor) of Manresa House as it apparently appeared in Hopkins's time; 1 full-size color photograph of Thomas Eakins's *The Swimming Hole*, along with 8 postcard-size black-and-white reproductions; 2 photographs of the United Nations Building marble wall containing the inscription of the first stanza of "The Wreck of the Deutschland."

429 Recordings (discs and cassettes): Sir Arthur Bliss, *The World is Charged with the Grandeur of God*, Lyrita LP SCRS.55; Ned Rorem, *Songs*, on New World Records LP NW229; *Gerard Manley Hopkins*, read by Cyril Cusack, Caedmon Records LP TC1111; *The Poems of William Blake and Gerard Manley Hopkins*, read by Robert Speaight, Spoken Arts LP 814; *Poems by John Keats and Gerard Manley Hopkins*, read by Margaret Rawlings, Argo Records LP RG13; William Cleary, *Three Songs* ("Spring and Fall," "At the Wedding March," and "Experiment to Make 'Spring and Fall' Perspicuous"), privately recorded on a cassette by the composer; Michael Dunham, *Realizing the Music of Hopkins*, a slide lecture privately recorded by Dunham on a cassette; Walter Lea Boothe III, *Commentary on Dunham's "Realizing the Music of Hopkins,"* privately recorded on cassette by Boothe; Michael Dunham, *Gerard Manley Hopkins/Four Songs*, performed by Michael Dunham, privately recorded on cassette by Dunham; Anthony Gilbert, *Inscapes*, privately recorded by Margaret Bogan at the World Premier, with permission of the composer who conducted the performance; David Daiches, *Gerard Manley Hopkins I*, a lecture to be used in the classroom, produced by

Everett/Edwards, Inc.; David Daiches, *Gerard Manley Hopkins II*, ibid.; *Poems by Gerard Manley Hopkins*, a discussion (parts 1 to 8, on 2 cassettes), produced by London AV for schools and Thomas S. Klise Co.; M. Jones, *Gerard Manley Hopkins / Background*, Exeter Tapes E661; Norman White, *Hopkins in Dublin*, privately recorded on cassette by White; William Hewett, *Unlikely Journey I and II*, autobiographical essays recorded by Hewett on cassette in which he frequently reads selections from Hopkins; William Hewett, *Another Unlikely Journey*, ibid.

430 Official Announcements and Programs: program and program notes for Cincinnati Symphony Orchestra's performance of Aaron Copland's *Inscape*, conducted by the composer, 18-19 January, no year given; an exhibition illustrating Stratford in the nineteenth century in connection with the 125th anniversary of the birth of the Stratford-born poet Gerard Manley Hopkins, London Borough of Newham Library Service, 18-25 October 1969; the flyer

Item 425: Article from *United Methodist Church Adult Bible Studies*, 22 February 1987.

announcing the sixth annual lecture sponsored by The Hopkins Society, 3 March 1975; the four-page flyer, a pre-announcement of the exhibition *All My Eyes See*, London, 1975; the small poster advertising the preceding exhibition, 10-28 June 1975; the large souvenir poster for the preceding exhibition; announcement of the world premier of Anthony Gilbert's *Inscapes*, conducted by the composer, 9 June 1975; program of The Stratford Association's Centenary celebration of "The Wreck of the Deutschland," London, 7 December 1975; the official news release of The Hopkins Society concerning the unveiling of the Westminster Abbey memorial slab, 8 December 1975; the official program of the Westminster Abbey ceremony, 8 December 1975; the schedule of the program (and other pertinent ephemera) of the Hopkins Easter Conference at St. Beunos, Wales, Easter week, 1980; the official announcement of a roundtable discussion about Gerard Manley Hopkins held in Paris, 24 February 1981; the official announcement poster for the conference on Hopkins entitled *Gerard Manley Hopkins ∫ The Poet in His Age* held in Waterloo, Canada, 6-7 March 1981; the official poster (and other pertinent ephemera) of the week-long conference entitled *Gerard Manley Hopkins in Ireland* to celebrate the centenary of the poet's arrival in Dublin, 11-16 July 1984; the official BBC poster announcing the film *To Seem the Stranger*, 1985; the announcement card of Michael Tang's exhibition of paintings entitled *The Hopkins Series*, Hollywood, California, 8 April–7 May 1986; the official announcement of *Schoderfest*, celebrating the 70th birthday of Raymond V. Schoder, Chicago, 11-12 April 1986; the announcement card of an exhibition of art entitled *The Inner Core*, in which Michael Tang's sculpture *The Wreck of the Deutschland* was displayed, Los Angeles, California, 16 September–17 October 1987; the official announcement of a lecture sponsored by the Faculty Seminar on British Studies, the Tom Lea Rooms, The University of Texas at Austin's Harry Ransom Humanities Research Center, Austin, Texas, 23 October 1987; the official poster announcing a lecture by René Gallet at Caen, France, 29 April [1988?]; 2 different official announcement posters of the *Centennial Lectures on Gerard Manley Hopkins*, by Norman MacKenzie, Oxford, October-November 1988; the preliminary announcement of the 1989 program of the Cardiff Literature Festival, at St. Beunos, Wales; the preliminary announcement of the 1989 celebration by the North Wales Arts Association, in various locales in Northern Wales, centered at Rhyl; the official preliminary announcement of the Hopkins Centennial Conference for 1989, St. Joseph's University, Philadelphia, Pennsylvania, 29-30 September.

431 Miscellaneous Ephemera: a Christmas greeting card, printed in 4 colors and quoting the last 4 lines of "God's Grandeur," calligraphy and design by Nan Runde, for Cahill and Co., Dobbs Ferry, New York, 1983; a Christmas greeting card quoting "Pied Beauty," handset and handprinted in 2 colors by

Theodor Jung at his Cloverleaf Press, Denver, Colorado, 1950; a greeting card designed and printed by Darlington Carmel in Britain, quoting the opening line of "God's Grandeur" and printed in 5 colors, no date; the 1979 calendar issued by Stonyhurst College with 7 reproductions of engravings, contemporary with Hopkins, of various views of the college; the 1981 David Levine *New York Review of Books* calendar, with the December page reproducing Levine's caricature of Hopkins, which appeared in *NYRB*, 27 September 1979, to accompany the review of Paddy Kitchen's biography of Hopkins; the 1982 Stonyhurst College calendar with 6 photographs of the College and its surroundings by Roger Fenton, captioned as "from Hopkins"; 4 postal card reproductions of pencil drawings by Gerard published in 1975 as part of the London exhibition, *All My Eyes See*; 2 postal card reproductions of pencil drawings by Arthur Hopkins, published for the preceding event; bookmarks published by The Hopkins Book Shop containing the last 6 lines of "God's Grandeur"; an enlarged copy of the Hopkins family crest/bookplate with the Latin motto, translated "to be rather than to seem to be"; a book of illustrated handouts, which Norman White of University College, Dublin, distributed to his 1982 students, containing 28 illustrated quotations from Hopkins; a character study by graphoanalysis of Hopkins based on photographic reproductions of the manuscripts of "God's Grandeur" and "Starlight Night," by Elizabeth C. Murray; and an original clipping from *The [London] Times* for Wednesday, 24 December 1913, containing the first poem to appear in print by Robert Bridges after his being designated Poet Laureate (germane in view of the fact that it was Bridges's laureateship which gave authority to his support of Hopkins in the 1918 First Edition).

ICONOGRAPHY BASED ON SPECIFIC POEMS BY HOPKINS

Hopkins was essentially a visual poet. Anyone talented in drawing or painting can transfer the pictures the poet draws with words (especially in his nature poems and in the octaves of his sonnets) onto paper or canvas. In the overview to this section of the exhibition I have already commented on the number of pieces of artwork assembled and on the wide range of media and schools of art represented. If Section VI is the heart of this commemoration, the iconography division is the face of that heart. As completely as feasible, the pieces listed here were hung in the order of the composition of the poems, with all interpretations of the same poem clustered together so that the viewer can see the different reactions of the represented artists to the same work. When a work is based on a specific quotation from the poem, that quotation is recorded in the catalog entries below, as well as on the label identifying the work.

432 *Heaven-Haven* (1988). By Suzanne Starr. Calligraphy. 18 x 27 ins.

433 *After Hopkins's Illustration for "A Vision of the Mermaids"* (1988). By Elizabeth Jones Sutton. Embroidery on linen. 19 x 17½ ins.

The embroidery, drawn enlarged on linen by Tomás Bustos, is a 1988 needlework interpretation of the drawing which heads Hopkins's 1862 prize poem.

Item 433: Elizabeth Jones Sutton's *After Hopkins's Illustration for "A Vision of the Mermaids"* (1988), embroidery on linen. 19 x 17½ ins.

434 *Hope Had Grown Grey Hairs,* versions I, II, & III (1987). By Catherine Doyle Egan. Watercolor collages. I measures 11 x 13 ins., II measures 10½ x 14½ ins., and III measures 11 x 10 ins.

All three are signed and dated 1987. All three are multicolored abstract watercolor collages based on a line from "The Wreck of the Deutschland."

435 *Crimson Cresseted East* (1988). By Dennis McNally. Acrylic on linen. 60 x 48 ins.

The painting is a representation of a quotation from "The Wreck of the Deutschland."

436 *The Wreck of the Deutschland* (1988). By Dennis McNally. Acrylic on canvas. 82 x 104 ins.

This is a triptych based on the poem in the title.

437 *The Wreck of the Deutschland* (1988). By Michael Tang. A photograph of a multimedia sculpture of various dimensions according to the space a gallery can allot it. 8 x 10 ins.

438 The same as above. Photographed from a different angle. 8 x 10 ins.

439 A photograph of a bas-relief wall in the United Nations Building in Geneva, Switzerland, inscribed with the first stanza of "The Wreck of the Deutschland" surrounding a figure of a nude male reaching out his hand to be touched by the hand of God (1961). By Arthur Ayers. The wall measures about 12 x 30 ft.; the photograph, 8 x 10 ins.

440 The same as item 439 but photographed from a different angle.

441 *Dappled-with-Damson West* (n.d.). By Raymond V. Schoder. Art photograph based on a phrase from "The Wreck of the Deutschland." 11 x 14 ins.

442 *Crimson-Cresseted East* (n.d.). By Raymond V. Schoder. Art photograph based on a phrase from "The Wreck of the Deutschland." 11 x 14 ins.

443 *The Kentish Knock* (n.d.). By Raymond V. Schoder. Art photograph based on a phrase from "The Wreck of the Deutschland." 11 x 14 ins.

444 *Moonrise Diptych* (1987). By Michael Tang. A photograph of a multimedia painting measuring 72 x 90 x 10 ins. 8 x 10 ins. Based on the fragmentary poem "Moonrise June 19, 1876."

445 *Moonrise III* (1987). By Michael Tang. A photograph of a multimedia painting measuring 28 x 29 x 4 ins. 10 x 8 ins. Based on the same poem as item no. 444.

446 *Woodlark I* (1987). By Michael Tang. A photograph of a mixed media painting measuring 72 x 70 x 13 ins. 10 x 8 ins. Based on the incomplete poem "The Woodlark."

447 *Woodlark II* (1987). By Michael Tang. A photograph of a mixed media painting measuring 53 x 60 x 12 ins. 8 x 10 ins. Based on the same poem as in the preceding item.

Item 437: Photograph of Michael Tang's *The Wreck of the Deutschland* (1988), a multimedia sculpture of various dimensions according to the gallery space. 8 x 10 ins.

448 *God's Grandeur* (n.d.). By Alan Russell-Cowan. Oil on canvas. 16 x 12 ins.

449 *God's Grandeur* (1977-87). By Michael Martin. Pencil sketch. 8½ x 12 ins.

450 *God's Grandeur* (1988). By Suzanne Starr. Calligraphy. 25 x 28 ins.

451 *With, ah! Bright Wings* (1988). By Dennis McNally. Acrylic on canvas. 72 x 99 ins. Based on a phrase from *God's Grandeur*.

452 *Morning at Brown Brink Eastward, Springs* (n.d.). By Raymond V. Schoder. An art photograph attempting to recapture the specific image Hopkins had in mind in the poem "God's Grandeur." 11 x 14 ins.

453 *God's Grandeur* (n.d.). By James L. Ballard. A photographic copy of a photographic broadside, measuring 30 x 18 ins., based on "God's Grandeur," quoting the poem in its entirety. 14 x 11 ins.

454 *Starlight Night* (n.d.). By David Nicholls. Calligraphy. 15 x 22 ins. including custom frame (integral to the work). Gouache and gold on Ingres paper.

The first three lines of the poem describe a sky sprinkled with stars.

455 *The Starlight Night* (1988). By Suzanne Starr. Calligraphy. 19 x 25 ins.

456 *As Kingfishers Catch Fire* (1988). By Suzanne Starr. Calligraphy. 7 x 19 ins.

457 *As Kingfishers Catch Fire* (1962). By Donald Dennis. Woodblock engraving on rice paper. 24 x 15 ins.

458 *As Kingfishers Catch Fire* (1962). By Donald Dennis. Three wood engraving blocks for printing copies of illustration of preceding item. 15 x 7 ins., 16 x 7 ins., 17 x 7 ins.

459 *As Kingfishers Catch Fire* (1988). By David Nicholls. Calligraphy; acrylic, spirit lacquer, glazes, and gold on board. 25 x 35 ins.

460 *Lovely in Limbs* (1988). By Dennis McNally. Acrylic on canvas. 78 x 36 ins.

This painting is a reaction to the sonnet "As Kingfishers Catch Fire."

461 *GMH's "Spring"* (n.d.). By Gaynor Goffe. Calligraphy. 20 x 31 ins.

462 *Spring: GMH* (1988). By John Newberry. Oil on canvas. 25 x 25 ins.

The artist states that his stick figure drawing is based on the sestet of the poem.

463 *Spring* (1988). By Anita Lane. Calligraphy. 22 x 30 ins.

464 *Spring* (1988). By Jane McSloy. Illuminated manuscript in watercolor. 10 x 7 ins.

465 *The Caged Skylark I* (1986). By Michael Tang. Mixed media. 84 x 63 x 4 ins.

466 *The Caged Skylark* (1986). By Michael Anthony McMains. Felt-tip pen drawing. 13 x 10½ ins. Two signed copies.

One of the signed copies represents the human being imprisoned and the bird free; the other signed copy represents the bird caged and the human being (presumably Hopkins himself) free. Undated but drawn in 1986.

467 *The Caged Skylark I* (1987). By Michael Tang. A photograph of a mixed media painting measuring 84 x 63 x 4 ins. 10 x 8 ins.

468 *The Caged Skylark II* (1987). By Michael Tang. Mixed media. 43 x 53 x 4 ins.

469 *The Caged Skylark II* (1987). By Michael Tang. Three photographic views from different angles of the preceding item. Each 10 x 8 ins.

470 *The Sea and the Skylark I* (1962). By Ernst Wahlert. Pastel crayons. 24 x 16 ins.

471 *The Sea and the Skylark II* (1966). By Ernst Wahlert. Egg-tempera on canvas. 35 x 18 ins.

472 *The Sea and the Skylark* (1986). By Eric André Stephan Gerard. Watercolor. 11½ x 9½ ins.

On a skyblue background the skylark is flying above both land and sea in this striking, stylized painting, which also shows St. Asaph's Cathedral and an interestingly textured sun.

473 *The Windhover: Sprung Rhythm Coiled* (1971). By Michael Jacob.

Item 464: Jane McSloy's *Spring* (1988), an illuminated manuscript in watercolor. 10 ins. x 7 ins.

Calligraphy: 11 x 8½ ins. and 9 x 7 ins. Two original copies each drawn as one continuous spiral.

The smaller copy is preceded on the same sheet by an autograph letter by the artist.

474 *A Windhover* (1980). By Cicely Lushington. A near full-size ceramic sculpture. Commissioned by Audrey Elstob and Betty Hay. 8 x 5 x 5 ins.

475 *Pied Beauty* (1988). By Anita Lane. Calligraphy. 9 x 12 ins.

476 *Pied Beauty* (1988). By Suzanne Starr. Calligraphy. 22 x 30 ins.

477 *Landscape Plotted and Pieced* (n.d.). By Raymond V. Schoder. An art photograph based on the phrase from "Pied Beauty." 11 x 14 ins.

The photographer has taken the picture looking toward Moely parc, from the Rock Chapel at St. Beuno's.

478 *Hurrahing in Harvest* (1988). By Anita Lane. Calligraphy. 22 x 30 ins.

479 *Hurrahing in Harvest* (n.d.). By R.K.R. Thornton. A commercially produced broadside picturing a sheaf of wheat beside the printed poem. 23 x 17 ins.

480 *"Silk-Sack Clouds" and "Mealdrift"* (n.d.). By Raymond V. Schoder. An art photograph representing the two phrases from "Hurrahing in Harvest." 11 x 14 ins.

481 *Stooks, with Pendle Mountain in the Background* (n.d.). By Raymond V. Schoder. An art photograph representing one of the phrases in "Hurrahing in Harvest." 11 x 14 ins.

482 *"Silk-Sack Clouds"* (n.d.). By Raymond V. Schoder. An art photograph representing a phrase in "Hurrahing in Harvest." 11 x 14 ins.

483 *Christ Minds* (1988). By Michael Martin. Pen-and-ink drawing. 9 x 12 ins.

Based on a phrase from "The Lantern out of Doors."

484 *"First, Fast, Last Friend"* (1988). By Dennis McNally. Acrylic on canvas. 80 x 71 ins.

174

This painting is the representation of a phrase from "The Lantern out of Doors."

485 *Binsey Poplars* (1988). By John Newberry. Watercolor. 14 x 18 ins.

486 *Binsey Poplars* (1985). By Michael Tang. Photograph of mixed media painting. 8 x 10 ins.

487 *Evensong* (1985). By Michael Tang. Mixed media triptych on canvas. 60 x 142 x 8 ins.

Based on "Repeat that, repeat."

488 *Evensong Triptych* (1985). By Michael Tang. Mixed media. A photograph of the preceding item. 8 x 10 ins.

489 *Peace* (1970). By A.D. McGregory. Linoleum block print. 24 x 21 ins.

490 *Peace* (1966). By Ben Herman. Acrylic. 39 x 27 ins.

491 *Peace* (1970). By Warren McGriffin. Lithograph. 16 x 16 ins.

492 *Peace* (1988). By Suzanne Starr. Calligraphy. 19 x 23 ins.

493 *Perseus Rescues Andromeda I* (1985-86). By Mary Frances Judge. Mixed media on linen. 72 x 80 ins. Based on GMH's sonnet "Andromeda."

494 *Perseus Rescues Andromeda II* (1985-86). By Mary Frances Judge. Mixed media on linen. 74 x 78 ins. Based on G.M.H.'s sonnet "Andromeda."

495 *Andromeda* (1987). By David Nicholls. Calligraphy. Watercolor on paper. The entire poem in reds of varying intensity with accents of gold. 19 x 17 ins.

496 *Spring and Fall* (1987). By Marie E.L. Farrell. Pencil drawing in art deco style. 11½ x 8½ ins.

497 *Spring and Fall* (1988). Artist unidentified. Broadside in black and white quoting the entire poem. 11 x 23 ins.

This broadside is one of a series entitled *Poems on the Underground*, which are posted in cars of the London Underground, and are therefore potentially viewed by thousands every day.

498 *Inversnaid* (n.d.). By Raymond V. Schoder. An art photograph picturing the scene of the Hopkins poem. 11 x 14 ins.

499 *Beauty-in-Ghost* (1987). By Mary Frances Judge. Mixed media diptych. 72 x 88 ins.

These two pieces may be hung separately or together. Based on lines from G.M.H.'s "The Golden Echo": "And with sighs soaring, soaring sighs, deliver / Them; beauty-in-the-ghost, deliver it, early now, long before death / Give beauty back, beauty, beauty, beauty, back to God, beauty's self and beauty's giver."

500 *"No worst, there is none"* (1986). By Gaynor Goffe. Black on white calligraphy. 26 x 36 ins.

501 *"No worst, there is none"* (1986). By Gaynor Goffe. Dark-blue on white calligraphy. 26 x 36 ins.

Item 488: Photograph of Michael Tang's *Evensong Triptych* (1985), mixed media on canvas. 60 x 142 x 8 ins. Based on the lines "Repeat that, repeat, / Cuckoo bird, and open ear. . . ."

502 *I Wake and Feel the Fell* (1988). By Anita Lane. Calligraphy. 22 x 30 ins.

503 *Patience, Hard Thing!* (1988). By Suzanne Starr. Calligraphy. 19 x 24 ins.

504 *After Hearing Read Aloud "On the Portrait of Two Beautiful Young People"* (1975). By Tomás Bustos. Oil on canvas. 18 x 24 ins.

505 Circular motif based on "A Portrait of Two Beautiful Young People" made from machine-carved wood in the center of the lid of a wooden jewelry box (1988). By John Francis Farrell. Motif: 4½ ins. diameter. Box: 3 x 10 x 6½ ins.

506 *(Ashboughs)* (1987). By Michael Tang. Photograph of mixed media painting based on the Hopkins poem. 10 x 8 ins.

507 *In Majorca* (1988). By Dennis McNally. Acrylic on canvas. 80 x 41 ins.

This painting is based on the sonnet "In Honour of St. Alphonsus Rodriguez."

ICONOGRAPHY BASED ON HOPKINS BUT NOT ON SPECIFIC POEMS

The various portraits of Hopkins are massed together near the photographic portraits so that the viewer can absorb as much of the personality and character of the poet as is possible from visual representations before proceeding into the main body of iconographic reactions to the poems themselves. The few other pieces—mainly sculptures and oils—are displayed strategically throughout the exhibition space and are described in appropriate detail in the catalogue entries.

508 *Portrait of Hopkins* (1978). By David Levine. Pen-and-ink caricature. 21 x 11 ins.

This caricature of Hopkins, drawn by the staff artist of the *New York Review of Books*, appeared reduced in the 1978 edition of that publication along with the review of a biography of Hopkins by Paddy Kitchen.

509 *Portrait of Hopkins* (n.d.). By Peter Reddick. Wood engraving block. Master block for printing frontispiece of the Folio Society edition of Hopkins's *Poems*. 4½ x 3½ ins.

510 *Portrait of Hopkins* (1973). By Peter Reddick. Original wood engraving

print portrait of Hopkins from the block created for the frontispiece of the Folio Society edition of Hopkins's *Poems*. 4½ x 4 ins.

This copy is signed "artist's proof."

511 *Portrait of Hopkins* (1973). By Peter Reddick. Original wood engraving print portrait of Hopkins from the block created for the frontispiece of the Folio Society edition of Hopkins's *Poems*. 4½ x 4 ins.

This copy is number 15 of 50 copies.

512 *Portrait of Hopkins* (1975). By Robert Earl Johnson. Watercolor. 20 x 15 ins.

This official multi-colored poster based on two photographs announced the 1975 exhibition at U.N.T. commemorating the 100th anniversary of "The Wreck of the Deutschland."

513 *Portrait of Hopkins* (1979). By Janneke Venema. Pen-and-ink drawing. 12 x 9 ins. Two copies.

514 *Portrait of Hopkins* (1987). By Gerard Lanvin. Copper medallion. 3 ins. diameter.

A bas-relief portrait appears on the obverse of this coin and a bas-relief windhover appears on the reverse.

515 *Portrait of Hopkins* (1988). By Larry Johnson. Air-brush. 24 x 18 ins.

This is the original of the announcement poster for the current exhibition.

516 *Portrait of Hopkins* (n.d.) By Joan Caryl. Oil on canvas. 48 x 36 ins.

Portrait of young Hopkins done in muted colors against apparently a Welsh seaside. On loan from the Georgetown University library through the courtesy of Joseph E. Jeffs.

517 *Portraits of Hopkins* (1982). By Michael McCurdy. Five wood engraving blocks. Each block 5 x 4 ins.

The master blocks used in printing the illustrations for Philip Dacey's limited edition of poems entitled *Gerard Manley Hopkins Meets Walt Whitman in Heaven and Other Poems*.

178

518 *Portraits of Hopkins* (1982). By Michael McCurdy.

Four signed and numbered prints from the blocks described in the preceding item. Each print 5 x 4 ins.

519 *Portrait of Hopkins* (1982). By Michael McCurdy. Metal engraving plate. 5 x 4 ins.

This is the master plate used by McCurdy for printing one of the illustrations in Philip Dacey's book of poems.

520 *Poet's Heaven* (1983). By Letterio Calapai. Wood engraving block. 6 x 8 ins.

The master block used for printing 50 numbered copies of an illustration based on Philip Dacey's book of poems.

521 *Poet's Heaven* (1983). By Letterio Calapai. Wood engraving print. 6 x 8 ins.

522 A pen-and-ink sketch of a pattern for a stained glass panel based on Hopkins's drawing of an iris (1986). By Tomás Bustos. 40 x 16 ins.

523 *Manresa House, Roehampton, England* (1986). By Richard Jennings. Silk screen print. 14 x 11½ ins.

524 *Inscape I* (1970). By Tom Motley. Oil and acrylic. 36 x 36 ins.

525 *Inscape II* (1970). By Tom Motley. Acrylic on canvas. 27 x 22 ins.

526 *Bird's Eye View: Nature watching Hopkins watching Nature* (1988). By Tom Motley. Oil. 30 x 24 ins.

527 *86 St. Stephen's Green and Newman's Church, Dublin* (1978). By Norman White. Pencil sketch. 5¾ x 7¾ ins.

528 *After John Everett Millais's Painting Winter Fuel* (n.d.). By Jane McSloy. A pen-and-ink drawing. 4¾ x 3½ ins.

529 *After Hopkins's Garnet Humming Bird 1858* (1988). By Margaret Ann Turner. Silk thread embroidery on Aida cloth. 10½ x 11½ ins.

The embroidery, drawn enlarged on Aida cloth by Tomás Bustos, is a needlework interpretation of Hopkins's early watercolor.

530 *After Hopkins's Garnet Humming Bird 1858* (1988). By May Burnett. Embroidery on linen. 19½ x 19 ins.

The embroidery, drawn enlarged on linen by Tomás Bustos, is a needlework interpretation of Hopkins's early watercolor.

531 *After Hopkins's "Beech, Godshill Church Behind Fr. Appledurcombe, July 25, [1863]"* (1988). By Joanna Trepel. Embroidery on linen. 15 x 10 ins.

The embroidery, drawn on linen by Tomás Bustos, is a needlework interpretation of Hopkins's pencil drawing. Because of its appropriateness and because it belongs to the HRHRC, the original of this drawing is being used as the logo of the exhibition.

532 *Instress/Inscape* (1979). By Leon Pledger. Metal and glass sculpture. 22 x 10 x 10 ins.

533 *Soul's Core: Instress/Inscape* (1987). By Virginia Oechsner. Metal wire sculpture. 17 x 21 x 15 ins.

534 Thirty black-and-white art photographs from a portfolio entitled *Inscapes* (various dates). By Edward J. Ross II. 16 x 20 ins.

Ross has deliberately not indicated the specific locale of each of these photographs. Rather, he has wanted the viewer to look at the landscapes for their peculiar individualities. Ross has been a student of Ansel Adams.

535 Five photographs relevant to the ceremony in Westminster Abbey for the unveiling of the marble slab honoring Gerard Manley Hopkins (1975). Photographer unidentified. Each 10 x 8 ins.

536 A photograph of an outdoor mural on The Hopkins Book Shop in Burlington, Vermont (n.d.). Artist unidentified. 24 x 30 ins.

This mural occupies the outside wall of the bookshop and measures about 14 x 34 ft. and incorporates quotations from a number of different poems by Hopkins.

537 *Selected Poems: A Hopkins Anthology in Oils* (1988). By Tomás Bustos. Oil. 58 x 24 ins.

Item 537: Tomás Bustos's *Selected Poems: A Hopkins Anthology in Oils* (1988). 58 x 24 ins.

In this painting the artist has, after listening to recordings of all of the sonnets by Hopkins, incorporated some dozen images in his "anthology."

538 *Hopkins Lives* (1989). By Larry Johnson. Watercolor. 24 x 18 ins.

This is the official, limited edition souvenir poster of the exhibition. In addition to information concerning the exhibition, the artist has incorporated in the poster the exhibition logo (the drawing of the beech tree) and the last line of the exhibition theme sonnet.

AFTERWORD

This catalogue and the exhibition it details are fairly comprehensive in supporting the concept that Hopkins, almost totally unknown by the public during his lifetime, has, through the impact of his slender volume of poetry (not published until almost thirty years after his death), by now made his influence felt in almost every aspect of human communication.

But there are fields of human endeavor reflecting the poet's presence today which are, because of lack of space or time, not represented in the show: bookjacket art, a significant, thriving, and fairly new enterprise for artists; references to Hopkins in fiction and the uses made of such allusions by the authors; unpublished poetic tributes to the man—to name only three. And then there are the areas of impact which are under-represented—musical scores, for instance.

The catalogue is, therefore, by no means exhaustive in recording the poet's current and still-growing influence; I doubt that any catalogue can ever be. And that fact is proof indeed that *Hopkins Lives*.

Contributors to the Exhibition

Pilar Abad García
Wendy L. Abbott-Young
Francie R. Allen
Michael Allsop
Robin Anderson
Eugene R. August
Jack H. Bady
Michael Bampton
Martin Beckett
Frans Josef van Beeck
Todd K. Bender
Howard Bloch
Margaret M. Bogan
Jennifer Boller
John D. Boyd
Robert Boyle
Lacey Brady
John Brett-Smith
Lord Thomas Bridges
Alan Brisenden
Bob Brock
W. Bronzwaer
Philip Brown
Ann Bryan
Emilie Buchwald
May Burnett
Robert L. Burr
Tomás Bustos
John Byrne
Mary Jo Calarco
Paul Camp
Letterio Calapai
Ferdinando Carpanini
William Van Etten Casey

Edgar W. Castle
Pamela Chergotis
Cris Childers
John H. Childers
Bill Cleary
Bill Coon
Scott Coplen
C.G. Cordeaux
James Cotter
Charles Cox
Lisa Cox
Robert Cross
Philip Dacey
Ray Dane
John A. Dardis
Alan Denny
A. Devasahayam
David A. Downes
Michael Dunham
Tom H. Dunne
Ralph Eastwell
Francis Edwards
W. J. Edwards
Catherine Doyle Egan
Audrey Elstob
Paul English
Edward P. Ennis
Sandy Eustis
Angela Evans
Michael Farley
John Farrell
Maria Farrell
Joseph Feeney
Ernest Ferlita

Alan M. Fern
James Fisher
John Fletcher
Gerald Fluess
Hilary Fraser
Cola Franzen
Peter Gale
René Gallet
Colin Gardner
Charlene Garry
John Geraint
Eric Gerard
Richard Francis Giles
King I. Glass
Mary Lou Glass
Brian Glanvill
Gaynor Goffe
Tom Goldwasser
Ofelia González
Thomas Gornall
Michael Grace
Dorothy Greene
Dixie Griffin
Keith Griffin
Jane Hamlyn
A.J.C. Hamp
Valmai Hankel
Stephanie Harris
Renato Hasche
Betty Hay
Jerry Herrin
Michael Hewett
William Hewett
Lesley Higgins

Betsy Hilliard
Kyle Hilliard
Eugene Hollahan
Marcella Marie Holloway
David Hovatter
Shirley Humphries
Yuko Ibuki
Joseph E. Jeffs
Richard Jennings
J. Clifford Jones
Raymond Jones
Tommie June Jones
Mary Frances Judge
Krystyna Kapitulka
Hugh Kay
Kei Kasahara
Byron Denny Kindred
Marjorie Klise
Robert D. Knowles
Joaquin Kuhn
Maura Kuhn
Tina Ladwa
Anita Lane
George A. Lane
Scott Lenz
Christine Lewsey
Eileen Lieben
Michael Lynch
Cicely Lushington
Sheila MacCrindle
Norman H. MacKenzie
Michael Martin
Mary Alice Matthews
Francis O. Mattson
Michael McCurdy
William C. McInnes
Ian McKelvie
Justin McLoughlin
Michael McMains
Dennis McNally
C.J. McNaspy
Jane McSloy
Rita McSloy

Edwin P. Meness
Kim K. Merker
Auriol Milford
D.C. Miller
Elizabeth Morano
Tom Motley
Marylou Motto
Patricia A. New
Dorothy Newberry
George Newberry
John Newberry
David Nicholls
Jude V. Nixon
Dermot O'Brien
Virginia Oechsner
Suekichi Omichi
Kathy Olivieri
Walter J. Ong
F.E. Pardoe
W.A.M. Peters
Catherine Phillips
A. Pollet
John Pratt
Maria Price
Frederic Prokosch
J.J. Quinn
Peter Reddick
Diana Rendell
Kenneth W. Rendell
Anne Rennie
Ian F. Rennie
Edinice Garro Teixeira
 Rezende
Dane Richter
Jean-Georges Ritz
Gerald Roberts
Pamela Robinson
Eugene M. Rooney
Edward J. Ross, II
Sheelagh Russell-Brown
Alan Russell-Cowan
Kathy J. Schaefer
Merri Scheibe

Raymond V. Schoder
Alberto S. Segrera
Tom Sharpe
Benedict Simmonds
Carolyn Smith
Harry W. Smith
James Spence
Edward V. Stackpoole
Cornelia Starks
Suzanne Starr
Barbara Stearns
Howard Stearns
George Stephenson
Michael Tang
Michael Taylor
W. Thomas Taylor
Pawel Tomasz
 Tenerowicz
Joseph A. Tetlow
Alfred Thomas
Martin Thomas
Vicki Thomas
R.K.R. Thornton
André C. Trepel
Joanna Trepel
James Trissel
Akiko Tsutsumi
Decherd Turner
Margaret Ann Turner
Leo van Noppen
Janneke Venema
Dan R. Waggoner
Nora Waggoner
Ruth Adele Waggoner
Donald Walhout
S. Youree Watson
Gabrielle Wedder-
 burn
D.P. Williams
Norman White
Tom Whitlock
J. Howard Woolmer
Beryl J. Work

184

Rachel Blackburn Itsuki Yasuyoshi Mary Youdan
 Wright Eric Youdan

INSTITUTIONS

The Basilisk Press, London
The Bodleian Library, Oxford
 University
Boston College
British Broadcasting Corporation
Campion Hall, Oxford University
Enderle Book Company, Publishers,
 Japan
The Folio Society, London
Georgetown University
Harry Ransom Humanities Research
 Center, The University of Texas at
 Austin
The Hokuseido Press, Tokyo, Japan
Lorimar-Telepictures, Culver City,
 California
Modern Art Museum of Fort Worth
Newham Library Service
Oxford University Press
St. Paul's Bibliographies, Winchester,
 England
Shunju-Sha, Publishers, Japan
Society of Jesus
State Library of New South Wales
State Library of South Australia
Thomas S. Klise Company, Perrin,
 Illinois
Transamerica Life Companies
The Vatican
Warner Bros., Burbank, California

HRHRC STAFF

Thomas F. Staley, Director
Barbara Calaway
John P. Chalmers
Roberta Cox
Scott Garber
Kathleen Gee
John Kirkpatrick
Leslie Kronz
Sally Leach
Sue Murphy
Mary Sue Neilson
Dave Oliphant — *edited catalogue*
Rodolfo Sotelo
James Stroud
Bruce Suffield
Robert N. Taylor
Jill Whitten
John Wright

NOTES ON CONTRIBUTORS

TODD K. BENDER, a professor of English at the University of Wisconsin, Madison, has published numerous articles on Hopkins, in addition to two books: *Gerard Manley Hopkins: The Classical Background and Critical Reception of His Work* and *A Concordance to Gerard Manley Hopkins*. He is the editor-in-chief of the Commemorative Series of Studies in Gerard Manley Hopkins, published by Verlag Peter Lang, in Berne, Switzerland. At present, he is also preparing the first complete edition of the poems of Richard Watson Dixon, one of the few persons Hopkins allowed to read his mature poems.

JOSEPH J. FEENEY, S.J., a professor of English at Saint Joseph's University, Philadelphia, has published dozens of articles on Hopkins in various journals in the United States and in Europe, including *The Hopkins Quarterly*, *Victorians Institute Journal*, and *Stimmen der Zeit*.

RICHARD F. GILES, a Teaching Master at Mohawk College, Hamilton, Ontario, is the founder and editor of *The Hopkins Quarterly* and the founder of The International Hopkins Association. In addition to publishing numerous articles about Hopkins, he edited the IHA monograph *Hopkins among the Poets: Studies in Modern Responses to Gerard Manley Hopkins*. He has also published a special issue of *The Hopkins Quarterly* entitled *Hopkins: The Man and Dublin*, containing papers read at The International Hopkins Association conference held in Dublin, 11-16 July 1984, a conference for which he was coorganizer. He is at present preparing the second volume of papers delivered during the Dublin conference.

NORMAN HUGH MACKENZIE has taught in South Africa, Hong Kong, Australia, Rhodesia (now Zimbabwe), and Canada, and is currently professor emeritus at Queen's University in Kingston, Ontario. He first wrote about Hopkins in 1961 in the *Times Literary Supplement* and soon afterwards became editor (with the late W.H. Gardner) of the standard Fourth Edition of *The Poems of Gerard Manley Hopkins*. His other books include *Hopkins* and *A Reader's Guide to Gerard Manley Hopkins*. In the fall of 1988 he gave in Oxford the prestigious Martin D'Arcy Lectures, and in this centennial year he will publish two new editions of the *Poems*: a facsimile of the manuscripts and a variorum edition for the Oxford English Texts series of the Clarendon Press.

CARL SUTTON, curator of the exhibition *Hopkins Lives* and compiler of the accompanying catalogue, is professor emeritus at the University of North Texas in Denton, where he taught English for 33 years, until his retirement in 1979. He was a charter member of The Hopkins Society of England, now defunct, and is a charter member and president of The International Hopkins Association, which has its central headquarters in Canada. He and his wife Elizabeth chartered a local chapter of the Association in Denton.

Recent Publications of

THE HARRY RANSOM HUMANITIES RESEARCH CENTER

EXHIBITION CATALOGUES

The Eric Gill Collection by Robert N. Taylor, with the assistance of Helen Parr Young. $20.00.

AUTHORS' LIBRARIES

James Joyce's Trieste Library, a catalogue of materials at the HRHRC by Michael Patrick Gillespie, with the assistance of Erik Bradford Stocker. $30.00 in cloth.

CHRONICLE SPECIAL ISSUE BOOKS

Joyce at Texas, edited by Dave Oliphant and Thomas Zigal. Critical essays on Joyce materials at the HRHRC. $14.95.

Perspectives on Australia, edited by Dave Oliphant. Critical essays on the C. Hartley Grattan and other Australian collections at the HRHRC. $18.95.

Perspectives on Music, edited by Dave Oliphant and Thomas Zigal. Critical essays on music materials at the HRHRC. $16.95.

Perspectives on Photography, edited by Dave Oliphant and Thomas Zigal. Critical essays on photography at the HRHRC. $14.95.

No Symbols Where None Intended, a Catalogue of Books, Manuscripts, and Other Materials Relating to Samuel Beckett, selected and described by Carlton Lake, with the assistance of Linda Eichhorn and Sally Leach. $20.00.

WCW & Others, edited by Dave Oliphant and Thomas Zigal. Critical essays on William Carlos Williams. $13.95.

Lewis Carroll at Texas, the Warren Weaver Collection and related Dodgson materials at the Harry Ransom Humanities Research Center, compiled by Robert N. Taylor, with the assistance of Roy Flukinger, John O. Kirkpatrick, and Cinda Ann May. $25.00.

Lawrence, Jarry, Zukofsky: A Triptych, edited by Dave Oliphant and Gena Dagel. Critical essays on three representative HRHRC collections. $20.00.

Conservation and Preservation of Humanities Research Collections, edited by Dave Oliphant with an introduction by James Stroud. Essays on Treatment and Care of Rare Books, Manuscripts, Photography, and Art on Paper and Canvas. $17.95.